Bibliography of Repeat Photography for Evaluating Landscape Change

Bibliography of Repeat Photography for Evaluating Landscape Change

Compiled and Annotated, with an Introduction

BY

GARRY F. ROGERS

Department of Geography
Columbia University, New York

HAROLD E. MALDE

U. S. Geological Survey, Denver

RAYMOND M. TURNER

U. S. Geological Survey, Tucson

University of Utah Press
Salt Lake City

Library of Congress Cataloging in Publication Data

Rogers, Garry F., 1946-
 Bibliography of repeat photography for evaluating
landscape change.

 Includes index.
 1. Repeat photography--Bibliography. 2. Photography--
Landscapes--Scientific applications--Bibliography.
3. Landscape changes--Bibliography. I. Malde, Harold E.
(Harold Edwin), 1923- . II. Turner, R. M. (Raymond M.)
III. Title.
Z7136.R46R63 1984 [TR786] 016.7783 84-23437
ISBN 0-87480-239-3

Contents

ILLUSTRATIONS

Acknowledgments

During the preparation of the bibliography, contributions and advice came from Richard V. N. Ahlstrom, Mary Allcott, Donald L. Baars, James A. Banner, Nancy Barrett, Albert Allen Bartlett, Raymond M. Batson, Chester B. Beaty, James B. Benedict, Paul Berger, Joel R. Bergquist, Julio L. Betancourt, Arthur L. Bloom, Lowell Bodger, Frederick H. Bormann, Peter A. Bowler, John D. Bredehoeft, Peter S. Briggs, Ian A. Brookes, Mary M. Bryan, Bruce H. Bryant, Richard D. Burr, Parker E. Calkin, James B. Campbell, Edward Cavell, Sandra H. B. Clark, Charles W. Collinson, Donald J. Colquhoun, Ronald U. Cooke, Howard R. Cramer, Bruce F. Curtis, Verna Curtis, Marjorie E. Dalechek, Rexford Daubenmire, Don G. Despain, Rick Dingus, Jean-Marie Dubois, Peter W. Dunwiddie, Frank E. Egler, Mohamed T. El-Ashry, Don English, George R. Fahnestock, David Featherstone, William O. Field, Jr., Don D. Fowler, James B. Garvin, Dov Gavish, Robert P. Gibbens, William L. Graf, George E. Gruell, Richard F. Hadley, Thomas D. Hamilton, Alicia Hathaway, Eugene M. Hattori, C. Vance Haynes, Jonathan Heller, Richard Hereford, Gordon W. Hewes, Charles G. Higgins, Elizabeth R. Hobbs, Robin T. Holcomb, Lloyd C. Hulbert, Charles B. Hunt, Donald Lee Johnson, Rodney W. Klassen, Mark Klett, Austin Kovacs, Kathleen Krafft, Wayne Lambert, William A. Laycock, Alton A. Lindsey, R. Burton Litton, Jr., Stanley W. Lohman, J. David Love, Charles H. Lowe, Jack Major, Paul S. Martin, Edwin D. McKee, Brainerd Mears, Jr., Mark F. Meier, Byron D. Middlekauff, Henry J. Moore, James G. Moore, Joan Morris, Clifford M. Nelson, William A. Niering, Eric Paddock, R. N. Philbrick, Terence R. Pitts, Peggy A. Platner, Steven W. Plattner, Diane M. Rabson, Max W. Reams, John C. Reed, Jr., Dallas D. Rhodes, Richard Rudisill, Edward G. Sable, Jack C. Schmidt, Susan Seyl, Robert P. Sharp, Sarah Shields, James L. Smith, Allen M. Solomon, Richard C. Spicer, John H. Stewart, Todd Strand, William F. Tanner, Robert S. Thompson, Lyn Topinka, Don M. Triplehorn, James R. Underwood, Jr., Thomas R. Vale, Robert E. Wallace, Dave Walter, G. James West, Ian E. Whitehouse,

Garnett P. Williams, Howard G. Wilshire, Dan H. Yaalon, Dana L. Yensen, Ellis L. Yochelson, and Paul H. Zedler. Otto Grosz verified many of the citations against the holdings of the University of Arizona library. Caryl L Shields searched the computerized data files. Denise Rogers edited the index, and Alex J. Donatich edited an early version of the manuscript Helpful reviews were generously provided by Michael N. Machette and by Dingus, Gruell, Lambert, Martin, and Niering.

To all these individuals we are grateful, but we are solely responsible for any remaining errors.

Introduction

Repeat photography is the practice of finding the site of a previous photograph, reoccupying the original camera position, and making a new photograph of the same scene. For the three of us, repeat photography has been a means of evaluating landscape change as perceived in our respective fields of research: geography, geology, and botany. Beginning in March 1982, we decided to pool our resources and compile this bibliography on repeat photography of landscapes. Our goals have been to consolidate the published contributions to the subject, to provide perspective on the ways in which repeat photography has been used, and to make this body of knowledge available to others.

Purposes of Repeat Photography

The value of photographs as documents was probably recognized almost immediately after photography was invented in 1839. For example, Frederick Catherwood, the architect who traveled in Central America and Yucatán with John Lloyd Stephens from 1838 to 1842, tried to portray the Mayan ruins faithfully, using a daguerreotype camera.[1] Many more of the early photographic efforts were similarly motivated. Since then, photographs have become increasingly familiar as precise and revealing records of the physical and biological world. Photographs are also often used in the social sciences, such as anthropology[2] and history.[3]

1. von Hagen, Victor Wolfgang, 1947, Maya explorer, John Lloyd Stephens and the lost cities of Central America and Yucatán: Norman, Oklahoma, University of Oklahoma Press, pp. 209, 232.
2. Worth, Sol, 1980, Margaret Mead and the shift from "Visual anthropology" to the "Anthropology of visual communication": Studies in Visual Communication, v. 6, pp. 15-22.
3. Borchert, James, 1981, Analysis of historical photographs; A method and a case study: Studies in Visual Communication, v. 7, pp. 30-63.

Figure 1. Sandstone monuments at Perry Park, near Larkspur, Colorado.

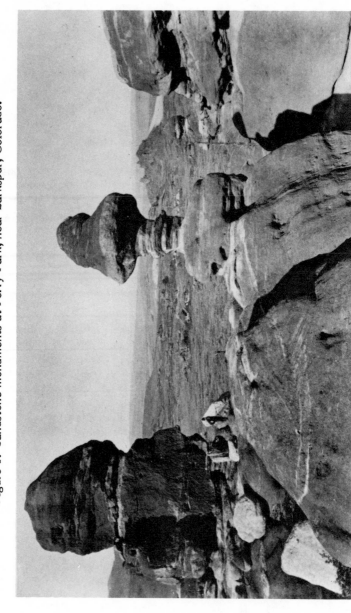

A. William Henry Jackson, 1874. "Sandstone monuments of Pleasant Park." Printed on page 74 in William H. Jackson by Beaumont Newhall and Diane Edkins: New York and Fort Worth, Morgan and Morgan, 1974. (International Museum of Photography at George Eastman House, Rochester, N.Y.)

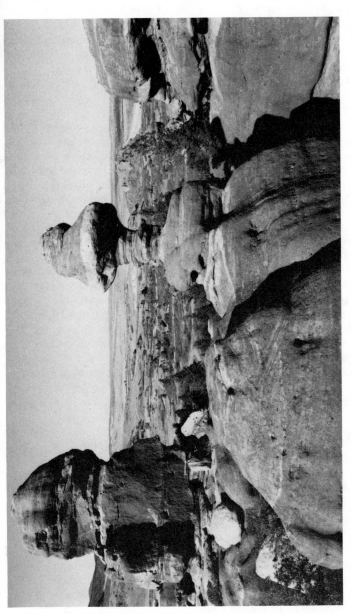

B. Harold E. Malde and Wayne Lambert, 1975. The original camera position was reoccupied at a time when the direction of sunlight was virtually the same as it was when Jackson took his photograph--namely, 3:43 p.m. Mountain Daylight Time on October 11, 1975. (Malde photograph no. 915 in U.S. Geological Survey Photographic Library, Denver, Colo., hereafter designated as USGS. Enlarged from 4 x 5-inch film negative; focal length 90 mm.)

Any previous photograph, when it is repeated, becomes part of a record of change with the passage of time. In this bibliography, we refer to the combined old and new images as a pair of matched photographs. Our particular concern is the use of matched photographs for the study of changes in vegetation and landforms, including changes caused by human activities. Historically, the first such efforts are attributed to Professor Sebastian Finsterwalder, the father of precise glacier mapping, who, in 1888 and 1889, initiated repeated photogrammetric surveys of glaciers in the eastern Alps.[4] Since then, matched photographs have been increasingly used in more and more fields of scientific research.

Matched photographs show the same subject at two or more times, ideally from the same spot and with the same angle of view and direction of lighting, as in Figure 1. (The pairs of photographs used here are selected to show aspects of repeat photography discussed in the text and are taken mainly from our own unpublished work.) If the initial photograph is not closely or exactly matched, we refer to the pair of photographs as being approximately or poorly matched, depending on the apparent degree of similarity in the respective camera positions and directions of view. Obviously, the initial photograph ordinarily must be selected from photographs made for purposes other than the study of a landscape. For example, early photographs taken to show mining districts in southern Arizona and adjacent Mexico have been repeated to measure vegetation change after a lapse of several decades.[5] Whatever the intent of an early photograph, however, it generally has the virtue of showing the landscape impartially and accurately, without the bias of giving attention only to selected features that are expected to change. (However, see the discussion that follows on the reliability of photographs.)

Besides the use of old photographs to demonstrate landscape change, the initial image is sometimes simply an artist's sketch.[6] Moreover, photographs have also been made to identify features described only in early field notes.[7]

The span of time between matched photographs is typically measured in years or decades. However, photographic records of landscape changes produced by some especially rapid natural processes, such as the minute-by-minute changes in the character of a stream channel or the nearly instantaneous effects of a volcanic explosion, have also been made.[8] In addition, the bibliography gives several examples of photographs that have

4. Hattersley-Smith (1966). This bibliography.
5. Hastings and Turner (1965). This bibliography.
6. Falconer 1962); Graf (1979a); Hattori and McClane (1980); Imbrie and Imbrie (1979); James (1969); Lamb (1982); Le Roy Ladurie (1971); Malde (1983); A. M. Rea (1983); Schneider with Mesirow (1976); Simpson (1951). This bibliography.
7. Lockett (1939). This bibliography.
8. Fahnestock (1963); Foxworthy and Hill (1982). This bibliography.

been repeated seasonally or annually. For example, botanists at the T. G. B. Osborn Vegetation Reserve, at Koonamore, South Australia, used annual photographs taken over a 31-year period to determine changes in biomass and the timing of germination events. Coupled with weather records, the photographs were then used to construct a germination model that incorporates daily rainfall, mean annual temperature, and annual potential evapotranspiration.[9] Research of this kind shows that matched photographs are commonly used in conjunction with other information, such as measurements of plant cover (Fig. 2).

In our work, we primarily use photographs made from ground level. We also try to achieve the ideal of repeating the camera placement and the lighting of a photograph as exactly as possible (Fig. 3), although valid interpretations of landscape change can sometimes be made by comparing photographs that are repeated less precisely.[10]

Those who have experienced the excitement of finding the site of an old photograph after a century of time know the thrill of standing in the footsteps of a pioneer photographer, seeing the landscape that he chose to photograph, and trying to comprehend his impressions of the scene. The intellectual effort of seeking to understand the perception of an early photographer is often as scientifically rewarding as identifying how the landscape has changed. That is, the significance of a former landscape may have changed as the landscape itself changed. The aesthetic perceptions of early photographers are also of interest.[11] Accordingly, we hope that users of this bibliography will be prompted to re-enact the travels of our photographic predecessors. By doing so, we believe that one's appreciation of the landscape will be improved.

Besides the subjective value of repeat photography in promoting enhanced perception of landscapes, matched photographs obviously have an objective purpose. A pair of matched photographs links a moment in the past with the intervening unseen events, and the new photograph establishes a point on a photographic network for future observation of the land.[12] Hence, photographs of landscapes have been referred to as bench marks.[13] Whenever such photographs are repeated, they become elements of a continuous record, and they provide a quantitative basis for understanding and predicting the natural forces that give a particular landscape its character. The dominant themes of repeat photography, therefore, are quantifying the rate, nature, and direction of change in the observed features; evaluating the underlying causes of the perceived changes; and establishing new photographic records for future viewers to study and ponder. The great value of matched photographs for pursuing these themes

9. Nobel and Crisp (1980). This bibliography.
10. Veatch (1969). This bibliography.
11. Dingus (1982); Klett (1979). This bibliography.
12. Lambert (1981). This bibliography.
13. Malde (1973). This bibliography.

Figure 2. MacDougal Pass in the Pinacate Mountain area of Sonora, Mexico. (Pls. 83a and b in Hastings and Turner, 1965. This bibliography. Copyright, The Board of Regents of the Universities and State College of Arizona; reprinted by permission of University of Arizona Press.)

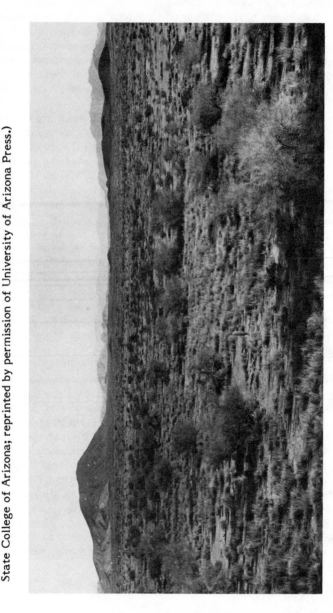

A. Daniel T. MacDougal, 1907. Hastings and Turner (p. 236) identified the area as follows: "This hot, sandy plain, flanked partly by volcanic intrusions and partly by dunes drifting inland from the Gulf of California, is near the upper edge of the arid Lower Colorado Valley province." (Arizona Historical Society. From 6½ x 8½-inch contact print.)

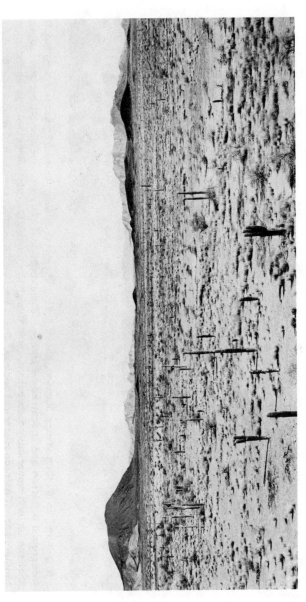

B. James Rodney Hastings and Raymond M. Turner, 1962. This area and most of an adjacent view have been made into a study plot. Hastings and Turner (p. 237) described some of the vegetational changes in the plot as follows: "Of the 219 mesquite trees, dead and alive on the plot, woodcutters have accounted for 43. Of the remaining 176 mesquites, 91, mostly small, are dead from natural causes; 27 are nearly dead; only 58 of those not tampered with . . . are alive and healthy. Among the blue paloverdes, a tree that is not suitable for fuel, . . . 30 are dead and only 25 . . . alive." (Turner photograph no. 63b. Enlarged from 2⅛ x 3¼-inch film negative; focal length 105 mm.)

Figure 3. Mesa Encantada from Acoma Pueblo, New Mexico.

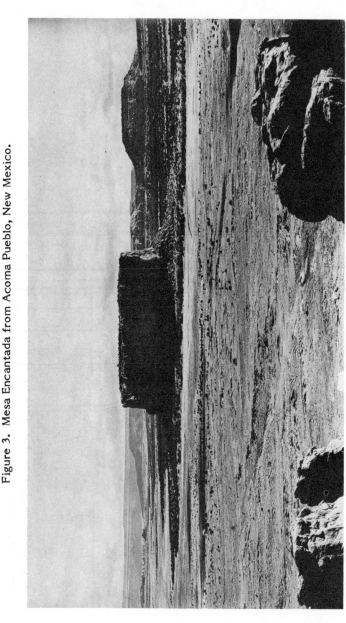

A. Attributed to William Henry Jackson, about 1899. The mesa is surrounded by juniper trees, but the foreground is barren and is scarred by gullies. The exceptional clarity of the distant horizon suggests that the air was remarkably transparent, even though Jackson's glass-plate negative was sensitive only to blue light. (Colorado Historical Society. From 8 x 10-inch contact print; focal length 555 mm.)

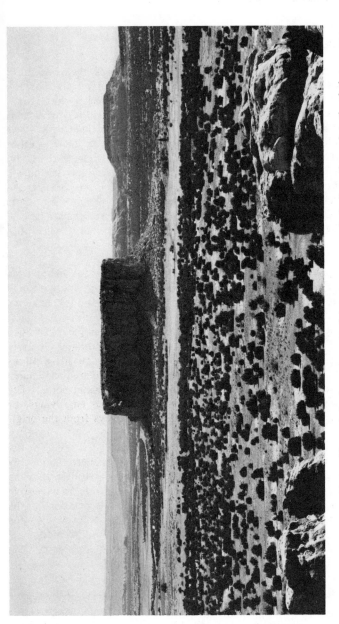

B. Harold E. Malde, 1977. The original camera position was reoccupied when the azimuth of the sun was nearly the same as it was at the time of Jackson's photograph, but the inclination of the sun was considerably higher. Even so, it is clear that the barren foreground of Jackson's day is now crowded with junipers, and the gullies have become subdued. (Malde photograph no. 994, USGS. June 21, 1977; 9:40 a.m. Mountain Daylight Time. Enlarged from 4 x 5-inch film negative; focal length 287 mm.)

is that they express an abundance of information for a particular place and
time.

Reliability of Matched Photographs

Despite the virtues of photographs as precise records, their reliability
deserves further comment. For example, a photograph may truly show the
presence of a boat on a lake, but the boat may be grounded on the bottom.
Hence, both the objective truth of a photograph and the validity of what it
may imply are matters of possible concern.[14] Of these two potential flaws
in a photograph, a natural scientist probably wants most to know whether
the features it purports to show are true, and the social scientist is likely
to wonder whether the inferences drawn from the photograph are indeed
correct. If flaws exist, the value of a photograph for interpreting the
character of a landscape is weakened or destroyed. The following points
discuss the degree to which matched photographs of landscapes can be
expected to be reliable, particularly when the initial photographs were
taken for other than documentary purposes.

Photographs may be unrealistic. Although a landscape photograph
can be intentionally altered, false images are generally easy to detect and
are not a matter of particular concern. Photographs reversed left to right,
skies printed in, and tonal changes introduced by pencil work on the nega-
tive are characteristic of typical efforts to deceive the viewer. Such
efforts seldom go unnoticed. Also, the technical inaccuracies of early
photographs, such as the fading of distant objects on blue-sensitive plates
or the peculiar tonalities produced by the printing-out process, are under-
standable, although perhaps imperfect. On the other hand, some early
photographs were reproduced only as lithographs, wood engravings, or
drawings, each of which differed in various distinct ways from the origi-
nals.[15]

Artistic motives can be misleading. Photographers commonly
attempt to emphasize their impression of a landscape by artfully employing
a gamut of practices, none of which is necessarily intended to be deceptive
but which can be nonetheless misleading. Shifts in the position of the
camera, the emphasis achieved by the relation of the foreground to the
background, changes in apparent perspective caused by use of wide-angle
and long-focus lenses, and the choice of the direction and angle of lighting

14. Becker, Howard S., 1979, Do photographs tell the truth? in Thomas D.
Cook and Charles S. Reichardt, eds., Qualitative and quantitative
methods in evaluating research: Beverly Hills, California, Sage
Publications, pp. 99-117.
15. Ostroff (1981). This bibliography.

are some of the methods by which a photographer can control the photographic appearance of his subject. Even the act of framing a landscape removes the resulting photograph from its surroundings and may introduce some uncertainty about what the photograph was intended to show. A fairly extreme example of artistic license is Timothy O'Sullivan's use of a tilted horizon to emphasize the inclined stance of some rock pedestals in Utah (Fig. 4). In our experience, the options exercised by our photographic predecessors have often been hard to identify with only their photographs in hand. Accordingly, upon finding a site, we have been frequently surprised by discrepancies between our prior interpretation of a photograph and the actual scene. In such cases, reality can be resolved only by finding the original site and facing the field of view that confronted the early photographer.

Photographs can be unrepresentative. When matched photographs are used, the lack of representative initial photographs is perhaps the greatest threat to reliable interpretations of landscape change. An early photograph of a landscape may be unrepresentative because of the artistic aims described above, but a greater problem is likely to be that the photograph does not show the extent of variation present. That is, by showing only one aspect of a scene, a photograph may be less than typical. Perhaps the photographer was unfamiliar with the existing variety or was simply not interested in the differences. Also, most photographers have preconceived notions about what subjects are worthy of a picture. For example, G. K. Gilbert's 1901 photographs of the Great Basin dealt entirely with block faulting, and (because of the geologic characteristics of the region) his photographs are thus mainly views of west-facing fault scarps.[16] East-facing scarps were seldom photographed. Similarly, Homer L. Shantz, an early botanist at the University of Arizona, often chose to photograph sites of disturbed vegetation, and a contemporary ecologist looking at his photographs might conclude erroneously that disturbed vegetation was more or less common. Users of historical photographs must also be mindful that many of them, because of current interest, were taken near settlements and along well-traveled routes where human impacts would have been comparatively great. Thus, in order to minimize the bias of a single early photographer, studies using repeat photography should be based on the work of as many photographers as possible. Finally, bias may influence interpretations in an opposite way: that is, an investigator may choose to repeat only those old photographs that are interesting, that seem to make sense, or that can be easily located. The most honest approach is to be aware that some bias in selecting early photographs is virtually unavoidable and that the selections inevitably influence the conclusions about how the changes seen in the photographs may have been caused.

16. Rogers (1982). This bibliography.

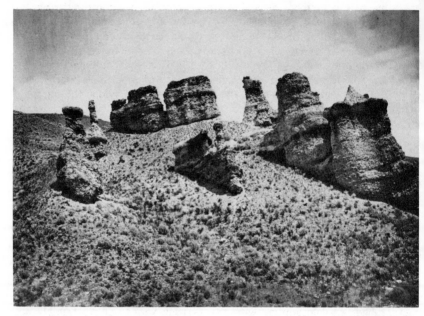

A.

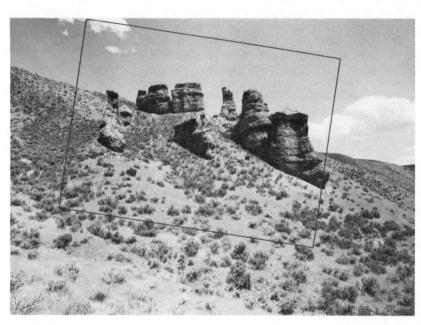

B.

Repeat photographs can be mismatched. Mismatched photographs are a problem of reliability peculiar to repeat photography, in that a mismatch results only because the second photograph is ineptly made. The primary requirements for making an accurate match are careful aim and placement of the camera, although full coverage of the initial photograph may also require the use of a lens of suitable focal length. (The technique of repeating photographs is briefly explained in the following section on methods.) Making the new photograph at the same time of day and at the same time of the year as the old, thus reproducing the angle of sunlight and the seasonal vegetation, is also desirable in most studies of landscape change. Of course, matched photographs are much easier to compare if they are the same size and encompass the same area. The necessary adjustments in scale and cropping are easily made in the darkroom. For many distant subjects, a mismatch can be of trivial significance, but errors in matching the foreground generally make accurate interpretations difficult or impossible (Fig. 5). Also, photographs made from conspicuously different angles of view limit the degree to which reliable interpretations can be made of landscape change (Fig. 6).

Methods of Repeat Photography

Reoccupying unmarked camera stations. Making a photograph that matches an earlier photograph depends, first, on finding and reoccupying the original camera position. Because the camera lens is the perspective center for all objects in a photograph, reoccupying the original site amounts to placing the camera lens at the position of the original lens and

Figure 4. Witches Rocks, Weber Canyon, Utah.

A. Timothy O'Sullivan, 1869. "Tertiary Conglomerates, Weber Valley." (From National Archives.)

B. Rick Dingus, for the Rephotographic Survey Project, 1978. "Here Dingus used a wider angle lens than O'Sullivan and leveled his camera. The rectangular outline reproduces O'Sullivan's framing. Note the degree to which O'Sullivan ignored the true horizon." (Pl. 15 in Dingus, 1982. This bibliography. Copyright, Rick Dingus, for the Rephotographic Survey Project; reproduced by permission of the photographer.) Dingus commented on O'Sullivan's perception (pp. 63-64): "Given the earlier [O'Sullivan] photographs in the sequence at Witches Rocks that emphasize the tilt of the slope, it seems to me that O'Sullivan canted the horizon here not as a formal exercise, but to heighten the visual record and to provide an equivalent for the drama of the landscape."

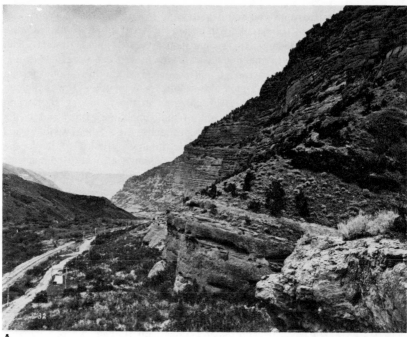

A.

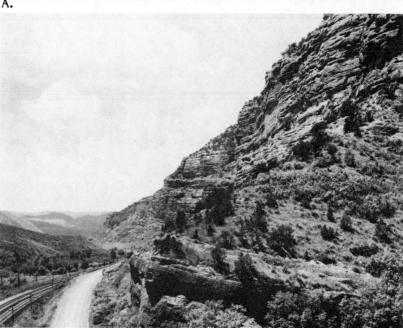

B.

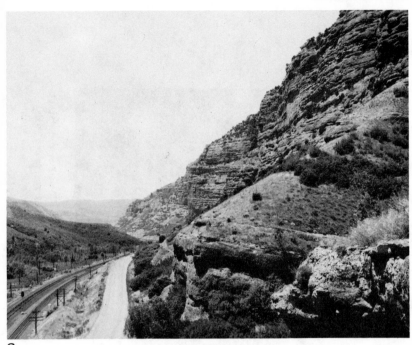

C.

Figure 5. Echo Canyon, Utah.

A. William Henry Jackson, 1869. Jackson described this view down Echo
Canyon as follows: "On the right, the high perpendicular walls, with the
strata dipping down westward, are cleft by deep gorges, leaving the
intermediate portions standing out like huge castles, massive in form and
vivid red in coloring." (From caption of Jackson photograph no. 32,
USGS.)

B. Ralf Rumel Woolley, 1940. Woolley's photograph, when compared with
Jackson's, was taken from a position too far forward and not far enough
to the left. Accordingly, the right foreground in Jackson's view is miss-
ing, and the relations of the "castles" described by Jackson are partly ob-
scured. (Woolley photograph no. 356, USGS.)

C. Garry F. Rogers, 1980. This view closely matches the original position
and direction of view. The shadows in the new photograph, however, are
more conspicuous than in Jackson's view, and the rendition of the
landforms is correspondingly improved. (Rogers photograph no. 349.
June 28, 1981; about 1:00 p.m. Mountain Daylight Time. Enlarged from
35-mm negative; focal length 35 mm.)

Figure 6. Malad Valley near Malad City, Idaho.

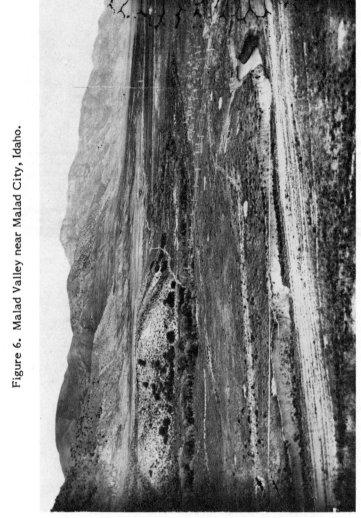

A. William Henry Jackson, 1872. In the foreground, the Malad River flows between steep and barren banks, but the valley floor (except for barren spots that mark ant hills) is densely covered with sagebrush. The more distant foothills have shrubs and junipers typical of upland areas in the Great Basin. (Jackson photograph no. 153, USGS.)

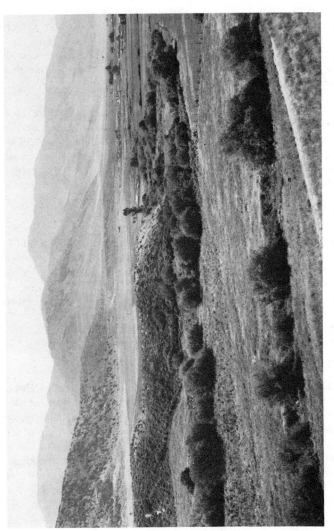

B. Ralf Rumel Woolley, 1939. The camera position is considerably higher and much farther to the left than Jackson's, making accurate comparisons of the vegetation and the river channel virtually impossible. (Woolley photograph no. 304, USGS.)

aiming it at the same point. A common mistake is to frame the new photograph to match the outline of the old, but this practice almost always results in some error in the position of the camera lens, because of differences in angles of view. Another fallacy is the notion that the focal length of the new camera must be proportional to that of the old. Instead, views made with cameras of different focal lengths from the same lens position will always match exactly, provided that both are printed and cropped to the same size.

With the old photograph in hand, the correct position and aim of the camera lens can be found visually by applying the familiar principle of parallax. As described by Malde:

> A position is found such that near and distant objects in the center of the field of view are brought into approximate alinement. Then, by moving along the centerline, objects at the periphery are alined so that their apparent parallax is also correct. This procedure identifies the aiming point and fixes the camera at the proper distance from the subject. The height of the camera at this distance can generally be determined only by observing the parallax of identifiable objects in the foreground.[17]

A similar procedure uses maps and surveying instruments to find the intersection of lines of sight and, hence, the camera position.[18] Some subjects, however, have no foreground objects, or perhaps none that are close enough to make the parallax method sufficiently accurate. In these circumstances, the position of the camera lens can be found by comparing ratios of horizontal and vertical distances on the old and new photographs.[19] When such measurements are made, either in the film plane or on "instant" photographs of the Polaroid type, the correct position can be reached by making a series of trials.

Matching the azimuth and altitude of sunlight. The second aspect of repeating a photograph is reproducing the character of its shadows--that is, matching the direction and inclination of the sunlight. This can obviously be achieved by making the new photograph at the same time of day and at the same time of the year--or at least approximately so. In this way, because the shadows and highlights are then faithfully reproduced, the old and new photographs can be better compared. Of course, close matching of the angle of sunlight may be of no particular importance for photographs made at midday or under a cloudy sky, and matched photographs made under different lighting conditions can nonetheless demonstrate significant

17. Malde (1973, pp. 197-98). This bibliography.
18. Borchers (1977); Ostaficzuk (1968). This bibliography.
19. A. E. Harrison (1974). This bibliography.

aspects of landscape change. Still, close matching of the shadows and highlights is almost always desirable in areas of high relief, such as an area of cliffs and canyons, or when the initial subject was photographed early or late in the day. Unfortunately, the circumstances under which a previous photograph was made are often unknown. The problem, then, lacking any notes by the previous photographer, is to determine more or less exactly the position of the sun when his photograph was made.

The azimuth and altitude of the sun for any particular time and date can be determined from astronomical tables, such as the "American Ephemeris and Nautical Almanac." Conversely, when the aiming point for a photograph has been identified, the time and date can be determined if the azimuth and the altitude can be deduced from the direction and length of the shadows. Whether the calculated date is in the fall or the spring is often obvious from other features in the photograph, such as the vegetation.

Fortunately, the relation of the time and date to the azimuth and altitude of the sun can be solved graphically. One graphical solution is given by a patented device called the Sundicator (Fig. 7). The Sundicator is a nomograph with a graduated pointer, which shows the azimuth and altitude of the sun from sunrise to sunset throughout the year. The Sundicator is made in several versions for use at various latitudes.

As might be expected, reproducing the direction of sunlight in a photograph is seldom done entirely analytically--at least in our experience. Usually, the site is visited and the nature of the shadows is compared with the existing lighting. The photographer may then decide to return at a better time, making a judgment about when the lighting can be matched more closely. Not uncommonly, several visits to a photographic site may be necessary to reproduce the proper angle of the sun.

Films and filters. Photographs made before panchromatic films became commercially available in the 1930s were taken on films and plates not sensitive to red light or (still earlier) on photographic materials that were insensitive to red, orange, and yellow and overly sensitive to blue. With these early films and plates, red was indistinguishable from black, the blue sky looked white, and distant parts of a landscape typically were rendered faintly or not at all.

With the advent of films sensitive to all colors, it became possible to record a landscape as the eye sees it. Moreover, by taking a photograph through a colored filter, it became feasible to alter the appearance of the subject, perhaps to emphasize certain features. Theoretically, it is even possible to reproduce the appearance of an old photograph by using modern film and a suitable filter. However, in our judgment, no useful purpose is served by efforts to match the rendition of colored objects in an old photograph. Such efforts do not necessarily improve one's ability to compare the old and new aspects of a landscape, and the false rendition of the new photograph makes it an imperfect document for future use.

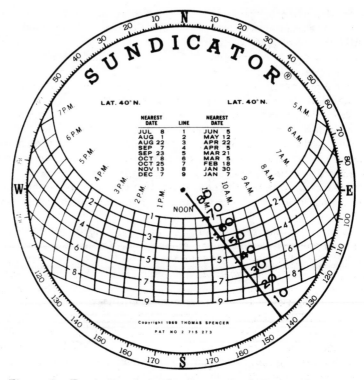

Figure 7. Facsimile of the Sundicator for latitude 40 degrees North. As shown, the markings on the radial line indicate that the azimuth and altitude of the sun at 10 a.m. on March 5 (or October 8) are at 142 degrees and 37 degrees, respectively. The scales are calculated for solar time and ignore small corrections for differences in longitude within a time zone.

One aspect of an old photograph, however, can sometimes be advantageously controlled by the use of filters--namely, the duration of the exposure. For example, because of long exposures, early photographs of rivers and coastlines show the moving water and the surf as a blur, in which the highest reach of the water is nonetheless defined more or less clearly. This effect can be matched on modern films by using a neutral density filter--that is, an uncolored filter that attenuates the light. For example, a filter with a density of 3.00, which transmits 0.10 percent of the light, might require an exposure of 40 seconds, counting the correction for reciprocity effects. Experiments might show that an exposure of this length accurately reproduces the height of the moving water in the old photograph.

Making records of new camera stations. The primary record of a camera station is a permanent mark on the ground, installed directly below the camera lens. For this purpose, a tripod and a plumb bob are recommended. When practical, a steel stake (such as a 40-inch length of half-inch rod) makes a long-lasting mark, when driven into the ground most of its length. In areas of barren rock, the station can be marked by a small hole made with a star drill. For some kinds of photographic observations, however, such as vertically oriented views of study plots, permanent marks are better placed in the field of view.[20] The camera position can then be determined with respect to those marks. In either case, the ease of finding the camera site at some future time will be enhanced if the camera on its tripod is shown in one or more related views, as in the use of witness marks to show the location of a bench mark. The position of the camera with respect to permanent features can also be specified. Finding the camera station will be further facilitated if more than one view is made from a given point. Indeed, panoramas made from a station can be advantageous, not only for finding the station in the future but also for giving wide coverage of a landscape from a given viewpoint.[21]

Measurements made from photographs are simplified if the camera is level and is aimed horizontally. If, however, when repeating a former photograph, the camera must be aimed up or down, the inclination should be recorded, and a second photograph should be made with the camera restored to its horizontal position. On the other hand, if an early photograph is tilted to one side, the tilt should not be repeated. If the tilt is an important attribute, it can be measured by comparing the old and new photographs. (See Fig. 4.)

Measurements from ground-level photographs are further facilitated if the photographs are made as stereoscopic pairs.[22] Such photographs give a greatly enhanced appreciation of the spatial relations in a landscape, and they are virtually a necessity when distances and heights must be accurately determined. For this purpose, the separation of the photographs and the focal length of the lens must be known.

Finally, a number of variables that pertain to each photograph should be noted. Figure 8 shows the kinds of data that are needed, arranged compactly on a 4 x 5-inch card. The illustration refers to a stereoscopic pair made with a level view camera, in which the lens was raised with respect to the center of the film plane and tilted forward to focus on near and far objects. The pair of photographs was then made by shifting the camera axis alternately 4 cm to the left and right, thus giving a total separation of 8 cm. Such information should be filed with the negative as a permanent part of the photographic record.

20. Poulin (1962). This bibliography.
21. Malde (1983). This bibliography.
22. Claveran (1966); Malde (1973). This bibliography.

STEREOPAIR

Station 82 M 58 **Date** SEP 22, 1982 **Time** 0935 MDT

Location Dorsey Butte quad., Idaho. 200 ft. S.,
1000 ft. W., NE cor. sec. 29, T. 4 S., R. 3 E.

Subject Black Butte lava flow and underlying
palagonite of Glenns Ferry Fm. cut by vent complex
of Stage 1 canyon fill of Bruneau Fm. The palagonite
is conformable on sediments that resemble the flood-
plain facies of the Glenns Ferry.

Film number	15	16	**Lens**	150 mm
Film type	FP-4		**Focus**	Lens tilted
Filter (X)	yellow (2)			forward 3 degrees;
Exposure	1/10			back vertical
f-Stop	32 1/3		**Aiming point**	
Developer	DK 50 1:1			Triangular shadow
Development	5m 45s		**Azimuth**	N. 8° W.
Axis right	4 cm		**Marker**	
Axis left		4 cm		Rod 25 cm high
Lens up	10 mm		**Height**	
Lens down				171 cm above ground
Remarks	Clear sky; no wind.			

Figure 8. A format for recording the data of photo-
graphs intended to be records of landscapes.

Sources of Landscape Photographs

Those who have practiced repeat photography have commonly done so
because interesting old photographs were available in an accessible ar-
chive. Obviously, a great many sources of photographs exist, public and
private, and many of them contain views of landscapes suitable for study.
Some of the sources are cited in references given in this bibliography.
Thus, the index edited by James McQuaid (1982) lists 458 collections avail-
able for public use. As a guide to newcomers in this field of research, we
list below a selected group of photographic archives in the United States,
which have large collections of landscape photographs.

American Geographical Society
Golda Meir Library
University of Wisconsin--
 Milwaukee
Milwaukee, WI 53201

American Museum of Natural
 History
Division of Photography
Central Park West at 79th Street
New York, NY 10024

Amon Carter Museum of
 Western Art
3501 Camp Bowie Boulevard
P. O. Box 2365
Fort Worth, TX 76101

Herbarium
College of Agriculture
University of Arizona
Tucson, AZ 85721

Archives and Manuscripts
Brigham Young University
5030 HBLL
Provo, UT 84602

Photographic Archives
Bancroft Library
University of California
Berkeley, CA 94720

The California Museum of
 Photography
Watkins House
University of California
Riverside, CA 92521

Center for Creative Photography
University of Arizona
843 East University Blvd.
Tucson, AZ 85719

Colorado Historical Society
Colorado Heritage Center
1300 Broadway
Denver, CO 80203

The Explorers Club
46 East 70th Street
New York, NY 10021

Field Museum of Natural History
Roosevelt Road at LakeShore
 Drive
Chicago, IL 60605

Photography Section
Division of Information and
 Education
Forest Service
U.S. Department of Agriculture
Washington, DC 20250

The Photography Collection
Humanities Research Center
University of Texas at Austin
Austin, TX 78712

International Museum of
 Photography at George Eastman
 House
900 East Avenue
Rochester, NY 14607

LDS Church Archives
50 E. North Temple
Salt Lake City, UT 84150

Library of Congress
Prints and Photographs Division
10 First Street, S.E.
Washington, DC 20540

Life Picture Service
Time & Life Building
Rockefeller Center
New York, NY 10020

Institute Archives and Special
 Collections
Massachusetts Inst. of Technology
Cambridge, MA 02139

Metropolitan Museum of Art
Department of Prints and
 Photographs
Fifth Avenue at 82nd Street
New York, NY 10028

Museum of the Great Plains
P. O. Box 68
Lawton, OK 73502

Still Picture Division
National Archives and Records
 Service
Eighth & Pennsylvania Ave., N.W.
Washington, DC 20408

The National Geographic Society
17th and M Streets, N.W.
Washington, DC 20036

Photo Archives
Museum of New Mexico
P. O. Box 2087
Santa Fe, NM 87503

The New York Public Library
Picture Collection
Fifth Avenue and 40th Street
New York, NY 10016

Division of Photographic History
National Museum of History and
 Technology
Smithsonian Institution
Washington, DC 20560

Special Collections Library
Northern Arizona University
C. U. Box 6022
Flagstaff, AZ 86011

Spence Collection
Department of Geography
University of California
Los Angeles, CA 90024

The Southwest Museum
Highland Park
Los Angeles, CA 90042

Photographic Library
U.S. Geological Survey
Box 25046, MS 914
Federal Center
Denver, CO 80225

Marriott Library
Special Collections
Photograph Section
University of Utah
Salt Lake City, UT 84112

University of Washington
Suzzallo Library
Historical Photography Collection
Seattle, WA 98195

The Beinecke Rare Book and
 Manuscript Library
Yale University Library
1603 A Yale Station
New Haven, CT 06520

In addition to the knowledge that can be gained by searching through the kinds of collections listed above, it is helpful to recall situations that have left a legacy of photographs, such as events in the history of photography,[23] subjects that are frequently photographed, and exploration in

23. Eder, Josef Maria, 1945, History of photography; translated by
 Edward Epstean: New York, Columbia University Press, 860 pp.
 Gernsheim, Helmut, and Alison Gernsheim, 1955, The history of
 photography: London, Oxford University Press, 359 pp.
 Newhall, Beaumont, 1964, The history of photography, from 1839 to
 the present day: New York, The Museum of Modern Art, 216 pp.

which photography has played a significant part.[24] For example, the
Crimean War (1853-1856) was the first major war that was covered by
photography, the Egyptian temples and the Holy Land were systematically
photographed by Francis Frith soon after photography was invented,[25]
features such as Indian pueblos in the Southwest,[26] Mount Fuji, and the
beach at Atlantic City have been photographed repeatedly by generations
of visitors, and photographs of Alaskan coastal glaciers made by G. K.
Gilbert and Edward S. Curtis during the 1899 Harriman Expedition are a
landmark by which subsequent changes in the glaciers have been meas-
ured.[27]

Description of the Bibliography and Its Index

Our search for published reports suitable for the bibliography was
accomplished primarily by reading the scientific literature in our respec-
tive fields. Occasionally, lists of references in these publications led to
still other significant reports. We have further benefited from the advice
of colleagues who have pointed out obscure publications on repeat photo-
graphy. It was generally necessary to review entire books and journals
because an article germane to repeat photography may give no hint in its
title or abstract that matched photographs are included. Indeed, for some
of the references listed in the bibliography, the use of repeat photography
is a secondary or incidental topic. Our practice has thus been to systemat-
ically search likely subject areas. In this way, an initially small list of
references has grown to its present size. Our emphasis is on the use of
photographs made from ground level, although several reports based on use
of vertical aerial photographs with oblique aerial photographs, ground-level
views, or with terrestrial measurements are also cited. To our knowledge,
no similar bibliography on repeat photography has been compiled.

Existing bibliographies generally have been a disappointing source of
references on repeat photography. For example, the subject of photo-
geology is indexed in the Bibliography of North American Geology (through
1970), but the emphasis is almost entirely on vertical aerial photography,
and photography itself is not indexed as a primary subject. For purposes of
this bibliography, similar problems are found in the Bibliography and Index
of Geology, which has been published since 1971, and the earlier Bibliog-
raphy and Index of Geology Exclusive to North America. Even so, our
search of these two bibliographies has turned up several relevant reports.

24. Naef and Wood (1975); Ostroff (1981). This bibliography.

25. Alinder (1979). This bibliography.

26. Mahood, Ruth I., ed., 1961, Photographer of the Southwest; Adam
 Clark Vroman, 1856-1916: Los Angeles, The Ward Ritchie Press,
 127 pp.

27. Gilbert (1903). This bibliography.

The literature of botany, forestry, and range science is largely cata logued in Excerpta Botanica, Biological Abstracts, Herbage Abstracts Forestry Abstracts, and Bibliography of Agriculture. The field of geogra phy is covered most completely by Geo Abstracts. Most of these source use key words from the title of an article to construct an index, and thi method of indexing obviously can lead to omissions and oversights whe repeat photography is not the main subject.

Finally, several computerized data files list titles and abstracts o repeat photography. We have searched GeoRef, GeoArchive, Meteorologi cal and Geoastrophysical Abstracts, NTIS, COMPENDEX, and BIOS Previews, using as key words terms such as "photo," "change," "land," an "vegetation." References from these files, which commonly are in lar guages other than English, although with English abstracts, are given verba tim in the bibliography.

The annotations given for each reference in the bibliography reflec our desire to provide information on specific topics or places. Thus, w note the results of a cited report only when the results seem unique to th subject of repeat photography, or when the results appear to highlight particular approach or method. Many of the annotations, however, giv only the general subject, location, number of matched photographs, and th dates or time span for the photographs. Thus, other matters in a give report that are potentially of even greater interest to some readers, or tha may be the main emphasis of the report, are not described. A number c the references deal primarily with photographic techniques or fiel methods, and the applications of these procedures are noted in the annota tions, where appropriate.

Except for articles dealing with photographic techniques and othe incidental topics, the bibliography excludes all but a few of the reports tha contain no pairs of matched photographs, even though repeat photograph may have played an important part in the study.[28] The use of repeate images from space is also considered to be beyond the scope of this bibliog raphy, although techniques analogous to terrestrial photographic methoc have been used at the two Viking Lander sites on Mars.[29] Finally, w

28. See, for example: Rhodes, F. M., 1977, Growth rates of the liche Lobaria oregana determined from sequential photographs: Canad an Journal of Botany, v. 55, no. 16, pp. 2226-33.
29. Moore, H. J., C. R. Spitzer, K. Z. Bradford, P. M. Cates, R. F Hutton, and R. W. Shorthill, 1979, Sample fields of the Vikin Landers, physical properties, and aeolian processes: Journal c Geophysical Research, v. 84, no. B14, pp. 8365-77.
 Guinness, Edward A., Craig E. Leff, and Raymond E. Arvidson, 198: Two Mars years of surface changes seen at the Viking landing site: Journal of Geophysical Research, v. 87, no. B12, pp. 10,051-58.
 Arvidson, Raymond E., Edward A. Guinness, Henry J. Moore, Jame Tillman, and Stephen D. Wall, 1983, Three Mars years; Viking Lan er 1 imaging observations: Science, v. 222, no. 4623, pp. 463-68.

clude studies that depend only on conventional aerial photography, such
many reports on changes in shorelines.

Although our bibliographic methods may seem haphazard to skilled
bliographers, we believe that the bibliography is a fairly comprehensive
view, at least for landscape changes that are expressed by vegetation and
ndforms. We recognize, however, that the bibliography is focused on
blications in the English language and that these mainly refer to research
the Western United States. Perhaps views of the Western United States
ve been favored for repeat photography because of the open vistas char-
teristic of an arid environment. However, it hardly seems likely that
peat photography has been practiced so provincially, and we suspect that
r bibliographic search has been overly influenced by our own scientific
terests in the West. We regret any omissions, but we trust that those
und will be accepted as being inadvertent. Further contributions to this
bliography are wanted and are invited. At present, for the subjects and
eas with which we are most familiar, the coverage is intended to be more
less complete through 1981, but some references as recent as 1984 are
cluded.

Altogether, the bibliography contains over 450 entries. Reports on
anges in vegetation and the effects of geologic processes are about
ually divided and make up about 90 percent of the contents. The other
percent deals mostly with techniques and cultural change.

Curiously, some likely aspects of landscape change seemingly have
t been studied by repeat photography. For instance, we have found no
dies of weathering (other than lichen growth and frost action), denuda-
n rates, litter decay and dispersal, and animal behavior (such as growth
decay of ant hills, rodent burrows, and bird nests). Furthermore, much
re can be done on topics that have already been pursued by repeat
otography. Parks and nature reserves, for example, could be more fully
cumented and monitored, if only because of the increasing impact of
man activity on the landscape. For this purpose, repeat photography is a
luable tool.

The index to the bibliography is intended to be a comprehensive list
subjects. Also, the bibliography is arranged alphabetically and serves as
separate index to the authors. All the authors of a report are listed by
oss references, so that each contribution of an individual can be identifi-
. The index also gives the names of photographers who have been credit-
in a report, when the photographer is not one of the authors. Obviously,
e main purpose of the index is to facilitate the search for reports on a
ven theme or on a particular area. To this end, most items in the bibliog-
phy are indexed under several headings. For example, the report about
cier mapping by Sebastian Finsterwalder in the Alps, which was men-
ned at the beginning of this introduction, is indexed under "Glaciers,
otogrammetric surveys," "Photogrammetry, Pioneer glacier surveys . . .
eastern Alps," "Finsterwalder, Sebastian," and in several subheadings
der "Techniques."

Finally, the index, through its headings, provides an outline of th subject of repeat photography, not only by listing the topics that have bee investigated, but by summarizing the progress of research. For those wl might be interested, it would be an easy task to correlate the index wi dates in the bibliography and thus compile a chronological history of repe photography.

Bibliography of Repeat Photography
for Evaluating Landscape Change

Bibliography

hlstrom, Richard V. N. See Baumler (1984).

lbee, William C. See Moore, J. G., and Albee (1981).

lcorn, Stanley M. See Turner, R. M., Alcorn, and Olin (1969).

linder, James, ed., 1979, Comparative photography; A century of change in Egypt and Israel; photographs by Francis Frith and Jane Reese Williams: Carmel, California, The Friends of Photography, Untitled no. 17, 55 pp.

Consists of 22 photographs of Egypt and Israel (11 each) taken by Frith in 1856 and 1857, which were repeated by Williams in 1976 and 1977. The Egyptian scenes are mainly archaeological monuments, and the scenes from Israel are mostly urban landscapes. For many of the photographs by Williams, the original camera site could not be closely reoccupied because of sand and rubble that had been removed or because of urban demolition and construction. Brian M. Fagan comments in the introduction on the changes brought by tourists and urban populations, pointing out that, "Considered together the two documentary photographs create a considerably richer understanding than either image by itself."

lpha, Tau Rho See Moore, J. G., and others (1981).

Ames, Charles R., 1977a, Along the Mexican border--Then and now: Journal of Arizona History, v. 18, no. 4, pp. 431-46.

Photographs taken by the International Boundary Commission in 1892 along the Arizona-Sonora border are shown with five closely matched photographs taken in 1969. Several additional approximately matched photographs are also included.

Ames, Charles R., 1977b, Wildlife conflicts in riparian management--Grazing, in R. Roy Johnson and Dale R. Jones, eds., Importance, preservation and management of riparian habitats--A symposium: U.S. Department of Agriculture, Forest Service General Technical Report RM-43, pp. 49-51.

Shows three of the 1969 matched photographs from Ames (1977a), which repeat photographs of riparian habitats along the Arizona-Sonora border taken in 1892 by the International Boundary Commission.

Anonymous, 1943, Range and livestock production practices in the Southwest: U.S. Department of Agriculture Miscellaneous Publication No. 529, 21 pp.

Several pairs of matched photographs and a set of three matched photographs show the effects of various livestock management practices on rangelands in the southwestern United States.

Anonymous, 1968, Variations of glaciers: American Geographical Society Newsletter, v. 1, no. 1, pp. 1-3.

Includes two pairs of matched photographs of glaciers in southeast Alaska as follows: South Sawyer Glacier in Tracy Arm (1941, 1967) and Rendu Glacier in Glacier Bay (1961 by M. T. Millett, 1966). Except as noted, the photographs are by William O. Field.

Anonymous, 1979a, Old sites revisited: Geotimes, v. 24, no. 6, pp. 36-37. Erratum, v. 24, no. 7, pp. 12.

Briefly describes the Rephotographic Survey Project of Mark Klett, JoAnn Verberg, and Ellen Manchester, who revisited scenes photographed by William Henry Jackson. Advice by Harold Malde is mentioned. Also noted is an exhibit at the Federal Building, Denver, of photographs by Jackson and John K. Hillers as repeated by Hal G.

Stephens of the U.S. Geological Survey. Jackson's 1873 view of Mount of the Holy Cross, Colorado, is mistakenly printed twice. The erratum correctly shows Jackson's view with a 1978 matched photograph by the Rephotographic Survey Project.

Anonymous, 1979b, Windows; Views across a century, a photographic reprise on the Old West of W. H. Jackson: Life, v. 2, no. 3, March 1979, pp. 9-10, 12.

Briefly reviews the Rephotographic Survey Project (1979), showing two color photographs and eight smaller black-and-white photographs.

Anonymous, 1981, Earthquake trail at Point Reyes National Seashore: U.S. Geological Survey, Earthquake Information Bulletin, v. 13, no. 2, pp. 52-61.

Photographs of surface features of the San Andreas fault that were taken shortly after the 1906 earthquake by Grove Karl Gilbert, U.S. Geological Survey, and by John Casper Branner, Stanford University, are compared with photographs of the same sites in 1981. Six pairs of matched photographs are shown.

Applegate, Lee H. See Turner, R. M., Applegate, Bergthold, Gallizioli, and Martin (1980).

Applegate, Lee H., 1981, Hydraulic effects of vegetation changes along the Santa Cruz River near Tumacacori, Arizona: Tucson, University of Arizona, M.S. Thesis, 74 pp.

Ten aerial views taken from 1965 to 1980 of a reach of the Santa Cruz River show changes in the riparian vegetation and the shape of the channel.

Arno, Stephen F. See Gruell and others (1982).

Arno, Stephen F., and George E. Gruell, 1983, Fire history at the forest-grassland ecotone in southwestern Montana: Journal of Range Management, v. 36, no. 3, pp. 332-36.

Tree-ring evidence of fire history is used to explain the vegetation

change shown by matched photographs of seven sites. Two pairs of matched photographs are presented.

Arnold, Joseph F., 1950, Changes in ponderosa pine bunchgrass ranges in northern Arizona resulting from pine regeneration and grazing: Journal of Forestry, v. 48, no. 2, pp. 118-26.

Two pairs of matched photographs illustrate vegetation changes between the early 1920s and 1947.

Arnold, Joseph F., Donald A. Jameson, and Elbert H. Reid, 1964, The pinyon juniper type of Arizona--Effects of grazing, fire and tree control: U.S. Department of Agriculture, Forest Service Production Research Report No. 84, 28 pp.

A pair of matched photographs shows increased growth of juniper and loss of grass after a plot was protected from grazing for 13 years.

Aschmann, Homer, 1977, Aboriginal use of fire, in H. A. Mooney and C. E. Conrad, eds., Proceedings of the Symposium on the Environmental Consequences of Fire and Fuel Management in Mediterranean Ecosystems: U.S. Department of Agriculture, Forest Service General Technical Report WO-3, pp. 132-41.

See Gibbens and Heady (1964).

Atkeson, Ray See Williams, C. (1980).

Ault, Wayne U. See Moore, J. G., and Ault (1965); Richter and others (1964).

Avery, George S., 1982, Early historical highlights, in The Connecticut Arboretum, its first fifty years: Connecticut College, Connecticut Arboretum Bulletin 28, pp. 3-8.

Two pairs of matched photographs document changes in the arboretum.

Baars, D. L., ed., 1973, Geology of the canyons of the San Juan River: Four Corners Geological Society, 7th Field Conference, Guidebook, 94 pp.

Includes four photographs of the San Juan River canyon below Bluff, Utah, taken by Hugh D. Miser in 1921, which are matched by the author's photographs of the same views in 1973. The captions for two of the photographs point out changes in the vegetation along the river, but the other matched photographs are said to be virtually unchanged.

Baars, D. L., and C. M. Molenaar, 1971, Geology of Canyonlands and Cataract Canyon: Four Corners Geological Society, 6th Field Conference, Guidebook, 99 pp.

Includes five of the Hal G. Stephens and Eugene M. Shoemaker 1968 photographs that match the views made by E. O. Beaman during the 1871 Powell Expedition. The captions point out that physical features are vitually unchanged, but sandy areas are now covered by tamarisk.

Bahre, Conrad J., and David E. Bradbury, 1978, Vegetation change along the Arizona-Sonora boundary: Annals of the Association of American Geographers, v. 68, no. 2, pp. 145-65.

Sets of three matched photographs taken in 1892, 1969, and 1976 are shown for each of 12 international monuments (numbers 98, 99, 103, 105, 106, 109, 111, 112, 113, 117, 118, and 124).

Bailey, Arthur W. See Wright, H. A., and Bailey (1982).

Bailey, Reed W. See Ellison and others (1951).

Banner, James A. See van Everdingen and Banner (1979).

Banner, James A., and Robert O. van Everdingen, 1979, Automatic time-lapse camera systems: National Hydrology Research Institute, Inland Waters Directorate Technical Bulletin 112 (NHRI Paper No. 4), 20 pp. (Ottawa, Canada).

Describes an automatic time-lapse camera system, using an Eastman Kodak type KB9A 16mm strike-recording motion-picture camera (military surplus), modified for automatic single-frame operation for field use under arctic conditions. The results of various cold-room and field tests are also described. Includes as examples of the results obtained four photographs taken at Bear Rock near Fort Norman, N.W.T.,

Canada. See also van Everdingen and Banner (1979).

Barber, K. E., 1976, History of vegetation, in S. B. Chapman, ed., Methods in plant ecology: Oxford, Blackwell Scientific Publications, pp. 5-83.

Barber comments that "Documentary records, written, cartographic and photographic, can be crucial to the success of any study in historical ecology," and he cites three examples of studies using repeat photography. No photographs are included.

Barger, Mary Elizabeth, 1982, Photographic sequences at the Elephant Butte Reservoir, New Mexico; An historical resource to increase public awareness: Southwest Federation of Archeological Societies, Transactions of the 17th Regional Archeological Symposium for Southeastern New Mexico and Western Texas, pp. 1-5. (Published by Midland Archeological Society, Midland, Texas.)

The use of repeat photography to show visitors how conditions have changed is illustrated with three pairs of matched photographs by the U.S. Bureau of Reclamation as follows: Elephant Butte surrounded by the reservoir (1911, 1980) and two views of the dam site (1909, 1980; 1910, 1980).

Barnes, William C. See Hickson, C. J., and Barnes (1982); Hickson, C. J., and others (1982).

Bartos, D. L. See Mueggler and Bartos (1977).

Bartsch, Susan R. See Clark and others (1972).

Bauer, A., M. Baussart, M. Carbonnell, P. Kasser, P. Perroud, and A. Renaud, 1968, Missions aériennes de reconnaissance au Groenland, 1957-1958-- Observations aériennes et terrestres, exploitation des photographies aériennes, détermination des vitesses des glaciers vêlant dans Disko Bugt et Umanak Fjord: Meddelelser om Groenland, v. 173, no. 3, 116 pp. (with English abstract).

From airphotos and direct observation, it was possible to map crevassed areas on the west side of the ice sheet, to delimit catchment basins of large glaciers between 68 degrees and 72 degrees North, and to deter-

mine annual velocity of the ice sheet by photointerpretation of intervals between large crevasses. Operations in 1958 included setting up abla-tion stakes and coring tests for tritium dating. A technique for measur-ing mean velocity at glacier fronts by taking repeated airphotos proved successful. (From GeoRef.)

Baumler, Mark F., 1984, The archeology of Faraway Ranch, Arizona; Pre-historic, historic, and 20th century; with contributions by Richard V. N. Ahlstrom and Lisa G. Eppley: Tucson, Arizona, U.S. Department of the Interior, National Park Service, Western Archeological and Conservation Center Publications in Anthropology No. 24, 194 pp.

Appendix 2 by Baumler discusses cultural changes and an increase in juniper at Faraway Ranch in southeast Arizona, as shown by a pair of approximately matched photographs (about 1900, 1983) and by two other views that closely match enlarged sections of the 1900 photograph.

Baussart, M. See Bauer and others (1968).

Beaty, Chester B., 1974, Debris flows, alluvial fans, and a revitalized catas-trophism: Zeitschrift für Geomorphologie N. F., Supplementband 21, pp. 39-51.

Includes three pairs of matched photographs by the author (1956, 1966) of Montgomery Creek in the White Mountains of California, showing the effects of a debris flow on July 30, 1965.

Berger, Paul See Klett and others (1984).

Berger, Paul, Leroy Searle, and Douglas Wadden, 1983, Radical rational space time; Idea networks in photography: Seattle, Washington, Henry Art Gallery, 72 pp.

This book of photographs and essays, which was prepared in conjunction with an exhibit of the same name at the Henry Art Gallery, University of Washington, consists mostly of matched photographs taken by several photographers for differing artistic purposes. Five pairs of matched photographs of Wichita Falls, Texas (April 1979, June 1980) taken by Frank Gohlke show the effects of a tornado in April 1979 and the subse-quent reconstruction. A pair of photographs of Spanish inscriptions on Inscription Rock, New Mexico, shows alternate views by Timothy H.

O'Sullivan in 1863 and Rick Dingus for the Rephotographic Survey Project in 1978. Four pairs of matched photographs variously taken by Mark Klett, JoAnn Verburg, and Gordon Bushaw between 1977 and 1979 for the Rephotographic Survey Project are based on initial photographs taken in Colorado by William Henry Jackson in 1873 and in Nevada and Wyoming by O'Sullivan in 1868 and 1872, respectively. A set of three matched photographs shows the Mountain of the Holy Cross, Colorado as photographed by Jackson in 1873, by Verburg and Bushaw in 1977, and by Klett and Bushaw in 1978. Lastly, pairs of matched photographs taken moments apart by Eve Sonneman give contrasting views of two street scenes in New York City in 1979 and 1980.

Bergquist, Joel R., 1979, A photographic record of change; Bolinas Lagoon, Marin County, California: California Geology, v. 32, no. 10, pp. 211-16.

Depositional changes in Bolinas Lagoon in the last 70 years are illustrated with four pairs of matched photographs by the author, based on views made by Grove Karl Gilbert as follows: view west from Bolinas Ridge (March 8, 1907 by Gilbert; March 14, 1977); Stinson Beach spit and Bolinas Lagoon (September 27, 1906 by Gilbert; September 26, 1976); panoramic view of Kent Island (April 1907 by Gilbert; September 26, 1976); and Pickleweed Island (ca. 1907 by Gilbert; September 26, 1976).

Bergthold, Patricia M. See Turner, R. M., Applegate, Bergthold, Gallizioli, and Martin (1980).

Berntsen, Carl M., R. Burton Litton, Jr., L. Jack Lyon, Paul E. Packer, P. Max Rees, Jack E. Schmautz, Paul R. Cleary, Richard M. Hartman, and Butch R. Keadle, 1983, 1983 update, new directions in management on the Bighorn, Shoshone & Bridger-Teton National Forests: U.S. Department of Agriculture, Forest Service Intermountain Region, Rocky Mountain Region, Ogden, Utah, 90 pp.

Includes 14 pairs of matched photographs (1970, 1982), four of them being panoramic views taken with a Widelux camera by Litton, which show effects of forest manangement practices in Wyoming. The report is a follow-up on a 1971 report by the same Wyoming Forest Study Team, in which most of the photographs shown here first appeared.

Betancourt, Julio L. See Love and others (1983).

Bezy, Robert L. See Lowe and others (1970).

Billings, W. D., 1965, Plants and the ecosystem: Belmont, California, Wadsworth Publishing Co., 154 pp.

Two matched photographs taken three years apart show the effect of eliminating all tree roots in a small area beneath an oak-hickory forest in North Carolina.

Biswell, H. H., 1963, Research in wildland fire ecology in California, in Tall Timbers Fire Ecology Conference, No. 2, Tallahassee, Florida, 1963, Proceedings: Tallahassee, Florida, Tall Timbers Research Station, pp. 63-97.

Describes the use of prescribed burning to improve forage conditions for game or livestock and to reduce wildfire hazards in California, giving as illustrations the following examples: a set of five matched photographs of the woodland-grass vegetation type in the central Sierra Nevada foothills, showing conditions before control burning in 1949 and after successive burning in 1951, 1954, and 1960; and a set of three matched photographs of ponderosa pine in the North Coast Range showing the technique of prescribed burning.

Black, Robin D. See Gage and Black (1979).

Blackburn, W. H., and P. T. Tueller, 1970, Pinyon and juniper invasion in black sagebrush communities in east-central Nevada: Ecology, v. 51, no. 5, pp. 841-48.

A pair of matched photographs shows an increase in pine and juniper between 1923 and 1966.

Blagovolin, N. S., and D. G. Tsvetkov, 1971, The utilization of repeated photographic and transit surveys for the study of slope processes (in Russian): Voprosy Geografii, no. 85, pp. 103-9.

Describes photogrammetric observations of changes in valley and slope profiles by gravity movements in the Crimean Peninsula. (From Geo-Archive.)

Blair, M. L. See Waananen and others (1977).

Blydenstein, John C., Roger Hungerford, G. I. Day, and Robert R. Humphrey, 1957, Effect of domestic livestock exclusion on vegetation in the Sonoran Desert: Ecology, v. 38, no. 3, pp. 522-26.

A pair of approximately matched photographs (1906, 1957) shows changes in vegetation at Tumamoc Hill, near Tucson, Arizona.

Bohning, John W. See Reynolds and Bohning (1956).

Borchers, Perry E., 1977, Photogrammetric recording of cultural resources: U.S. Department of the Interior, National Park Service Publication 186, 38 pp.

Discusses and illustrates various techniques and applications for photographic recording of architectural subjects using a phototheodolite, including the method of "reverse perspective analysis" for locating sites of historic photographs. An example is given of finding sites of photographs of Tesuque Pueblo, New Mexico, taken in 1879 by John K. Hillers and in 1899 by Adam Clark Vroman. The sites were reoccupied by Borchers in 1973. A pair of matched photographs based on the Vroman photograph is shown.

Bormann, F. Herbert, and Gene E. Likens, 1979, Pattern and process in a forested ecosystem; Disturbance, development, and the steady state based on the Hubbard Brook ecosystem study: New York, Springer-Verlag, 253 pp.

A set of four matching photographs (1968, 1970, 1971, 1972) shows rapid revegetation of an artificially cleared watershed in the Hubbard Brook Experimental Forest, White Mountains, New Hampshire.

Bozozuk, M., B. H. Fellenius, and L. Samson, 1978, Soil disturbance from pile driving in sensitive clay: Canadian Geotechnical Journal, v. 15, no. 3, pp. 346-61.

Soil disturbance produced on adjacent pile foundations by driving a large group of piles in marine clay was studied in part by making repeated photogrammetric measurements, using a technique described by Bozozuk, van Wijk, and Fellenius (1978).

Bozozuk, M., M. C. van Wijk, and B. H. Fellenius, 1978, Terrestrial photogrammetry for measuring pile movements: Canadian Geotechnical Journal, v. 15, no. 4, pp. 596-99.

Describes a photogrammetric method for monitoring movements of previously driven piles using a Wild P31 camera at one-week intervals over a five-week period. Steroscopic images were made from two camera stations placed 10.0 meters apart, using scaffolds for support. A photograph of the control points and the targets for photogrammetric measurements is shown, and the sources of error are discussed.

Bradbury, David E. See Bahre and Bradbury (1978); Mooney (1977).

Bradbury, David E., 1974, Vegetation history of the Ramona Quadrangle, San Diego County, California: Los Angeles, University of California, Ph. D. dissertation, 201 pp.

Changes mainly in chaparral vegetation are shown in 25 pairs of matched photographs taken 41 years apart.

Bradbury, David E., 1978, The evolution and persistence of local sage-chamise community pattern in southern California: Association of Pacific Coast Geographers Yearbook, v. 40, pp. 39-56.

Includes a pair of matched photographs from Bradbury (1974).

Branson, Farrel A., and Reuben F. Miller, 1981, Effects of increased precipitation and grazing management on northeastern Montana rangelands: Journal of Range Management, v. 34, no. 1, pp. 3-10.

Includes three pairs of matched photographs (1960, 1978) showing increased cover of grasses and shrubs.

Brown, Robert L., 1969, Ghost towns of the Colorado Rockies: Caldwell, Idaho, The Caxton Printers, 401 pp.

This account of changes in Colorado ghost towns and their environs is illustrated with more than 60 pairs of matched photographs by the author. The initial views, which are mostly undated, pertain to the heyday of early mining. Many of the early views are attributed to private collections.

Brugman, Melinda M., and Austin Post, 1981, Effects of volcanism on the glaciers of Mount St. Helens: U.S. Geological Survey Circular 850-D, 11 pp.

Changes caused by deformation and minor eruptions before the cataclysmic eruption of May 18, 1980, are shown in oblique aerial photographs taken from the northeast by Post (September 18, 1967) and by David Hirst (May 1, 1980).

Bryant, Bruce, 1971, Movement measurements on two rock glaciers in the eastern Elk Mountains, Colorado, in Geological Survey Research 1971: U.S. Geological Survey Professional Paper 750-B, pp. B108-B116.

Comparisons of three pairs of matched photographs show that the maximum surface movement from 1964 to 1968 amounted to about two feet per year.

Buchanan, Hayle, 1971, Changing conditions in the forests of Bryce Canyon National Park, Utah: Proceedings of the Utah Academy of Sciences, Arts, and Letters, pt. I, v. 48, pp. 31-36.

Includes three pairs of matched photographs taken in 1957 and 1969 that illustrate continuing soil loss and deterioration of vegetation cover despite the exclusion of domestic livestock.

Buckler, William R., and Harold A. Winters, 1983, Lake Michigan bluff recession: Annals of the Association of American Geographers, v. 73, no. 1, pp. 89-110.

Two pairs of approximately matched oblique aerial photographs taken in 1973 and 1977 show part of the bluff recession of Lake Michigan in Berrien County, Michigan. Long-term recession rates in Wisconsin and Michigan were determined by comparing measurements made in 1976 and 1977 with General Land Office surveys made between 1829 and 1855.

Budy, Jerry D. See Young and Budy (1979).

Buell, Peter F. See Dansereau and Buell (1966).

Bunting, Diane T. See Dutton and Bunting (1981).

Burke, Constance See Ohmart and others (1977).

Burkham, D. E. See Culler and others (1970).

Burkham, D. E., 1970, Precipitation, streamflow, and major floods at selected sites in the Gila River drainage basin above Coolidge Dam, Arizona: U.S. Geological Survey Professional Paper 655-B, 33 pp.

Two pairs of matched photographs show changes in the flood plain of the San Francisco River at Clifton, Arizona, between 1900 and 1966.

Burkham, D. E., 1972, Channel changes of the Gila River in Safford Valley, Arizona--1846-1970: U.S. Geological Survey Professional Paper 655-G, 24 pp.

The changes are shown in several pairs of oblique aerial photographs, by comparisons based on a remarkable set of old maps, and in more recent aerial photographs.

Burkham, D. E., 1976, Hydraulic effects of changes in bottom-land vegetation on three major floods, Gila River, in southeastern Arizona: U.S. Geological Survey Professional Paper 655-J, 14 pp.

The appearance of the stream channel and flood plain of the Gila River near Calva before and after tamarisk was eradicated in 1966 is shown in a pair of approximately matched photographs (1964, 1967). The hydrologic effects of the clearing on floods in 1967 and 1972, as compared with a flood in 1965, are described.

Burr, Richard D. See U.S. Bureau of Land Management (1967, 1969, 1971, 1979).

Burr, Richard D., 1961a, 1812-1960--The vegetation of the North Platte River basin: U.S. Department of the Interior, Missouri River Basin Field Committee, Progress, January-March 1961, pp. 43-50.

Evaluates changes and similarities in the vegetation in the Wyoming

reach of the North Platte River by quoting from journals and by comparing three of William Henry Jackson's photographs of Independence Rock and the Sweetwater Valley (Hayden Expedition, 1870) with photographs of the same subjects taken by the author in 1958.

Burr, Richard D., 1961b, Time and range vegetation: U.S. Bureau of Land Management, Our Public Lands, v. 11, no. 2, pp. 8-9, 12-13.

Includes William Henry Jackson's photographs of Independence Rock, the Sweetwater Valley, and Teapot Rock in Wyoming (1870, 1870, and 1869, respectively) and compares the same subjects with photographs taken by the author in 1958.

Burr, Richard D., 1965, The Great Divide Basin or Red Desert: U.S. Department of the Interior, Missouri River Basin Field Committee, Progress, January-March 1965, pp. 41-47.

The description of this Wyoming area includes two photographs made by Alfred Reginald Schultz of the U.S. Geological Survey in 1902, which are compared with the author's photographs of the same sites in 1960.

Burr, Richard D., 1966, Recovery and recreation: U.S. Bureau of Land Management, Our Public Lands, v. 15, no. 5, pp. 16-17.

A photograph of Maiden Canyon, Montana, taken by the U.S. Geological Survey in 1892 is matched with a three-part panorama of the same view by Burr in 1962. The discussion emphasizes regrowth of timber.

Burr, Richard D., 1970, Square Butte, Montana: U.S. Department of the Interior, Missouri River Basin Field Committee, Progress, Annual Report FY 1970, pp. 127-35.

Points out that there are 30 known photographs of the Square Butte area dating back 65 to 75 years, for which modern counterparts can be made to facilitate study of landscape changes.

Burrows, C. J., 1977, Vegetation in the Cass District and its ecology, in C. J. Burrows, ed., Cass: University of Canterbury, New Zealand, Department of Botany, pp. 173-84.

Includes a pair of matched photographs showing aspects of the vegeta-

tion and terrain at Cass settlement and Mount Misery (1915 by Charles
Foweraker, 1966 by the author).

Bushaw, Gordon See Klett and others (1984).

Byrne, John V., 1963, Coastal erosion, northern Oregon, in Thomas Clements,
ed., Essays in marine geology in honor of K. O. Emery: Los Angeles,
University of Southern California Press, pp. 11-33.

The illustrations include a set of three approximately matched photo-
graphs (at different scales) showing erosion of Jumpoff Joe, a sea stack
north of Yaquina Bay (1880, 1910, 1930, the last being by W. D. Smith).

Cable, Dwight R. See Martin, S. C., and Cable (1974).

Cable, Dwight R., 1967, Fire effects on semidesert grasses and shrubs:
Journal of Range Management, v. 20, no. 3, pp. 170-76.

Four photographs from the same position at the Santa Rita Experi-
mental Range, southern Arizona, show that Haplopappus tenuisectus
(burroweed) was removed by fire but was fully re-established after 14
years.

Cable, Dwight R., 1973, Fire effects in southwestern semidesert grass-shrub
communities, in Tall Timbers Fire Ecology Conference, No. 12, Lubbock,
Texas, 1972, Proceedings: Tallahassee, Florida, Tall Timbers Research
Station, pp. 109-27.

Several pairs of matched photographs and a set of four matched photo-
graphs illustrate the effects of fire on shrubs within a grass-shrub
community at the Santa Rita Experimental Range, southern Arizona.

Cable, Dwight R., 1975, Range management in the chaparral type, and its
ecological basis--The status of our knowledge: U.S. Department of
Agriculture, Forest Service Research Paper RM-155, 30 pp.

Describes potential and existing grazing management practices in
chaparral vegetation. As examples, two sets of matched photographs
(1936 and 1960; January and March 1969) are given to show the effects
of removing shrubs in the Tonto National Forest, Arizona.

Cable, Dwight R., 1976, Twenty years of changes in grass production follow-
ing mesquite control and reseeding: Journal of Range Management, v.
29, no. 4, pp. 286-89.

Includes one set of three matched photographs (1956, 1958, 1974) from
the Santa Rita Experimental Range, southern Arizona, which shows
recovery of velvet mesquite and other changes in vegetation after
herbicide was applied in 1955.

Calkin, Parker E. See Ellis and others (1981).

Campbell, D. A., 1966, Miracle of management: Soil and Water, v. 2, no. 3,
pp. 4-12.

Discusses and illustrates restoration of barren, eroding tussock grassland
in the Waitaki Catchment of South Island, New Zealand, using three
pairs of matched photographs (1948, 1966) to show improved condi-
tions. The previous deterioration and soil erosion had been brought
about by burning, rabbits, and overgrazing.

Carbonnell, M. See Bauer and others (1968).

Carbonnell, M., 1968, Exploitation des couvertures photographiques aéri-
ennes répétées du front des glaciers vêlant dans Disko Bugt et Umanak
Fjord, Juin-Juillet 1964--Pt. 1, Nouvelles mesures photogrammétriques
de la vitesse superficielle des glaciers du Groenland: Meddelelser om
Groenland, v. 173, no. 5, pp. 1-53 (with English abstract).

Gives results of (aerial) photogrammetric measurements taken in 1964
from repeated photographic coverage of the front of 16 glaciers calving
into Disko Bugt and Umanak Fjord. The velocities of transverse profiles
and position and heights of the front are given for each glacier. Mean
values of the velocity at the front of Jakobshavns Isbrae range between
0.9 and 19.1 m/24 hr. (From GeoRef.)

Cardenas, M. See Hennessy and others (1983).

Carey, Henry H., 1980, Playing with fire--Fuelwood prospects in the South-
west: Sun Paper, Bulletin of the New Mexico Solar Energy Association,
v. 5, no. 8, pp. 23-29.

Regrowth of pinyon-juniper woodland after harvesting in the late nineteenth century near Santa Fe, New Mexico, is documented by a pair of matched photographs dating from 1885 and 1950. An increase of woodland trees is convincingly shown despite differences between the photographs in scale and angle of view.

Carlson, Clinton E. See Schmidt and others (1983).

Carothers, Steven W. See Johnson, R. R., and Carothers (1982).

Casadevall, Thomas J. See Keith and others (1981).

Cavell, Edward, 1983, Legacy in ice; The Vaux family and the Canadian Alps: Banff, Alberta, Canada, The Whyte Foundation, 98 pp.

The Vaux family, comprised of George Vaux, Sr., and his children, Mary M. Vaux, George Vaux, Jr., and William S. Vaux, Jr., initiated the first continuous detailed study of glaciers in Canada. This book describes and illustrates how the Vaux family, particularly Mary, George, and William, measured and photographed the position and character of glaciers in the Canadian Rockies (British Columbia and Alberta) between 1887 and 1913. Their method was to establish standard photographic points and take repeated views over a long period, using the same equipment. Cavell comments that this resulted in a record of "inestimable value." However, only single images from this photographic archive are reproduced here.

Cheetham, G. H., 1979, Flow competence in relation to stream channel form and braiding: Geological Society of America Bulletin, pt. I, v. 90, no. 9, pp. 877-86.

Includes a pair of matched photographs of a braided glacial meltwater stream in the Okstindan region, northern Norway, showing development of braiding between September 10, 1974, and July 19, 1975.

Christensen, Earl M., 1955, Ecological notes on the mountain brush in Utah: Proceedings of the Utah Academy of Sciences, Arts, and Letters, v. 32, pp. 107-11.

Refers to some repeat photographs by Woolley (1941) taken in 1939 and

1940 of early 1870s photographs by William Henry Jackson.

Christensen, Earl M., 1957, Photographic history of the mountain brush on "Y" Mountain, central Utah: Proceedings of the Utah Academy of Sciences, Arts, and Letters, v. 34, pp. 154-55 (abstract).

The earliest photographs are from 1917 and 1924. Refers to repeat photographs by Woolley (1941), but the dates are not given.

Clanton, Uel S., and Earl R. Verbeek, 1981, Photographic portrait of active faults in the Houston metropolitan area, Texas, in Evelyn M. Etter, ed., Houston area environmental geology; Surface faulting, ground subsidence, hazard liability: Houston Geological Society, pp. 70-113.

Includes a pair of closely matched oblique aerial photographs showing differences in the apparent contrast between a marsh and drier ground on opposite sides of a fault, as photographed with true-color and color-infrared film.

Clark, Sandra H. B., Helen L. Foster, and Susan R. Bartsch, 1972, Growth of a talus cone in the western Chugach Mountains, Alaska: Geological Society of America Bulletin, v. 83, no. 1, pp. 227-30.

An increase in the size of a talus cone near the terminus of Eklutna Glacier from June 4, 1964, to July 25, 1970, is described and illustrated by two pairs of matched photographs.

Claveran, Ramon A., 1966, Two modifications of the vegetation photographic charting method: Journal of Range Management, v. 19, pp. 371-73.

The use of Polaroid positive/negative film and the making of stereoscopic pairs are recommended for measuring vegetation changes by the photographic charting method, and the advantages and disadvantages of these procedures are discussed. Matched photographs are produced by the described procedure, but none are illustrated.

Cleary, Paul R. See Berntsen and others (1983).

Clements, Frederic Edward, 1905, Research methods in ecology: Lincoln,

Nebraska, University Publishing Company, 334 pp.

Recommends the use of photographs to supplement the information obtained by charting quadrats, pointing out (p. 170) that a photograph shows the height, form, position, and arrangement of the plants. Explains that vertically oriented photographs taken from above the center of a plot and those made from ground-level at one side are both useful. However, because a vertical photograph may be impractical in areas of tall vegetation, the ground-level views are recommended for general use. Matching photographs of a 1-meter quadrat in a denuded area are shown for July 22, 1903, and September 7, 1904.

Clowes, D. R. See Godwin and others (1974).

Cohen, Stan, and Don Miller, 1978, The big burn, the Northwest's forest fire of 1910: Missoula, Montana, Pictorial Histories Publishing Co., 88 pp.

This profusely illustrated account of forest fires that burned 3 million acres in the Pacific Northwest in 1910 includes a closely matched pair of photographs by the U.S. Forest Service of a burned-over area in the Coeur d'Alene National Forest, between Wallace and Kellogg, Idaho, taken in 1912 and 1929.

Cole, Charles J. See Lowe and others (1970).

Collings, M. R. See Culler and others (1970).

Committee on Surface Mining and Reclamation, 1979, Surface mining of non-coal minerals: Washington, D.C., National Academy of Sciences, 339 pp.

Includes a photograph taken in 1978 by Mark Klett of the Animas River Valley at the site of the Sunnyside Mine, San Juan Mountains, Colorado, which matches a 1875 photograph by William Henry Jackson.

Cooper, William S., 1924, An apparatus for photographic recording of quadrats: Journal of Ecology, v. 12, no. 2, pp. 317-21.

Describes a method for taking vertical photographs from a standard distance for use in continuing studies of quadrats.

Cooper, William S., 1928, Seventeen years of successional change upon Isle Royale, Lake Superior: Ecology, v. 9, no. 1, pp. 1-5.

Several photographs taken in 1909 and 1910 were matched in 1926. Cooper laments that the quadrats and camera stations were not permanently marked during the original visit.

Copeland, Otis L., 1960, Watershed restoration--A photo-record of conservation practices applied in the Wasatch Mountains of Utah: Journal of Soil and Water Conservation, v. 15, no. 3, pp. 105-20.

Presents 10 pairs of approximately matched photographs from the 1930s and 1940s, which were taken to show the devastating effects of flooding and the success of restoration efforts.

Corte, Arturo E., and Ambrose O. Poulin, 1972, Field experiments on freezing and thawing at 3,350 meters a.s.l. in the Rocky Mountains of Colorado, Boulder USA, in Processus périglaciaires étudiés sur le terrain: Les Congrès et Colloques de L'Université de Liège, v. 67, pp. 43-56 (in English).

Describes an experiment to measure soil movement in response to freezing and thawing in the Boulder watershed using repeated topographic maps made with a specially designed 22.5 x 22.5 cm format camera mounted vertically on a bridge-like structure erected over each of four soil plots. Maps were made for the years 1960, 1961, 1962, 1964, and 1966.

Cotner, Melvin L., 1963, Controlling pinyon-juniper on southwestern rangelands: University of Arizona, Agricultural Experiment Station, Report 210, 28 pp.

A pair of matched, but undated, photographs shows conditions before and after mechanical removal of pinyon-juniper vegetation. The same pair is shown by Springfield (1976).

Cox, Jerry R., Howard L. Morton, Jimmy T. La Baume, and Kenneth G. Reynard, 1983, Reviving Arizona's rangelands: Journal of Soil and Water Conservation, v. 38, no. 4, pp. 342-45.

An undated pair of matched photographs shows semidesert grassland before and after removal of shrubs. A matched pair (1933, 1980) shows

an increase in shrubs and cacti on an overgrazed hillside.

Crisp, Michael D. See Noble and Crisp (1980).

Crisp, Michael D., 1978, Demography and survival under grazing of three
Australian semi-desert shrubs: Oikos, v. 30, no. 3, pp. 520-28.

Derives data on longevity, survivorship, recruitment, and change in
population size for the perennial plants, Maireana sedifolia and Acacia
aneura, using photographs taken at almost yearly intervals since 1926 at
the T. G. B. Osborn Vegetation Reserve at Koonamore, South Austral-
ia. Includes two pairs of matched photographs (1932 and 1972; 1955 and
1973).

Croft, A. R. See Ellison and others (1951).

Culler, R. C., D. E. Burkham, M. R. Collings, E. S. Davidson, and others,
1970, Objectives, methods, and environment--Gila River Phreatophyte
Project, Graham County, Arizona: U.S. Geological Survey Professional
Paper 655-A, 25 pp.

The frontispiece is a pair of matched photographs of an area near Calva
showing encroachment of tamarisk on the Gila River flood plain
between 1932 and 1964. See also Burkham (1972) and R. M. Turner
(1974b) for additional uses of this same wide-angle view of the Gila
River.

Currie, Pat O. See Gary and Currie (1977).

Curry, Robert R., 1967, On repeated photographs, in Luna B. Leopold, ed.,
Field methods for the study of slope and fluvial processes--A contribu-
tion to the International Hydrological Decade: Revue de Géomorpholo-
gie Dynamique, v. 17, no. 4, pp. 175-76 (with French summary).

Explains that photographs that repeat those made 50 to 100 years ago
can be used to observe changes in slopes, but gives no examples of
repeat photographs. Recommends erroneously that the ratio of focal
length to the diagonal length of the negative in a repeated photograph
should be proportional to the corresponding ratio in the early photo-
graph. Suggests that old and new photographs can be compared by using

a pocket stereoscope.

Czerny, Peter G., 1976, The Great Salt Lake: Provo, Utah, Brigham Young University Press, 123 pp.

Three photographs taken in 1869 on the east and north sides of Great Salt Lake, Utah, are matched with contemporary color photographs.

Dansereau, Pierre, and Peter F. Buell, 1966, Studies on the vegetation of Puerto Rico: University of Puerto Rico, Institute of Carribean Science Special Publication No. 1, Mayaguez, Puerto Rico, 287 pp.

Aerial photographs (not included) taken in 1951 and 1964 show successional changes.

Daubenmire, Rexford, 1968, Plant communities; A textbook of plant synecology: New York, Harper and Row, 300 pp.

Gives a brief discussion of the applications of repeat photography, which erroneously explains that the focal length of the original camera must be duplicated for successful matching. The technique of repeat photography is illustrated by a pair of matched, but undated, photographs of the steppe vegetation in eastern Washington taken 10 years apart.

Daubenmire, Rexford, 1970, Steppe vegetation of Washington: Washington Agricultural Experiment Station, Technical Bulletin 62, 131 pp.

Includes two pairs of matched, but undated, photographs and a set of three approximately matched photographs of steppe vegetation taken in 1916, 1939, and 1968.

Dauphin, Edgar See Torlegård and Dauphin (1976).

Dauphin, Edgar, and Kennert Torlegärd, 1976, Measurement of displacement using the time-parallax method: Fotogrammetriska Meddelanden, series 2. (Stockholm, Sweden.)

Describes mathematically a method of comparing stereopairs made with a phototheodolite at different times from the same camera stations, using a stereocomparator to determine displacements in the subject.

Dauphin, Edgar, and Kennert Torlegärd, 1977, Displacement and deformation measurements over longer periods of time: Photogrammetria, v. 33, no. 6, pp. 225-39.

Describes two photogrammetric methods of measurement using repeated photographs: 1) displacements in the walls and roof of an underground mine in central Sweden, as determined with a Wild P32 phototheodolite placed over a geodetic control point; and 2) an investigation of simulated displacements in adjoining elements in a multistory building, using a Hasselblad superwide-angle, non-metric camera. The accuracy of each method is given and evaluated, but no matching photographs are shown.

Davidson, E. S. See Culler and others (1970).

Day, G. I. See Blydenstein and others (1957).

Deason, Wayne O. See Ohmart and others (1977).

Degenhardt, William G., 1977, A changing environment; Documentation of lizards and plants over a decade, in Roland H. Wauer and David H. Riskind, eds., Transactions of the Symposium on the Biological Resources of the Chihuahuan Desert Region, United States and Mexico, Sul Ross State University, Alpine, Texas, 17-18 October 1974: U.S. Department of the Interior, National Park Service Transactions and Proceedings Series, no. 3, pp. 533-55.

Includes six pairs of matched photographs showing an increase in vegetation density in Big Bend National Park, Texas, from 1957 to 1968. The increase is attributed to the exclusion of livestock and is correlated with a decrease in lizard population.

Dietz, Donald R., Daniel W. Uresk, Harold E. Messner, and Lowell C. McEwen, 1980, Establishment, survival, and growth of selected browse species in a ponderosa pine forest: U.S. Department of Agriculture, Forest Service Research Paper RM-219, 11 pp.

Matched photographs show 10 years of growth of shrubs planted in sites of old fires and in open areas of pines in the Black Hills, South Dakota.

Dietz, Robert S., 1947, Aerial photographs in the geological study of shore features and processes: Photogrammetric Engineering, v. 13, no. 14, pp. 537-45.

Includes a pair of closely related oblique aerial photographs of a break-water at Santa Monica, California, showing that the beach was built out in a cuspate form between June 1925 and October 1934.

Digerness, David S., 1980, Time exposure--100 years apart: The Denver Post, Empire Magazine, November 23, 1980, pp. 24-26, 28.

Repeats five of William Henry Jackson's Colorado railroad photographs, some in color, from approximately reoccupied sites. The photographs are from the first two volumes of a projected five-volume set of books by Digerness, The Mineral Belt, published by Sundance Books.

Dingus, Phillip Rick See Klett and others (1984).

Dingus, [Phillip] Rick, 1979, Applying the rephotographic methodology for the future--Field report, Zuni Pueblo, NM, Summer 1979: Sun Valley, Idaho, The Rephotographic Survey Project, Unpublished manuscript, 14 pp.

Describes the setting up of camera stations for future monitoring with the aid of archaeologists and with the interests of the tribe in mind.

Dingus, Phillip Rick, 1981, The photographic artifacts of Timothy O'Sullivan: Albuquerque, University of New Mexico, M.F.A. dissertation, 193 pp.

See Dingus (1982).

Dingus, [Phillip] Rick, 1982, The photographic artifacts of Timothy O'Sullivan: Albuquerque, University of New Mexico Press, 158 pp.

This is a revised and expanded version of Dingus (1981). Contains the author's repeat photographs taken in 1980 of views of the West photo-graphed by Timothy H. O'Sullivan from 1867 to 1874. Also contains five lithographs, a stereograph, and reproductions from 58 of O'Sullivan's glass-plate negatives. Discusses O'Sullivan's work from an artist's point of view.

Dolan, Robert, Alan Howard, and Arthur Gallenson, 1974, Man's impact on the Colorado River in the Grand Canyon: American Scientist, v. 62, no. 4, pp. 392-401.

A pair of matched photographs dating from 1932 and 1969 shows pronounced beach erosion along the Colorado River downstream from Glen Canyon Dam.

Douglas, P. M. See Voight and others (1981).

Duffield, Wendell A. See Swanson and others (1972, 1979).

Dunrud, C. Richard, and Frank W. Osterwald, 1980, Effects of coal mine subsidence in the Sheridan, Wyoming, area: U.S. Geological Survey Professional Paper 1164, 49 pp.

A pair of approximately matched photographs taken in March and May 1978 of a firepit above the northern part of the Acme mine shows seasonal changes that reflect the extent of an underground fire in burning coal. The extent was marked in March by bare ground in snow-covered terrain and in May by bare spots surrounded by grass.

Dutton, Allen A., and Diane T. Bunting, 1981, Arizona then and now; A comprehensive rephotographic project: Phoenix, Arizona, Ag2 Press, 162 pp.

Presents 109 pairs of juxtaposed old and new photographs that show changes in Arizona communities over the last 80 to 100 years.

Eardley, Constance M. See Hall, E. A. A., and others (1964).

Eaton, Jerry P. See Richter and others (1964).

Edwards, Owen, 1979, A second view--The Rephotographic Survey Project: Close-Up (published by the Polaroid Corporation), v. 10, no. 1, pp. 10-13.

Discusses the Rephotographic Survey Project (1979) and reproduces a pair of matched photographs from the project that are based on William

Henry Jackson's 1873 view of Snow Mass Mountain and Elk Lake, Colorado.

Ellis, James M., Thomas D. Hamilton, and Parker E. Calkin, 1981, Holocene glaciation of the Arrigetch Peaks, Brooks Range, Alaska: Arctic, v. 34, no. 2, pp. 158-68.

Includes photographs taken in 1979 of the two views of the cirque glacier complex in the Arrigetch Peaks reproduced in Hamilton (1965).

Ellison, Lincoln, 1949, Establishment of vegetation on depleted subalpine range as influenced by microenvironment: Ecological Monographs, v. 19, no. 2, pp. 95-121.

Includes two pairs of matched photographs from the Wasatch Plateau, Utah, each showing the vegetation in 1913 and 1940 in quadrats measuring one square meter.

Ellison, Lincoln, 1954, Subalpine vegetation of the Wasatch Plateau, Utah: Ecological Monographs, v. 24, no. 2, pp. 89-184.

Six photographs taken between 1909 and 1943 were repeated between 1939 and 1949. The matched photographs are used with repeated surveys of quadrats and other historical information to document vegetational succession. The negatives are stored at the U.S. Forest Service, Washington, D. C.

Ellison, Lincoln, A. R. Croft, and Reed W. Bailey, 1951, Indicators of condition and trend on high range-watersheds of the Intermountain Region: U.S. Department of Agriculture Handbook, no. 19, 66 pp.

Includes a pair of matched photographs spanning a single season and another pair of photographs representing a period of unspecified length.

Elson, Jerry W. See Johnsen and Elson (1979).

Emery, K. O., and G. G. Kuhn, 1980, Erosion of rock shores at La Jolla, California: Marine Geology, v. 37, pp. 197-208.

Several sets of matched photographs are used to determine processes

and rates of rock-shore and sea-cliff erosion as follows: Figures 2 and 3, solution basins on sandstone benches (six pairs of close-up photographs taken in 1944 and 1979); Figure 4, sea-cliff retreat by removal of joint blocks (1945 and 1953); Figure 5, progressive changes in micro-badlands in sandstone (two sets of close-up photographs taken in 1945, 1953, and 1979); and Figure 6, movement of sandstone boulders (1943 and 1979; 1940, 1944, and 1979).

ppley, Lisa G. See Baumler (1984).

agan, Brian M. See Alinder (1979).

ahnestock, Robert K., 1963, Morphology and hydrology of a glacial stream--White River, Mount Rainier, Washington: U.S. Geological Survey Professional Paper 422-A, 70 pp.

This study of the processes of a proglacial stream includes a sequence of five repeated photographs taken at 15-minute intervals from 1:00 to 2:00 p.m. on July 18, 1958. The photographs show rapid changes in the channel pattern of the White River. Also included is an example of one of the panoramic photographs of the White River valley train, which "were taken as frequently as several times per day when channels were changing rapidly and every 3 to 4 days when there was little or no change."

alconer, G., 1962, Glaciers of northern Baffin and Bylot Islands, NWT: Canada Department of Mines and Technical Surveys, Geographical Branch, Geographical Paper 33, 31 pp.

Besides several vertical aerial photographs, includes a set of approximately matched photographs of glaciers nos. 10 and 11 on the Borden Peninsula (1906 by G. R. Lancefield, 1928 by R. M. Anderson, 1944 by P. D. Baird, and 1961 by the Geographical Branch) and a pair of closely matched photographs of glacier no. 32 on Baffin Island (1924 by L. T. Burwash, 1961 by the Geographical Branch). Also, a sketch of glacier no. 14 on Bylot Island drawn by A. H. Markham in 1873 is shown with a related low-oblique aerial photograph taken by the U.S. Navy between 1946 and 1948.

arrow, E. P., 1915a, On a photographic method of recording developmental phases of vegetation: Journal of Ecology, v. 3, no. 2, pp. 121-24.

Stakes placed beneath the camera and in the center of the field of view mark the camera station for subsequent photographs. The camera height, film, and exposure are also noted. Points out that matched photographs are an objective means to determine changes in vegetational associations, and they provide efficient records of the vegetational characteristics. No photographs are shown.

Farrow, E. P., 1915b, On the ecology of the vegetation of Breckland; II General description of Breckland and its vegetation (with 3 plates): Journal of Ecology, v. 3, no. 4, pp. 211-28.

Includes a pair of matched photographs (1913 and 1914) from East Anglia, England, which illustrate the method described in Farrow (1915a).

Fassett, James E. See Lohman (1980).

Fellenius, B. H. See Bozozuk, Fellenius, and Samson (1978); Bozozuk, van Wijk, and Fellenius (1978).

Fellin, David G. See Schmidt and others (1983).

Feoli, E. See Lausi and Feoli (1979).

Field, William O., Jr., 1932, The glaciers of the northern part of Prince William Sound, Alaska: Geographical Review, v. 22, no. 3, pp. 361-88.

Includes a set of three matched photographs of the west margin of Columbia Glacier as follows: 1899 by Grove Karl Gilbert; 1909 by Ulysses Sherman Grant, showing an advance in progress; and 1931 by Field, showing a barren zone uncovered by retreat after the 1909 advance. In addition, the author refers to a 1914 photograph of this subject by Dora Keen. Also includes a pair of matched photographs of the east margin of Harriman Glacier (1909 by Grant, 1931 by Field), which shows about 1,500 feet of advance.

Field, William O., Jr., 1937, Observations on Alaskan coastal glaciers in 1935: Geographical Review, v. 27, no. 1, pp. 63-81.

Includes six pairs of matched photographs of glaciers taken by the author in 1931 and 1935 as follows: Bryn Mawr Glacier; Smith Glacier; a view southwest along the eastern terminus of Columbia Glacier; Harriman Glacier; Toboggan Glacier; and the most advanced tongue of Toboggan Glacier. Also includes a photograph of the west margin of Columbia Glacier that matches the three photographs of this subject in Field (1932).

ield, William O., Jr., 1949, Glacier observations in the Canadian Rockies, 1948: Canadian Alpine Journal, v. 32, pp. 99-114.

Includes pairs of matched photographs of Athabaska Glacier and the terminus of Saskatchewan Glacier, Alberta, both taken by the author in 1922 and 1948. Also includes a 1948 photograph of Columbia Glacier, Alberta, from a site occupied by Howard Palmer in 1924. The site was subsequently reoccupied by the author in 1949 and 1953 (William O. Field, personal communication, 1983). Further includes a 1948 photograph of Saskatchewan Glacier from a site established by the Interprovincial Boundary Survey between Alberta and British Columbia in 1919 (Wheeler, 1920). The site was also reoccupied by Byron Harmon in 1924 (Freeman, 1925) and again by the author in 1953 and 1963 (personal communication, 1983).

ield, William O., Jr., 1955, Glaciers: Scientific American, v. 193, no. 3, pp. 84-92; reprinted in Scientific American, The planet Earth, pp. 95-100, 1957.

Includes the pair of photographs of the terminus of Saskatchewan Glacier, Alberta, Canada, in Field (1949).

ield, William O., Jr., 1969, Current observations on three surges in Glacier Bay, Alaska, 1965-1968, in Seminar on the causes and mechanics of glacier surges, St. Hilaire, Quebec, 1968: Canadian Journal of Earth Sciences, v. 6, no. 4, pt. 2, pp. 831-39.

Includes three pairs of matched photographs showing features of glacier surges as follows: Tyeen Glacier (1966, 1968 by M. T. Millett); Rendu Glacier (1961, 1966); and Carroll Glacier (1964, 1967). Except as noted, all the photographs are by the author.

ield, William O., Jr., 1974, Glaciers of the Chugach Mountains, in William O. Field, Jr., ed., Mountain glaciers of the northern hemisphere, Volume

2: Hanover, New Hampshire, U.S. Army Corps of Engineers, Col
Regions Research and Engineering Laboratory, pp. 299-492.

Describes, but does not illustrate, fluctuations in the terminus c
Columbia Glacier and other glaciers of College Fjord and Harrima
Fjord, Alaska, based on repeated photographs and other observation
beginning with the visit of Grove Karl Gilbert in 1899 (Gilbert, 1903).

Field, William O., Jr., and Calvin J. Heusser, 1954, Glacier and botanica
studies in the Canadian Rockies, 1953: Canadian Alpine Journal, v. 3
pp. 127-140.

Includes pairs of matched photographs of Southeast Lyell Glacier (191
by Arthur O. Wheeler, 1953 by William O. Field) and Freshfield Glacie
Alberta (1937 by J. Monroe Thorington, 1953 by Field). The photo
graphic site for Freshfield Glacier was established by Howard Palmer i
1922 (H. Palmer, 1924) and was also reoccupied by Thorington in 192
and 1934 (William O. Field, personal communication, 1983).

Findley, Rowe, 1981, Eruption of Mount St. Helens: National Geographi
Magazine, v. 159, no. 1, pp. 3-65.

Includes several pairs and sets of matched photographs showing effec1
of the eruption of Mount St. Helens, Washington, May 18, 1980, a
follows: five of the eight matched photographs by Gary Rosenquist, a
completely reproduced in Foxworthy and Hill (1982) and Voight (1981);
pair of matched panoramic photographs by Michael Lawton from a sit
north of Spirit Lake, first about a month before the blast, and then fol
months later, as reproduced at larger scale and without cropping in C
Williams (1980); a pair of photographs by John V. Christiansen fro
Mount Adams, 35 miles east; and a set of four photographs by Rober
Landsberg, taken from a site 3 miles northwest of the volcano jus
before he was killed by the eruption.

Fish, Ernest B. See Martin, S. C., and others (1974).

Fleming, Ronald Lee, 1982, Facade stories; Changing faces of Main Stree
storefronts and how to care for them: Cambridge, Massachusetts, Th
Townscape Institute, and New York, Hastings House, 128 pp.

Gives about 40 examples of related historic and contemporary photo
graphic views of storefronts taken from cites and towns throughout th

United States. Historical and aesthetic values are emphasized. Most of the photographs are not explicitly dated, but the associated text provides a chronology of the changes.

Flint, Richard F. See Longwell and others (1932).

Foster, Helen L. See Clark and others (1972).

Foxworthy, Bruce L., and Mary Hill, 1982, Volcanic eruptions of 1980 at Mount St. Helens, the first 100 days: U.S. Geological Survey Professional Paper 1249, 125 pp.

The frontispiece is a pair of matched photographs taken by Harry Glicken on May 17 and September 10, 1980, from the Coldwater II observation station, 5.7 miles north-northwest of Mount St. Helens, Washington, showing changes in the volcano caused by the eruption of May 18, 1980. Includes several remarkable sets of photographs of the initial stages of the eruption as follows: A, a set of eight oblique aerial photographs taken by Dorothy B. and Keith L. Stoffel during a flight just north of the summit crater at the start of the eruption. Two of the photographs show, first, the virtually serene crater, and then an avalanche of ice and rock triggered by a strong earthquake. The next three photographs show the collapse of a large slab of the mountainside, further described by Voight and others (1981). The last three photographs show the initial stages of the eruption cloud. B, a set of five photographs taken by Robert Rogers during the first 15 seconds of the eruption from a ridgetop 7.6 miles west of the volcano. C, a further sequence of three photographs, taken by Ty Kearney from the site occupied by Rogers, and shortly thereafter, covering an additional 15 seconds of the eruption. D, a set of eight matched photographs taken by Gary Rosenquist from a site near Bear Meadow, 11 miles northeast of Mount St. Helens, over a span of about 20 seconds. E, a pair of photographs taken by Keith Ronnholm, also from Bear Meadow, followed by three views taken as Ronnholm was driving northward to escape the rapidly advancing blast cloud. F, a pair of photographs taken by Mrs. Jim Lenz about one hour after the start of the eruption from a site about 31 miles northwest of Mount St. Helens.

Frank, David, Austin Post, and Jules D. Friedman, 1975, Recurrent geothermally induced debris avalanches on Boulder Glacier, Mount Baker, Washington: U.S. Geological Survey Journal of Research, v. 3, no. 1, pp. 77-87.

Annual aerial photographs since 1958 show release of six avalanches consisting of snow, firn, and hydrothermally altered rock from Sherman Peak (1958, 1960, 1962, 1966, 1969, 1973). Maps constructed from the photographs show striking similarities in the patterns of several avalanches.

Frassanito, William A., 1975, Gettysburg; A journey in time: New York, Charles Scribner's Sons, 248 pp.

This study of the photographic record of the Civil War Battle of Gettysburg, Pennsylvania, is based on the more than 230 existing photographs that were taken from 1863 to 1866 by Alexander Gardner, Timothy H. O'Sullivan, James F. Gibson, Mathew B. Brady, Isaac G. and Charles J Tyson, Peter S. and Hanson E. Weaver, and Frederick Gutekunst. The author repeated virtually all of the early photographs in the winter months of 1967-1968 and especially 1971 in order to determine their original locations; and about half of them are reproduced in the book as pairs of matched photographs, although not usually at the same scale.

Freeman, Lewis R., 1925, The mother of rivers; An account of a photographic expedition to the great Columbia Ice Field of the Canadian Rockies: National Geographic Magazine, v. 47, no. 4, pp. 377-446.

Reproduces a 1924 photograph of Saskatchewan Glacier, Alberta, taken by Byron Harmon from a site established by the Interprovincial Boundary Survey between Alberta and British Columbia in 1919, which was again reoccupied by William O. Field in 1948 (Field, 1949).

Frey, Ed., 1959, Die Flechtenflora und -vegetation des Nationalparks im Unterengadin. II. Teil. Die Entwicklung der Flechtenvegetation auf photogrammetrisch kontrollierten Dauerflächen: Ergebnisse der wissenschaftlichen Untersuchungen des schweizerischen Nationalparks, Band 6 (Neue Folge), pp. 237-319 (English summary).

Describes and illustrates repeated matching photographs showing development of lichen vegetation on 33 sites of rock and wood in Swiss National Park. The longest observations were made over 33 to 34 years (1922-1956), the average being between 18 and 19 years.

Friedman, Jules D. See Frank and others (1975).

Frischknecht, Neil C., and Lorin E. Harris, 1968, Grazing intensities and systems on crested wheatgrass in central Utah--Response of vegetation and cattle: U.S. Department of Agriculture, Forest Service Technical Bulletin 1388, 47 pp.

Three pairs of matched photographs are used to supplement vegetational data from permanent plots that were sampled through the period from 1948 to about 1958.

Gage, Maxwell, and Robin D. Black, 1979, Slope-stability and geological investigations at Mangatu State Forest: New Zealand Forest Service, Forest Research Institute Technical Paper, no. 66, 46 pp.

Classifies the slope stability of the Mangatu area, New Zealand, in relation to geologic and geomorphic factors, using as illustrations eight pairs of matched photographs (1906, 1976).

Gaines, David, and the Mono Lake Committee, 1981, Mono Lake guidebook: Lee Vining, California, Kutsavi Books, 113 pp.

Includes the matched photographs given by the Mono Lake Committee (1982) and three other pairs of matched photographs as follows: Lower Rush Creek (1920, 1981), tufa towers west of Black Point (1880s, 1981), and the shoreline near Negit Island (1949, 1981). The 1981 photographs are by Viki Lang.

Gallenson, Arthur See Dolan and others (1974).

Gallizioli, Steve See Turner, R. M., Applegate, Bergthold, Gallizioli, and Martin (1980).

Ganzel, Bill, 1978, Familiar faces, familiar places: Exposure, v. 16, no. 3, pp. 5-15.

The author describes photographing people and places in the Great Plains that were first photographed during the drought and Depression of the 1930s by photographers of the Farm Security Administration. Includes several related or approximately matched views as follows: Atlanta houses (1936 by Walker Evans, 1938 by John Vachon); barn in Cass County, North Dakota (1930s by John Vachon, 1977 by the author); Falls City farmstead, Nebraska (1936 by Arthur Rothstein, 1975 by the

author); and a store front in Omaha, Nebraska (1938 by John Vachon, 1977 by the author).

Ganzel, Bill, 1984, Dust bowl descent: Lincoln, University of Nebraska Press, 130 pp.

This album of 189 photographs shows changes in people and places since the Dust Bowl of the 1930s, based on initial photographs taken by photographers of the Farm Security Administration, which are shown with approximately matched or related views taken by the author from 1977 to 1980. Includes photographs by Walker Evans, Dorothea Lange, Russell Lee, Arthur Rothstein, John Vachon, and Marion Post Wolcott. The photographs pertain to California, Georgia, Kansas, Montana, Nebraska, New Mexico, North Dakota, Oklahoma, South Dakota, Texas, Washington, and Wyoming.

Gartner, F. Robert, and Wesley W. Thompson, 1973, Fire in the Black Hills forest-grass ecotone, in Tall Timbers Fire Ecology Conference, No. 12, Lubbock, Texas, 1972, Proceedings: Tallahassee, Florida, Tall Timbers Research Station, pp. 37-68.

The effects of controlled burning of open grassland in the late spring of 1971 on the outskirts of Rapid City, South Dakota, are illustrated by two pairs of approximately matched photographs taken shortly before and 15 months later.

Gary, Howard L., and Pat O. Currie, 1977, The Front Range pine type--A 40-year photographic record of plant recovery on an abused watershed: U.S. Department of Agriculture, Forest Service General Technical Report RM-46, 17 pp.

Twenty photographs taken at 11 sites in 1937 were matched in 1977. Fifteen pairs of photographs are shown. Steel pipes and rock cairns were used to mark the camera stations.

Gibbens, Robert P. See Hennessy and others (1983).

Gibbens, Robert P., and Harold F. Heady, 1964, The influence of modern man on the vegetation of Yosemite Valley: University of California, Division of Agricultural Science Manual 36, 44 pp.

Includes two pairs of matched photographs and nine sets of three matched photographs. The pairs compare photographs taken in 1961 with those taken in 1866 and between 1921 and 1933. The sets compare photographs taken in 1943 and 1961 with those taken between 1866 and 1899. Aschmann (1977) cited this study to support his argument that fires were more frequent in earlier times.

Gilbert, Grove Karl, 1903, Glaciers and glaciation (Alaska, Volume III): New York, Doubleday, Page & Company, 231 pp. (Republished 1910, as Smithsonian Institution Harriman Alaska Series, Publication 1992.)

As a member of the Harriman Expedition to Alaska in 1899, Gilbert photographed glaciers in Glacier Bay, Yakutat Bay, Prince William Sound, Harriman Fiord, and Cook Inlet. Photographs from which text figures were made are listed in a table. Besides Gilbert, the photographs are attributed to Edward S. Curtis, C. Hart Merriam, and the Canadian Boundary Commission, Ottawa, Canada. At Prince William Sound he traveled for three days by boat from point to point around Columbia Bay with Charles Palache, F. V. Colville, and Curtis, mapping Columbia Glacier and establishing photographic stations to record its relation to adjacent land for future comparison. A photograph of Columbia Glacier by Curtis, as seen from Heather Island, is reproduced as Plate XII.

Gilbert, Grove Karl, 1904, Variations of Sierra glaciers: Sierra Club Bulletin, v. 5, no. 1, pp. 20-25.

Describes changes in Lyell Glacier shown by repeating in 1903 a photograph taken by Israel Cook Russell in 1883. Explains that photography is one of the best methods for recording the position of a glacier front, especially if the point of view shows the relation of the ice to fixed objects in the foreground and if the camera position is marked, as by the building of a cairn.

Gilkerson, Michael See U.S. Bureau of Land Management (1979, 1980).

Gillon, Edmund V., Jr. See Watson and Gillon (1976).

Glancy, Patrick A., 1981, Streamflow, sediment transport, and nutrient transport at Incline Village, Lake Tahoe, Nevada, 1970-73: U.S. Geological Survey Open-file Report 80-2045, 89 pp.

Includes several sets of matched photographs of the Lake Tahoe area, Nevada, as follows: Five photographs demonstrate erosion and mass wasting along a roadcut from April 1970 to June 1975, three photographs taken in December 1969 and June and August 1971 show seasonal differences in the discharge of a small stream, and three vertical aerial photographs document rapid urban growth on the north shore of Lake Tahoe from 1956 to 1966 and then less rapid growth up to 1973.

Glendening, George E., 1952, Some quantitative data on the increase of mesquite and cactus on a desert grassland range in southern Arizona: Ecology, v. 33, no. 3, pp. 319-28.

A pair of photographs taken 17 years apart (1932, 1949) shows an increase in woody plants and a decrease in perennial grasses in a plot on the Santa Rita Experimental Range from which livestock were excluded.

Glendening, George E., 1955, Reproduction and establishment of velvet mesquite as related to invasion of semidesert grasslands: U.S. Department of Agriculture, Forest Service Technical Bulletin 1127, 50 pp.

A pair of photographs shows an increase in mesquite and a decrease in density of grass on the Santa Rita Experimental Range, Arizona, between 1903 and 1941.

Glicken, Harry See Voight and others (1981).

Godwin, H., D. R. Clowes, and B. Huntley, 1974, Studies in the ecology of Wicken Fen, V. Development of fen carr: Journal of Ecology, v. 62, no. 1, pp. 197-214.

A pair of matched photographs from Cambridgeshire, England (1928, 1944) is used to supplement vegetational data obtained by repeated mapping.

Goldsmith, F. B., and Carolyn M. Harrison, 1976, Description and analysis of vegetation, in S. B. Chapman, ed., Methods in plant ecology: New York, John Wiley and Sons, pp. 85-156.

Discusses the use of aerial and ground-level photography for recording vegetation.

Gomberg, David N. _See_ Lohman (1980).

Graf, William L., 1978, Fluvial adjustments to the spread of tamarisk in the Colorado Plateau region: Geological Society of America Bulletin, v. 89, no. 10, pp. 1491-501.

Includes a pair of matched photographs from the Grand Canyon, Arizona. The earlier photograph was taken by John K. Hillers in 1871 during the second Powell Expedition. The matching photograph was taken by Hal G. Stephens and Eugene M. Shoemaker in 1968. Other photographs used in the study to document fluvial changes are cited.

Graf, William L., 1979a, Mining and channel responses: Annals of the Association of American Geographers, v. 69, no. 2, pp. 262-75.

A series of eight photographs spanning the years from 1864 to 1977, together with a sketch dated about 1862, are used to document cultural and geomorphic changes at Nevadaville, Colorado. The series is remarkable because all the photographs, except for a 1977 view by the author, were taken independently from the same favorite overlook. Thus the photographs encompass similar, although not identical, areas.

Graf, William L., 1979b, Rapids in canyon rivers: Journal of Geology, v. 87, no. 5, pp. 533-51.

This study of rapids in 12 rivers of the Colorado Plateau includes three pairs of matched photographs made in 1968 by Hal G. Stephens and Eugene M. Shoemaker of the 1871 Powell Expedition photographs.

Graf, William L., 1982a, Tamarisk and river-channel management: Environmental Management, v. 6, no. 4, pp. 283-96.

Encroachment of tamarisk on the Salt and Gila Rivers in central Arizona since the 1890s is shown in several pairs of approximately matched photographs (1892 and 1980, 1949 and 1979 for the Salt River; 1923 and 1979, 1949 and 1979 for the Gila River). The photographs differ in scale, making comparisons difficult.

Graf, William L., 1982b, Spatial variation of fluvial processes in semi-arid lands, _in_ Colin E. Thorn, ed., Space and time in geomorphology, The Binghampton Symposia in Geomorphology, International Series, no. 12,

pp. 193-217: London, George Allen and Unwin.

The discussion is focused on the Henry Mountains region, Utah, using as
one of the illustrations a pair of matched photographs showing changes
in the channel of the Fremont River (late 1930s by A. L. Inglesby, 1980
by the author).

Graf, William L., 1983a, Flood-related channel change in an arid-region
river: Earth Surface Processes and Landforms, v. 8, no. 2, pp. 125-39.

The effects of floods on the Gila River upstream from Phoenix, Arizona,
are illustrated in part by two sets of matched photographs: the river
bed eight miles west of Granite Reef Dam (1949, January 1980, Decem-
ber 1980) and a gravel mine in the main-flow channel five miles west of
the dam (January, February, April, October 1980).

Graf, William L., 1983b, Downstream changes in stream power in the Henry
Mountains, Utah: Annals of the Association of American Geographers,
v. 73, no. 3, pp. 373-87.

A decrease in the power of streams in the Henry Mountains to transport
sediment after 1940 is shown in two pairs of approximately matched
photographs: an unnamed creek below Avery Springs (1934 by C. B.
Hunt, 1980 by the author); and the Fremont River at its confluence with
Muddy Creek (1939 by Hunt, 1980 by the author).

Grant, P. J., 1977, Recorded channel changes of the upper Waipawa River,
Ruahine Range, New Zealand: Water and Soil Technical Publication No.
6, 22 pp. (Water and Soil Division, Ministry of Works and Development,
Wellington, New Zealand.)

Changes in river channels in the Tukituki river basin, North Island, New
Zealand, which are attributed to increased rates of sediment transport,
are documented in part by a pair of matched photographs of the upper
Waipawa River (1937 by Mrs. W. H. Macdonald, 1976 by the author).

Grant, Ulysses Sherman, and D. F. Higgins, 1913, Coastal glaciers of Prince
William Sound and Kenai Peninsula, Alaska: U.S. Geological Survey
Bulletin 526, 75 pp.

Includes several pairs or sets of matched photographs of glaciers as
follows: west part of front of Columbia Glacier (1899 by Grove Karl

Gilbert, 1909 by Grant); edge of Columbia Glacier (1899 by Gilbert, 1905 by Sidney Paige, and 1908 by Grant); and Barry Glacier (1905 by Paige, 1909 by Grant). In addition, several other photographs of glaciers are shown, some of them from Gilbert's 1899 sites (Gilbert, 1903), and many other photographs are listed by number, name of photographer, caption, and date. Besides the photographers named above, the others are W. C. Mendenhall, 1898; F. C. Schrader, 1898; and A. C. Spencer, 1900.

Grant, Ulysses Simpson, IV See Shepard and Grant (1947).

Graves, Walter L. See Kay and Graves (1983).

Greeley, Ronald See Ward and Greeley (1984).

Grelsson, Gunnel, and Christer Nilsson, 1982, Förändringar i en älvdals vegetation belysta genom upprepad fotografering: Svensk Botanisk Tidskrift, v. 76, pp. 368-79.

This study of vegetation changes along the lower reaches of the Umealven river in northern Sweden is based on evidence provided by five pairs of approximately matched photographs. The photographs represent conditions before and after (1959, 1981) development of the river for hydroelectric power.

Gruell, George E. See Arno and Gruell (1983); Loope and Gruell (1973).

Gruell, George E., 1973, An ecological evaluation of Big Game Ridge: U.S. Department of Agriculture, Forest Service Intermountain Region, Ogden, Utah, 62 pp.

Ten pairs of matched photographs and a set of three matched photographs show that vegetation on the elk habitat in the Teton National Forest, Wyoming, has improved in the past 56 years. This interpretation differs from that of previous studies, which have not used photographic evidence.

Gruell, George E., 1979, Wildlife habitat investigations and management implications on the Bridger-Teton National Forest, in Mark S. Boyce and Larry D. Hayden-Wing, eds., North American elk; Ecology, behavior and

management: Laramie, Wyoming, University of Wyoming, pp. 63-74.

Six pairs of matched photographs show various aspects of vegetation change and plant succession in the Jackson Hole region, Wyoming. The photographs are dated as follows: 1918, 1969; 1939, 1968; 1878 by W. H. Jackson, 1968; 1906, 1968; 1887-1896 by Owen Wister, 1969; and 1899, 1971.

Gruell, George E., 1980a, Fire's influence on wildlife habitat on the Bridger-Teton National Forest, Wyoming. Volume I--Photographic record and analysis: U.S. Department of Agriculture, Forest Service Research Paper INT-235, 207 pp.

Includes 85 pairs of photographs of the wildlife habitat taken from 1872 to 1975. The photographs show increases above an altitude of 6,000 feet in sagebrush and conifers, accompanied by a buildup of material vulnerable to fire, a loss of understory plants, and a reduction in wildlife carrying capacity. When possible, efforts were made to repeat the photographs at the same time of year and time of day.

Gruell, George E., 1980b, Fire's influence on wildlife habitat on the Bridger-Teton National Forest, Wyoming. Volume II--Changes and causes; Management implications: U.S. Department of Agriculture, Forest Service Research Paper INT-252, 35 pp.

Includes two pairs of matched photographs of quadrats (1954 and 1968, 1954 and 1976). A third pair illustrates the marked year-to-year differences that occur in grassland vegetation. The causes and management implications of changes described by Gruell (1980a) are discussed.

Gruell, George E., 1983, Fire and vegetative trends in the northern Rockies; Interpretations from 1871-1982 photographs: U.S. Department of Agriculture, Forest Service General Technical Report INT-158, 117 pp.

Changes in forest and range vegetation in Montana and adjacent Idaho caused by the absence of fire are interpreted from 86 pairs of matched photographs, which show that woody vegetation increased markedly from 1871 to 1982.

Gruell, George E., and L. L. Loope, 1974, Relationships among aspen, fire, and ungulate browsing in Jackson Hole, Wyoming: U.S. Department of Agriculture, Forest Service Intermountain Region, and U.S. Department

of the Interior, National Park Service, Rocky Mountain Region, 33 pp.

A matched pair of ground-level photographs (1970 and 1973) and a matched pair of aerial photographs show changes in stands of quaking aspen.

Gruell, George E., Wyman C. Schmidt, Stephen F. Arno, and William J. Reich, 1982, Seventy years of vegetative change in a managed ponderosa pine forest in western Montana--Implications for resource management: U.S. Department of Agriculture, Forest Service General Technical Report INT-130, 42 pp.

Presents a photographic record of plant successsion in the Bitterroot National Forest after fire and timber harvesting. Matched photographs from 10 camera stations are shown for 1909, 1925, 1937, 1948, 1958, 1968, and 1979. Matched photographs from still another station are given only for 1909, 1925, 1937, and 1948 because the camera angle in 1958 was incorrect.

Gutierrez, Alberto A. See Wells, S. G., and others (1983).

Hall, Elizabeth A. A., R. L. Specht, and Constance M. Eardley, 1964, Regeneration of the vegetation on Koonamore Vegetation Reserve, 1926-1962: Australian Journal of Botany, v. 12, no. 2, pp. 205-64.

Parts of seven series of annual photographs taken between 1924 and 1964 are used with data from permanent quadrats and transects to describe recovery of vegetation on arid rangeland that had been overgrazed. In addition to changes in density of species, the photographs are used to determine growth rates of individual plants, rates of decomposition of standing and fallen litter, establishment of seedlings and their destruction by rabbits, and soil recovery and vegetational response on former sheep trails.

Hall, Frederick C., 1976, Fire and vegetation in the Blue Mountains--Implications for land managers, in Pacific Northwest, Tall Timbers Fire Ecology Conference, No. 15, Portland, Oregon, 1974, Proceedings: Tallahassee, Florida, Tall Timbers Research Station, pp. 155-70.

Gives the same pair of photographs as in F. C. Hall (1977) but at smaller scale.

Hall, Frederick C., 1977, Ecology of natural underburning in the Blue Moun-
tains of Oregon: U.S. Department of Agriculture, Forest Service
Pacific Northwest Region, R6-ECOL-79-001, 11 pp.

Discusses the effect of fire control in producing overly dense and stag-
nated stands of ponderosa pine in the Blue Mountains, Oregon, giving as
an illustration a pair of approximately matched photographs of a stand
of young ponderosa pine, taken first in 1964 when the density was 2,000
stems per acre and then 10 years after the stand had been thinned to
110 trees per acre.

Hall, Stephen A. See Love and others (1983).

Hall, Wade B. See Reid, E. H., and others (1980); Strickler and Hall (1980).

Hallet, Bernard See Wilshire and others (1981).

Halliday, William R., 1982, Impact of posteruption mudflows on the caves of
the Cave Basalt Lava Flow of Mount St. Helens, in S. A. C. Keller, ed.,
Mount St. Helens; One year later: Cheney, Washington, Eastern Wash-
ington University Press, pp. 55-60.

A pair of matched photographs by the author shows the effect on June
22, 1980, of ashfalls at the Ape Cave road and entrance trail, on the
southwest flank of Mount St. Helens, Washington, and again on Novem-
ber 10, 1980. Another pair of matched photographs (1967 by the author,
1981 by Becky Taylor) shows more than 1.5 m of aggradation of the
Hopeless Cave area with coarse streamwash since August 1980.

Hamilton, Thomas D. See Ellis and others (1981).

Hamilton, Thomas D., 1965, Comparative glacier photographs from northern
Alaska: Journal of Glaciology, v. 5, no. 40, pp. 479-87.

Includes two pairs of matched photographs of the cirque glacier com-
plex in the Arrigetch Peaks of the south-central Brooks Range (1911,
1962), which show glacial recession and thinning, emergence of trim-
lines, and partial melting of ice cores beneath recent moraines. The
initial photographs were taken by Philip Sidney Smith.

Hardman, George, and Cruz Venstrom, 1941, A 100-year record of Truckee River runoff estimated from changes in levels and volumes of Pyramid and Winnemuca Lakes: American Geophysical Union Transactions, v. 22, no. 1, pp. 71-90.

Discusses the implications of a decline in the level of Pyramid Lake, Nevada, as recorded by a set of matched photographs: 1871 by Timothy H. O'Sullivan; 1882 by Israel Cook Russell; and 1939 by the authors.

Harris, Lorin E. See Frischknecht and Harris (1968).

Harrison, A. E., 1950, Glaciers then and now: Sierra Club Bulletin, v. 35, no. 6, pp. 113-16.

Photographs of glaciers in the Sierra Nevada, California, taken by the author in 1949 are matched with three earlier photographs as follows: Lyell Glacier (1903 by Grove Karl Gilbert); Dana Glacier (1883 by Israel Cook Russell); and Maclure Glacier (1903 by Gilbert).

Harrison, A. E., 1960, Exploring glaciers with a camera: San Francisco, California, Sierra Club, 71 pp.

Provides advice on choosing a site for the camera to record changes in a glacier, and suggests that camera positions previously used should be reoccupied to give continuity to the measurements. As examples, repeated views of Lyell Glacier, California, in 1937, 1951, and 1953 and Nisqually Glacier, Washington, in 1932, 1944, 1951, and 1954 are shown. Descriptive records of photographs make the photographs more useful. Permanent files of glacier photographs are kept by the American Geographical Society and by the University of Washington Library.

Harrison, A. E., 1974, Reoccupying unmarked camera stations for geological observations: Geology, v. 2, no. 9, pp. 469-71.

Presents a detailed method for relocating an unmarked camera station using a transparent plastic overlay of landmarks fitted to the original photograph. The site is found by making successive measurements on the focal plane or on Polaroid-type photographs during repeated trials. Shows three pairs of matched photographs: Lyell Glacier (1903, 1949) and Maclure Glacier (1903, 1949) in California and Muldrow Glacier (1942, 1966) in Alaska.

Harrison, Carolyn M. See Goldsmith and Harrison (1976).

Hartesveldt, Richard John, 1962, The effect of human impact upon Sequoia gigantea and its environment in the Mariposa Grove, Yosemite National Park, California: Ann Arbor, University of Michigan, Ph.D. dissertation, 310 pp.

The effects of human impact are shown in seven pairs of matched photographs, which span a period of about 100 years, and in several unmatched photographs taken between 1888 and 1912.

Hartman, Richard M. See Berntsen and others (1983).

Hastings, James Rodney, 1963, Historical changes in the vegetation of a desert region: Tucson, University of Arizona, Ph. D. dissertation, 456 pp.

Approximately 90 pairs of matched photographs show vegetational changes in the oak woodland, the desert grassland, and the Sonoran Desert in northern Sonora, Mexico, and southern Arizona. See also Hastings and Turner (1965).

Hastings, James Rodney, and Raymond M. Turner, 1965, The changing mile; An ecological study of vegetation change with time in the lower mile of an arid and semiarid region: Tucson, University of Arizona Press, 317 pp.

Includes 97 pairs of matched photographs, the earliest being from 1883. Symbols on the photographs are used to identity individual plants and other important features. Measurements and estimates of species abundances and mortality rates are described in the captions. This is a revised and expanded version of Hastings (1963).

Hattersley-Smith, G., 1966, The symposium on glacier mapping: Canadian Journal of Earth Sciences, v. 3, no. 6, pp. 737-43.

Describes the pioneer role of Sebastian Finsterwalder in precise glacier mapping, who, in 1888 and 1889, introduced photogrammetric intersection methods in his repeated surveys of the Vernagtferner in the eastern Alps. In 1895 he designed a lightweight phototheodolite, which is still used in surveys of glaciers throughout the world. The continuing work

of Finsterwalder's son, Richard, who is equally famous for his glacier surveys, is also described.

Hattori, Eugene M., and Alvin R. McClane, 1980, Archaeological and historical studies at Simpson Pass, Churchill County, Nevada: Reno, Desert Research Institute, Social Sciences Center Technical Report No. 12, 37 pp.

Includes a photograph taken in 1979 that matches an artist's sketch of Carson Lake as it appeared from Simpson Pass in 1860. The sketch, although distorted by unrealistic vertical exaggeration, was useful in locating the alignment of the Pony Express route through the pass.

Hawley, J. W., D. W. Love, and S. G. Wells, 1983, Summary of the hydrology, sedimentology, and stratigraphy of the Rio Puerco valley, in Stephen G. Wells, David W. Love, and Thomas W. Gardner, eds., Chaco Canyon country; A field guide to the geomorphology, Quaternary geology, paleoecology, and environmental geology of northwestern New Mexico: Albuquerque, New Mexico, American Geomorphological Field Group, 1983 Field Trip Guidebook, pp. 33-36.

A pair of approximately matched photographs (1916, 1983) of the Rio Puerco, New Mexico, south of the AT&SF railroad bridge shows development of an active inner channel and a flood plain since floods in 1929.

Haynes, Vance, 1980, Journey to the Gilf Kebir and Uweinat, Southwest Egypt, 1978; II. Quaternary geology and archaeological observations: The Geographical Journal, v. 146, pt. 1, pp. 59-63.

This account of a 1978 reconnaissance in the Western Desert of Egypt includes several pairs of matched photographs. Comparison with a photograph taken 53 years earlier at Bir Tarfawi shows virtually no change in dune morphology and only minor changes in the vegetation. In the Gilf Kebir region, repeat photographs of the base camp of R. A. Bagnold near Aqab el Gadim, based on two views taken in 1938 by Ronald F. Peel, show little change in the desert floor, but a seif dune has migrated 40 m to the south. Based on three more of Peel's photographs, the 1978 photographs also indicate at least one episode of discharge at Wadi Ard el Akhdar in Uweinat.

Heady, Harold F. See Gibbens and Heady (1964).

Heady, Harold F., 1958, Vegetational changes in the California annual type: Ecology, v. 39, no. 3, pp. 402-16.

A set of three photographs shows rapid changes in grassland vegetation for February, April, and June, 1955, in Mendocino County, California.

Heady, Harold F., and Paul J. Zinke, 1978, Vegetational changes in Yosemite Valley: U.S. Department of the Interior, National Park Service Occasional Paper, no. 5, 25 pp.

Two pairs of matched photographs (1866, 1961; 1866, 1973) show vegetation changes in Yosemite National Park, California, especially increased forest cover. The influence of modern man on fires is discussed.

Heller, Jonathan, 1981, Rephotography in the American West: Picturescope, The Quarterly Bulletin of the Picture Division, Special Libraries Association, v. 29, pp. 130-32.

Discusses various rephotography projects and reproduces a matching photograph of the John K. Hillers 1879 view of Mummy Cave, Canyon de Chelly, Arizona, taken in 1978 by the Rephotographic Survey Project (1979).

Hennessy, J. T., R. P. Gibbens, J. M. Tromble, and M. Cardenas, 1983, Vegetation changes from 1935 to 1980 in mesquite dunelands and former grasslands of southern New Mexico: Journal of Range Management, v. 36, no. 3, pp. 370-74.

A pair of matched photographs on the Jornada Experimental Range shows replacement of black-gramma grassland by mesquite duneland in 45 years.

Henry, Mary Ann See Webb, R. H., and others (1983).

Heusser, Calvin J. See Field and Heusser (1954).

Hickson, Catherine J., and William C. Barnes, 1982, The initial pyroclastic surge at Mount St. Helens and its deposits, in S. A. C. Keller, ed., Mount St. Helens; One year later: Cheney, Washington, Eastern Washington University Press, pp. 13-19.

Gives three photographs from a sequence of seven matched photographs of the eruption of Mount St. Helens, Washington, May 18, 1980, taken by Paul and Catherine J. Hickson from a site 15 km east of the eruption crater.

Hickson, Catherine J., Paul Hickson, and William C. Barnes, 1982, Weighted vector analysis applied to surge deposits from the May 18, 1980 eruption of Mount St. Helens, Washington: Canadian Journal of Earth Sciences, v. 19, no. 4, pp. 829-36.

Gives two of the photographs in C. J. Hickson and Barnes (1982).

Hickson, Paul See Hickson, C. J., and others (1982).

Higgins, D. F. See Grant, U. S., and Higgins (1913).

Hill, Mary See Foxworthy and Hill (1982).

Hobbs, Elizabeth, 1980, Effects of grazing on the northern population of Pinus muricata on Santa Cruz Island, California, in Dennis M. Power, ed., The California islands: Proceedings of a multidisciplinary symposium: Santa Barbara, California, Santa Barbara Museum of Natural History, pp. 159-65.

A pair of matched photographs (about 1929 and 1977) shows a decline in Bishop pine (Pinus muricata) at Pelican Bay.

Holcomb, Robin T., Donald W. Peterson, and Robert I. Tilling, 1974, Recent landforms at Kilauea Volcano; A selected photographic compilation, in Ronald Greeley, ed., Hawaiian Planetology Conference: National Aeronautics and Space Administration Technical Memorandum X-62362, pp. 49-86.

Includes a remarkable set of nine closely matched photographs showing filling and draining of lava in the summit crater of Mauna Ula between May 6 and November 12, 1973. Other matched photographs show changes in Pauahi Crater (1961 by W. W. Dunmire, 1973 by Holcomb); development of talus-and-lava cones at Makaopuhi (June 30, 1972, by W. A. Duffield, and August 2 and October 29, 1972, by Holcomb); and chilling of a pahoehoe tongue by surf (April 19, 1971, by Donald A. Swanson).

Holmes, Jon, and Glenn Rifkin, 1978, Rocky Mountain fervor: 35 mm Photography, Summer 1978, pp. 56, 120.

Discusses the work of the Rephotographic Survey Project (1979).

Houston, Douglas B., 1982, The northern Yellowstone elk; Ecology and management: New York, MacMillan, 474 pp.

Describes changes in the winter and summer ranges of elk in Yellow-stone National Park by means of 51 pairs of matched photographs that span intervals of from 30 to 102 years.

Howard, Alan See Dolan and others (1974).

Howard, Alan D., and Gordon Kerby, 1983, Channel changes in badlands: Geological Society of America Bulletin, v. 94, no. 6, pp. 739-52.

Includes two pairs of matched photographs showing seasonal changes in channels and slopes in badlands (October 1970 and March 1971; March 1970 and October 1970), which formed when an area of coastal plain sediments near Stafford, Virginia, was stripped of vegetation and soil.

Humphrey, Robert R. See Blydenstein and others (1957).

Humphrey, Robert R., 1953, The desert grassland; Past and present: Journal of Range Management, v. 6, no. 3, pp. 159-64.

Includes a pair of approximately matched photographs (1903, 1947) taken on the Santa Rita Experimental Range, Arizona, which shows invasion of the desert grassland by woody shrubs.

Humphrey, Robert R., 1958, The desert grassland; A history of vegetational changes and an analysis of causes: University of Arizona, Agricultural Experiment Station Bulletin 299, 62 pp.

Includes a pair of matched photographs (1893, 1956) of monument number 96 on the United States-Mexico boundary. The report was originally published in Botanical Review, v. 24, pp. 193-252 (1958) with-out illustrations.

Humphrey, Robert R., 1959, History of vegetational changes in Arizona, _in_ Robert R. Humphrey, ed., Your range--Its management: University of Arizona, Agricultural Experiment Station Special Report No. 2, pp. 5-7.

Includes the same pair of photographs as in Humphrey (1958), but the dates of the photographs are given here as 1892 and 1955.

Humphrey, Robert R., 1963, The role of fire in the desert and desert grass-land areas of Arizona, _in_ Tall Timbers Fire Ecology Conference, No. 2, Tallahassee, Florida, 1963, Proceedings: Tallahassee, Florida, Tall Timbers Research Station, pp. 44-61.

Two pairs of matched photographs show an increase in woody species (mainly mesquite) in desert grassland. One pair is from the boundary between Arizona and Sonora, Mexico. The other is from the Santa Rita Experimental Range, Arizona.

Hungerford, C. Roger _See_ Blydenstein and others (1957).

Hunt, Charles B., 1973, Thirty-year photographic record of a shale pedi-ment, Henry Mountains, Utah: Geological Society of America Bulletin, v. 84, no. 2, pp. 689-95.

Photographs from a captive balloon and from airplanes are compared with horizontal photographs made at ground level. Very little change in rill patterns and the location of small stones is detected.

Huntley, B. _See_ Godwin and others (1974).

Hurley, Gerald D., and Angus McDougall, 1971, Visual impact in print; How to make pictures communicate; A guide for the photographer, the editor, the designer: Chicago, Visual Impact, Inc., 208 pp.

For comparison, shows and discusses an unmatched pair of photographs and a matched pair. The mismatch (p. 50) is a football field taken during preparations for a game and while the game was underway, but from different positions with different framing. The matched pair shows part of Los Angeles, California, with and without smog.

Imbrie, John, and Katherine Palmer Imbrie, 1979, Ice ages; Solving the

mystery: Hillside, New Jersey, Enslow Publishers, 224 pp.

Reproduces the etching and photograph of Argentière Glacier in the
French Alps as given by Schneider with Mesirow (1976).

Imbrie, Katherine Palmer See Imbrie, J., and Imbrie (1979).

Jackson, A. S., 1965, Wildfires in the Great Plains grassland, in Tall Timbers
Fire Ecology Conference, No. 4, Tallahassee, Florida, 1965, Proceed-
ings: Tallahassee, Florida, Tall Timbers Research Station, pp. 241-59.

Two pairs of matched photographs show rapid regrowth of grassland
vegetation after fire. One pair was taken March 19 and August 27,
1962, in Hemphill County, Texas. The other pair was taken March 16
and August 27 after a fire on March 3, presumably also in 1962 in
Hemphill County.

Jackson, Dallas B. See Swanson and others (1972, 1979).

James, Harold L., 1969, History of the United States-Mexican boundary
survey--1848-1855, in Guidebook of the border region--New Mexico
Geological Society 20th Field Conference, 1969: Socorro, New Mexico,
New Mexico Bureau of Mines and Mineral Resources, pp. 40-55.

Includes eight landscape sketches by John Russell Bartlett made in New
Mexico and Arizona between 1850 and 1852, which are reproduced with
modern photographs of the same scenes. Bartlett was the U.S. Bound-
ary Commissioner from 1850 to 1853, and the sketches are from his
famous "Personal Narrative," which has been often quoted by scientists
and historians. The comparisons reveal Bartlett's artistic exaggeration,
although James comments that Bartlett's renderings are amazingly
exact.

Jameson, Donald A. See Arnold and others (1964).

Janda, Richard J. See Voight and others (1981).

Janda, Richard J., Kevin M. Scott, K. Michael Nolan, and Holly A. Martin-
son, 1981, Lahar movement, effects, and deposits, in Peter W. Lipman

and Donal R. Mullineaux, eds., The 1980 eruptions of Mount St. Helens, Washington: U.S. Geological Survey Professional Paper 1250, pp. 461-78.

Includes a pair of matched vertical aerial photographs of the North Fork Toutle River, taken by the Washington Department of Natural Resources, showing preeruption conditions, June 5, 1978, and the area inundated by a mudflow produced by the eruption of May 18, 1980, as seen on June 19, 1980. The effects of this and other mudflows are futher described and illustrated.

Jensén, Eva Waldemarson, 1979, Successions in relationship to lagoon development in the Laitaure delta, North Sweden: Acta Phytogeographica Suecica, Uppsala, v. 66, 120 pp. (Ph.D. dissertation, Uppsala University, Sweden).

Vegetation changes related to stream channel development, lagoon formation, and other processes of coastal hydrology and geomorphology are shown in eight sets of matched photographs taken from Mount Skerfe: 1899, 1922, and 1971; 1904 and 1922 (three sets); 1904, 1922, and 1974; and 1971 and 1974.

Jercinovic, Devon E. See Wells, S. G., and others (1983).

Johnsen, Thomas N., Jr., and Jerry W. Elson, 1979, Sixty years of change on a central Arizona grassland-juniper woodland ecotone: U.S. Department of Agriculture Science and Education Administration, Agricultural Reviews and Manuals ARM-W-7, 28 pp.

Vegetational changes between Prescott and Seligman, Arizona, are documented by 20 pairs of matched photographs taken in 1916 and 1977.

Johnson, Alexandra, 1979, Double exposure--Then and now: Christian Science Monitor, February 2, 1979.

Describes the Rephotographic Survey Project (1979), with information on William Henry Jackson and two photographs.

Johnson, Arthur, 1980, Grinnell and Sperry Glaciers, Glacier National Park, Montana--A record of vanishing ice: U.S. Geological Survey Professional Paper 1180, 29 pp.

The shrinkage of Grinnell and Sperry Glaciers since their discovery in 1887 and 1895, respectively, is documented by comparing photographs taken since 1887 and by detailed topographic mapping since 1900.

Johnson, Donald Lee, 1972, Landscape evolution on San Miguel Island, California: Lawrence, University of Kansas, Ph.D. dissertation, 391 pp.

Besides a set of photomaps of the island (1929, 1940, 1954, and 1960), includes two pairs of approximately matched photographs as follows: a view from Hoffman Point showing recovery from effects of grazing by sheep (1893 by C. D. Vay, 1965 by the author) and development of a shingle beach and vegetation at a landslide at Cuyler Harbor (sometime during 1940 to 1942 by U. F. Stevens, 1967 by the author).

Johnson, Hyrum B., 1964, Changes in the vegetation of two restricted areas of the Wasatch Plateau as related to reduced grazing and complete protection: Provo, Utah, Brigham Young University, Ph.D. dissertation, 123 pp.

Includes seven pairs of matched photographs and three sets of three photographs taken between 1914 and 1962 illustrating range recovery in several types of vegetation on the Wasatch Plateau, Utah.

Johnson, R. Roy, and Steven W. Carothers, 1982, Riparian habitats and recreation: interrelationships and impacts in the Southwest and Rocky Mountain region: Eisenhower Consortium for Western Environmental Forestry Research Bulletin 12, 31 pp. (Rocky Mountain Forest and Range Experiment Station, Forest Service, U.S. Department of Agriculture, Fort Collins, Colorado.)

Describes increasing recreational pressures on riparian habitats, using as an example two pairs of matched photographs of the Santa Cruz River, Arizona, which show a decline of riparian vegetation (1942 by David E. Brown, 1981 by Raymond M. Turner; 1940 by Johnson A. Neff, 1981 by Turner).

Johnston, David A. See Keith and others (1981).

Joint Committee of the American Society of Range Management and the Agriculture Board, 1962, Basic problems and techniques in range research: Washington, D.C., National Academy of Sciences, National

Research Council Publication No. 890, 341 pp.

Discusses, but does not illustrate, the use of repeated photographs of small plots in conjunction with other observations of the vegetation and soil. A brief list of important data to be recorded is given. The use of photographs made with a vertically oriented camera for measuring vegetation changes by the photographic charting method is criticized because the required equipment is cumbersome and costly.

Karpiscak, Martin M. See Turner, R. M., and Karpiscak (1980).

Karpiscak, Martin M., 1980, Secondary succession of abandoned field vegetation in southern Arizona: Tucson, University of Arizona, Ph.D. dissertation, 219 pp.

Several groups of matching photographs show short-term changes in abandoned fields from 1976 to 1980. A set of four aerial photographs of one area shows changes between 1937 and 1969.

Kasser, P. See Bauer and others (1968).

Kay, Burgess L., and Walter L. Graves, 1983, History of revegetation studies in the California deserts, in Robert H. Webb and Howard G. Wilshire, eds., Environmental effects of off-road vehicles; Impacts and management in arid regions: New York, Springer-Verlag, pp. 315-24.

A pair of approximately matched, undated photographs of a site excluded from cattle grazing in the western Mojave Desert, California, shows rapid growth of four-wing saltbush (Atriplex canescens) during a single season.

Kaye, Clifford A., 1964, The upper limit of barnacles as an index of sea-level changes on the New England coast during the past 100 years: Journal of Geology, v. 72, no. 5, pp. 580-600.

A pair of matched photographs of Bass Rock, at Nahant, Massachusetts, which shows the upper barnacle limit in 1880 and 1962, provides part of the evidence that sea level in the mid-nineteenth century was approximately the same as in the mid-twentieth century, but that it was about 0.5 foot lower at the turn of the century. Comparisons of photographs showing the barnacle limit at Minot's Ledge Lighthouse (1950, 1962) and

Pulpit Rock (1871, 1962) are also discussed.

Keadle, Butch R. See Berntsen and others (1983).

Keen, Dora, 1915, Studying the Alaskan glaciers: Bulletin of the Geographical Society of Philadelphia, v. 13, no. 2, pp. 71-78.

Describes reoccupying in 1914 sites from which glaciers in Prince William Sound, Alaska, had previously been photographed and making comparison photographs. Changes in the glaciers are described and four photographs are reproduced, but no pairs of matched photographs are given.

Keith, Terry E. C., Thomas J. Casadevall, and David A. Johnston, 1981, Fumarole encrustations; Occurrence, mineralogy, and chemistry, in Peter W. Lipman and Donal R. Mullineaux, eds., The 1980 eruptions of Mount St. Helens, Washington: U.S. Geological Survey Professional Paper 1250, pp. 239-50.

Includes a pair of approximately matched photographs showing encrustations on July 1 and September 16, 1980, at a fumarole associated with the debris avalanche that was formed by the eruption of May 18, 1980.

Kellman, Martin C., 1975, Plant geography: New York, St. Martin's Press, 135 pp.

Comments that the use of repeated photographs is difficult in areas of dense vegetation.

Kennan, T. C. D., 1972, The effects of fire on two vegetation types at Matopos, Rhodesia, in Fire in Africa, Tall Timbers Fire Ecology Conference, No. 11, Tallahassee, Florida, 1971, Proceedings: Tallahassee, Florida, Tall Timbers Research Station, pp. 53-98.

The effects of experimental burning of sites in areas known locally as Thornveld and Sandveld in the Matabeleland Province, Rhodesia, are illustrated with 11 pairs of matched photographs. The initial photographs were taken by Oliver West in October 1948, and the later photographs were taken from 1965 to 1970 variously by A. Stead and S. S. Daniels.

Kennedy, Michael P., 1973, Sea-cliff erosion at Sunset Cliffs, San Diego: California Geology, v. 26, no. 2, pp. 27-31.

Rates of marine erosion were determined by comparing two photographs (1905 and 1920) with photographs made from approximately the same locations in 1971 by W. P. Reetz.

Kerby, Gordon See Howard and Kerby (1983).

Kingsbury, Louise, 1981, Bridger-Teton's fire and habitat history--A photographic study: Forestry Research West, June, 1981, pp. 7-9.

Reviews the work of Gruell (1980a, 1980b) using three pairs of matched photographs as illustrations. The initial photographs were taken in 1878, 1887, and 1893, and the matched photographs were made in 1968, 1968, and 1969, respectively.

Kittams, Walter H., 1973, Effects of fire on vegetation of the Chihuahuan Desert region, in Tall Timbers Fire Ecology Conference, No. 12, Lubbock, Texas, 1972, Proceedings: Tallahassee, Florida, Tall Timbers Research Station, pp. 427-44.

The effects of fire on vegetation at Carlsbad Caverns National Park, New Mexico, are described, using as illustrations four pairs of matched photographs taken after fires that occurred between 1967 and 1971. Altogether, 10 fires were studied and photographed.

Klett, Mark See Rephotographic Survey Project (1979); Verburg and Klett (1978).

Klett, Mark, 1979, Subject, vantage point, viewpoint--Factors in rephotography: Exposure--The Quarterly Journal of the Society for Photographic Education, Fall 1979, pp. 49-55.

Discusses the importance of rephotography in terms of the light it sheds on the sensibilities of earlier photographers and the personal decisions that must be made in applying even the strictest of methodologies. Includes three pairs of matched photographs and two other nineteenth century views of the same sites.

Klett, Mark, Ellen Manchester, JoAnn Verburg, Gordon Bushaw, and Rick Dingus, 1984, Second view; The Rephotographic Survey Project, with an essay by Paul Berger: Albuquerque, The University of New Mexico Press, 224 pp.

The Rephotographic Survey Project was a three-year effort to locate and repeat photographs made in the western United States in the late nineteenth century by William Henry Jackson, Timothy O'Sullivan, J. K. Hillers, A. J. Russell, and Alexander Gardner. The text discusses the methodology, the problems encountered, and the aesthetic choices made by the original photographers. Includes 120 pairs of matched photographs, which reveal subtle, sometimes startling, geologic and environmental changes.

Knapman, Larry, 1982, Fireline reclamation on two fire sites in interior Alaska: U.S. Bureau of Land Management, Alaska Resource Manangement Note 1, 23 pp.

Uses approximately matched pairs and sets of photographs to show recovery along firelines in two forested areas 40 km north of Fairbanks, Alaska. All the photographs were taken between 1972 and 1979, many of them only a few months apart.

Knopf, Adolph See Longwell and others (1932).

Knutson, Paul L., 1979, Sand stabilization, Nauset Beach, Massachusetts, in Stephen P. Leatherman, ed., Environmental geologic guide to Cape Cod National Seashore: Amherst, Massachsusetts, University of Massachusetts National Park Service Cooperative Research Unit, pp. 141-54.

A pair of matched photographs (May 1973, October 1977) shows growth of beach grass in experimental plots.

Kockelman, William J. See Waananen and others (1977).

KOIN-TV Newsroom 6, Portland, Oregon See Palmer, L., and KOIN-TV Newsroom 6, Portland, Oregon (1980).

Komar, Paul D., 1976, Beach processes and sedimentation: Englewood Cliffs, New Jersey, Prentice-Hall, 429 pp.

Two pairs of photographs taken from ground level show coastal changes at San Diego, California (1946, 1968, both by Francis P. Shepard), and at East Anglia, England (1907, 1914, both by F. Jenkins).

Kovacs, Austin, 1970, Camp Century revisted, a pictorial view--June 1969: U.S. Army Corps of Engineers, Cold Regions Research and Engineering Laboratory Special Report 150, 53 pp.

This photographic essay of ice deformation of the buried camp complex at Camp Century, Greenland, which was constructed in 1959 and abandoned in 1966, includes five pairs of approximately matched photographs based on conditions in 1960 and 1962 and as seen again in 1969.

Kovacs, Austin, 1983, Shore ice ride-up and pile-up features. Part 1--Alaska's Beaufort Sea coast: U.S. Army Corps of Engineers, Cold Regions Research and Engineering Laboratory Report 83-9, 51 pp.

Appendix A gives two pairs of approximately matched photographs of a boulder rampart at the shore west of Konganevik Pt., which was formed by ice-shove and ride-up processes (1979, 1981).

Koyanagi, Robert Y. See Tilling and others (1976).

Krenetsky, John C. See Potter and Krenetsky (1967).

Krimmel, Robert M., and Austin Post, 1981, Oblique aerial photography, March-October 1980, in Peter W. Lipman and Donal R. Mullineaux, eds., The 1980 eruptions of Mount St. Helens, Washington: U.S. Geological Survey Professional Paper 1250, pp. 31-51.

Includes seven pairs of closely matched oblique aerial photographs of the volcano, all but one of which were taken with a standard large-format aerial camera on 241-mm (9 1/2 in.) roll film that provides more than 300 frames per roll. The single exception was taken by David Frank on March 24 using 57-mm film. Data for 30 rolls of film are listed in a table. The photographs can be purchased from the EROS Data Center, Sioux Falls, South Dakota, and can be seen at the U.S. Geological Survey offices in Tacoma and Vancouver, Washington.

Kuhn, G. G. See Emery and Kuhn (1980).

Kuhn, G. G., and F. P. Shepard, 1983, Beach processes and sea cliff erosion in San Diego County, California, in Paul D. Komar, ed., CRC handbook of coastal processes and erosion: Boca Raton, Florida, CRC Press, pp. 267-84.

Coastal changes are illustrated by three pairs of ground-level views taken by Kuhn as follows: collapse of the seawall and The Strand at Oceanside (September 1979, February 1980); damaged houses at Oceanside (January 1978, February 1980); and collapse of the sea cliff at Encinitas (February 1978, April 1978).

Kullman, Leif, 1979, Change and stability in the altitude of the birch tree-limit in the southern Swedish Scandes 1915-1975: Acta Phytogeographica Suecica, Uppsala, v. 65, 121 pp. (Ph.D. dissertation, Umea University, Sweden).

Vegetation changes at the upper tree limit of birch (Betula pubescens), caused primarily by colonization during a period of warmer and dryer weather that began in the 1930s, are shown in a pair of matched photographs (1929 and 1977) and in eight sets of photographs taken between 1969 and 1979. Establishment of seedlings stopped with the end of favorable climate in the 1950s.

Kullman, Leif, 1982, Tandövala--fjäll eller va(r)d? [Tandövala--a real barren hill or what?]: Svenska Botanisk Tidskrift, v. 76, pp. 185-96.

Tandövala is a representative hill east of the Scandes mountain chain, Sweden. Invasion of the hill by spruce (Picea abies), Scotch pine (Pinus sylvestris), and birch (Betula pubescens) is shown in three pairs of matched photographs: 1919 and 1974, 1919 and 1981, and 1919 and 1981. Captions for the photographs are in Swedish and English.

Kullman, Leif, 1983, Past and present tree-lines of different species in the Handölan Valley, central Sweden, in Pierre Morisset and Serge Payette, eds., Tree-line ecology, Proceedings of the Northern Québec Tree-Line Conference: Quebec, Université Laval, Centre d'Études Nordique, pp. 25-45.

Expansion of birch (Betula pubescens) on the east slope of Lillulvâjälet is shown by a pair of matched photographs taken on June 11, 1914, and June 10, 1981. Another pair of matched photographs taken on June 6, 1974, and July 22, 1981, shows the declining vitality of spruce (Picea abies) at tree-limit on the east slope of Storsnasen.

Kuntz, Mel A. See Rowley and others (1981).

Kyram, Dan See Schiller (1980).

La Baume, Jimmy T. See Cox and others (1983).

LaChapelle, Edward R. See Post and LaChapelle (1971).

Ladd, William S., and J. Monroe Thorington, 1924, A mountaineering journey to the Columbia Icefield: Canadian Alpine Journal, v. 14, pp. 34-47.

Includes a photograph of Saskatchewan Glacier, Alberta, taken by Thorington in 1923. According to William O. Field (personal communication, 1983), the photograph was taken from a site established by the Interprovincial Boundary Survey between Alberta and British Columbia, which was subsequently reoccupied in 1924, 1948, 1953, and 1963. See also Field (1949).

Lagasse, Peter F. See Love and others (1983).

Lagasse, Peter F., 1981, Geomorphic response of the Rio Grande to dam construction, in Stephen G. Wells and Wayne Lambert, eds., Environmental geology and hydrology in New Mexico: New Mexico Geological Society Special Publication No. 10, pp. 27-46.

Includes two pairs of approximately matched photographs that show coarsening of the surface bed material of the Rio Grande after closure of the Cochiti Dam. One pair (November 1973, October 1974) shows rapid development of an armor layer at a site immediately below the dam. The other (September 1973, February 1980) shows development of an extensive gravel layer at a site just below the Santo Domingo Bridge, nine miles downstream.

LaMarche, Valmore C., Jr. See Stewart and LaMarche (1967).

Lamb, H. H., 1982, Climate history and the modern world: New York, Methuen, 387 pp.

A panoramic watercolor of the Swiss Alps by Hans Conrad Escher, which shows several glaciers in 1820 (Epicoune, Otemma, Crete Sêche Fenêtre, Mont Durand, and La Tsessette), is compared with a 1974 panoramic photograph by W. Schneebeli. Also, a 1750 view of the Rhône Glacier by an unnamed artist is compared with a 1950 photograph.

Lambert, Wayne See Wells, S. G., and Lambert (1981).

Lambert, Wayne, 1981, Desertification monitoring using ground-based repeat photography: Geological Society of America, Cordilleran Section, 77th Annual Meeting, Hermosillo, Sonora, Mexico, March 25-27, Abstracts with Programs, v. 13, no. 2, p. 66 (abstract).

Indicators of desertification can be monitored by repeating old landscape photographs and by establishing new ground-based photographic stations, which can be reoccupied at intervals of from 1 to 10 years.

Lanner, Ronald M., 1981, The piñon pine; A natural and cultural history: Reno, The University of Nevada Press, 208 pp.

Includes a pair of matched photographs taken at Eureka, Nevada, in the early 1870s and in 1978, which shows an increase in the density of singleleaf pinyon pine.

Lausi, D., and E. Feoli, 1979, Hierarchical classification of European salt marsh vegetation based on numerical methods: Vegetatio (The Hague, Netherlands), v. 39, no. 3, pp. 171-84 (in English).

Repeated stereo color ground photography can be a useful method in permanent plot studies. It allows detailed measurements on important vegetation attributes and can reduce costly field work. Raw field data can be easily stored, and measurements can be repeated or taken at a later date. Trends can be easily illustrated. The discussion emphasizes a combination of aerial photography and ground photography. (From BIOSIS Previews.)

Laycock, William A., 1967, How heavy grazing and protection affect sagebrush-grass ranges: Journal of Range Management, v. 20, no. 4, pp. 206-13.

Matched photographs from two plots at the U.S. Sheep Experiment

Station in Idaho (1952, 1955, 1958, and 1964; 1952 and 1964) are used to compare vegetation changes resulting from heavy grazing in the spring and fall.

aycock, William A., 1975, Rangeland reference areas: Denver, Colorado, Society for Range Management, Range Science Series No. 3, 66 pp.

Four pairs of matched photographs illustrate the use of grazing exclosures, as follows: Buckhead Mesa exclosure, Tonto National Forest, Arizona (1945 and 1974); Cliff Lake Research Natural Area, Beaverhead National Forest, Montana (1945 and 1965); and Upper Bear Creek exclosure, Manti-LaSal National Forest, Utah (1932 and 1953; 1919 and 1953).

ekson, Stephen H., ed., 1983, The architecture and dendrochronology of Chetro Ketl, Chaco Canyon, New Mexico: Albuquerque, New Mexico, U.S. Department of the Interior, National Park Service, Chaco Center Report No. 6, 355 pp.

A pair of matched photographs (Pls. 1 and 2, Appendix D) shows the Chetro Ketl Indian ruin in 1893 and 1983.

eopold, Luna B., 1951, Vegetation of southwestern watersheds in the nineteenth century: Geographical Review, v. 41, no. 2, pp. 295-316.

Includes four examples from 59 pairs of matched photographs from northwest New Mexico and adjacent Arizona, covering the period from 1895 to 1946. Leopold concludes that the photographs show no appreciable long-term change in the development of grass and herbs and that the vegetative changes during the period were not great enough for the method of repeat photography to have much value.

e Roy Ladurie, Emmanuel, 1971, Times of feast, times of famine; A history of climate since the year 1000; translated by Barbara Bray: Garden City, New York, Doubleday & Company, 426 pp.

Climatic changes are deduced in part from changes in glaciers of the Alps. Thus, in Figures 12C-K, the terminus of Rhône Glacier, Switzerland, in 1777, 1794, and 1848, as painted and drawn by artists, is compared with engravings reproduced from photographs made in 1849 (daguerreotype), 1850 (probably a daguerreotype), 1870, 1874, 1899, and in the 1950s (photograph by Jules Geiger). In Plates 3-8, the terminus of the lower Grindelwald Glacier, Switzerland, in 1640, 1720 (drawing by F.

Meyer), 1748, and about 1775 to 1780 is compared with a 1966 photo
graph by Madeleine Le Roy Ladurie (M.L.R.L.). In Plates 9-12, th
Rhône Glacier in 1705, about 1720 (drawing by F. Meyer), and 177
(drawing by T. Bourrit) is compared with a photograph made in 1966 b
M.L.R.L. In Plates 15 and 16, Des Bois Glacier at Chamonix, France, a
painted in about 1800 to 1820, is compared with a 1966 photograph b
M.L.R.L. In Plates 19 and 20, the Argentière Glacier, France, as seen i
an engraving made in 1780 looking up the Chamonix Valley, is compare
with a 1966 photograph by M.L.R.L. Further, in Plates 21 and 22,
frontal view of the Argentière Glacier, as seen in an engraving mad
about 1850 to 1860, is compared with a 1966 photograph by M.L.R.L. I
Plates 23 and 24, Des Bossons Glacier, near Chamonix, as seen in a
engraving made about 1830 to 1850, is compared with a 1966 photograp
by M.L.R.L. In Plates 25 and 26, a 1767 drawing of La Brenva Glacie
on Mont Blanc, Italy, is compared with a 1966 photograph by M.L.R.L
In Plates 27 and 28, a view of the Allée Blanche Glacier, Italy, drawn b
E. Aubert in 1861, is compared with a 1966 photograph by M.L.R.L
Finally, in Plates 30 and 31, a 1781 engraving of La Mer de Glace nea
Chamonix, as seen from La Montenvers, is compared with a 1966 photo
graph by M.L.R.L.

Lewin, John, 1976, Initiation of bed forms and meanders in coarse-graine
sediment: Geological Society of America Bulletin, v. 87, no. 2, pp. 28
85.

Includes approximately matched photographs showing changes in th
River Ystwyth, Wales, as follows: a set of three photographs of a mear
dering channel (September 1969, November 22, 1969, and January
1970) and a pair of photographs of a gravel bar (February 25 and Marc
25, 1970).

Lewis, Roy R., III, 1982, Low marshes, peninsular Florida, in Roy R. Lew
III, ed., Creation and restoration of coastal plant communities: Boc
Raton, Florida, CRC Press, pp. 147-52.

A set of three approximately matched photographs taken in April 197
August 1978, and April 1979, shows growth of smooth cordgrass (Spa
tina alterniflora) planted in a tidal marsh covering 1.8 ha on Arch
Creek, Tampa, Florida. The marsh area had been formed by excavati
an upland site.

Likens, Gene E. See Bormann and Likens (1979).

Limerinos, J. T. See Waananen and others (1977).

Lindsey, Alton A., 1977, Time and the mountain: National Parks and
 Conservation Magazine, v. 51, no. 11, pp. 4-7.

 Changes in Mount Rainier National Park, Washington, caused by human
 impact (1933, 1974), erosion (1933, 1974), the 1947 mudflow on Kautz
 Creek (1935, 1974), and a fire in 1930 at Klapatche Point (1941, 1974)
 are shown in four pairs of matched photographs.

Lipman, Peter W. See Moore, J. G., and others (1981); Tilling and others
 (1976).

Lipman, Peter W., and Donal R. Mullineaux, eds., 1981, The 1980 eruptions
 of Mount St. Helens, Washington: U.S. Geological Survey Professional
 Paper 1250, 844 pp.

 The frontispiece is a pair of closely matched photographs showing the
 volcano before and after the eruption of May 18, 1980.

Litton, R. Burton, Jr. See Berntsen and others (1983).

Lobeck, A. K., 1939, Geomorphology, an introduction to the study of land-
 scapes: New York and London, McGraw-Hill, 731 pp.

 Includes a pair of approximately matched photographs (not at the same
 scale) of Indian Head at Fort Lee, New Jersey (1886, 1926), showing
 toppling of a basalt column in the Palisades but no significant differ-
 ences in weathering.

Lockett, H. C., 1939, Along the Beale Trail--A photographic account of
 wasted range land: U.S. Office of Indian Affairs, Education Division, 56
 pp.

 Includes 26 photographs taken in the 1930s along the trail followed in
 1857 and 1858 by Lt. Edward Fitzgerald Beale. The photographs are
 discussed in light of detailed statements on the vegetation and terrain
 in Beale's journal. Covers the route from McCartys, New Mexico, to
 Flagstaff, Arizona. This pamphlet, which was prepared primarily for use
 in Federal Indian Schools, is now rare.

Lockwood, John P. See Tilling and others (1976).

Lohman, Stanley W., 1974, The geologic story of Canyonlands National Park: U. S. Geological Survey Bulletin 1327, 126 pp.

Includes two of the 150 pairs of matched photographs (Bowknot Bend and Stillwater Canyon) made in 1968 by Hal G. Stephens and Eugene M Shoemaker of the 1871 Powell Expedition photographs. (Some of the negatives are in the U.S. Geological Survey Photographic Library in Denver, Colorado.)

Lohman, Stanley W., 1980, Bowknot Bend: Geotimes, v. 25, no. 3, cover illustration, caption on p. 3. Comments by David N. Gomberg, v. 25, no 6, p. 9; by James E. Fassett, v. 25, no. 7, p. 12; by John W. Mason, v. 25 no. 8, p. 10; reply by Lohman, v. 25, no. 9, p. 12; and further remarks by Lohman, v. 26, no. 1, pp. 10-11.

A photograph made by E. O. Beaman in 1871 on the Green River in Canyonlands National Park, Utah, is compared with a matched photograph made by Hal G. Stephens in 1968. Gomberg inquired about the location of Beaman's camera. Fassett pointed out the reports by Baars and Molenaar (1971) and Shoemaker and Stephens (1975). Mason asked about the change in vegetation. Lohman explained (v. 26) that the Stephens 1968 photographs, paired with those of Beaman and John K Hillers, are to be published by the Powell Society Limited of Denver in a report by E. M. Shoemaker and H. G. Stephens.

Longwell, Chester R., Adolph Knopf, and Richard F. Flint, 1932, A textbook of geology. Part I--Physical geology: New York, John Wiley and Sons 514 pp.

A pair of matched photographs (Figs. 25 and 26) shows Niagara Falls New York, before and after a large mass of rock fell on January 17 1931.

Loope, Lloyd L. See Gruell and Loope (1974).

Loope, Lloyd L., and George E. Gruell, 1973, The ecological role of fire in the Jackson Hole area, northwestern Wyoming: Quaternary Research, v 3, no. 3, pp. 425-43.

Two pairs of matched photographs spanning the period 1899 to 1971 emphasize vegetational changes associated with the establishment of aspen after a fire that took place in 1879.

Love, D. W. See Hawley and others (1983); Wells, S. G., and others (1983).

Love, D. W., S. G. Wells, J. L. Betancourt, S. A. Hall, and P. F. Lagasse, 1983, Third day road log; Road log from Visitor Center at Chaco Culture National Historical Park to Shabikeschee turn-around, Gallo Wash near Una Vida, Pueblo del Arroyo and picnic area near major ruins, in Stephen G. Wells, David W. Love, and Thomas W. Gardner, eds., Chaco Canyon country; A field guide to the geomorphology, Quaternary geology, paleoecology, and environmental geology of northwestern New Mexico: Albuquerque, New Mexico, American Geomorphological Field Group, 1983 Field Trip Guidebook, pp. 19-24.

A pair of matched photographs of Chaco Wash shows changes in the channel between November 1975, and July 1979. Direct comparison is difficult because the photographs are not at the same scale.

Lowe, Charles H., Jr. See Steenbergh and Lowe (1977, 1983).

Lowe, Charles H., Jr., 1958-1959, Contemporary biota of the Sonoran Desert--Problems: University of Arizona Arid Lands Colloquia, pp. 54-74.

Changes in vegetation are documented by a pair of matched photographs from the Pinecate region, Mexico (1907, 1959), and by a set of three matched photographs from Tumamoc Hill, southern Arizona (1906, 1928, and 1959).

Lowe, Charles H., Jr., John W. Wright, Charles J. Cole, and Robert L. Bezy, 1970, Natural hybridization between the Teiid lizards Cnemidophorus sonorae (parthenogenetic) and Cnemidophorus tigris (bisexual): Systematic Zoology, v. 19, no. 2, pp. 114-27.

A pair of matched photographs of Huerfano Butte in the Santa Rita Experimental Range, Arizona, shows an increase in shrubs and cactus and a decrease in grasses and forbs between about 1902 and 1969.

68 Lund

Lund, Steven W. See Trimble and Lund (1982).

Lyon, L. Jack See Berntsen and others (1983).

Lyon, L. Jack, 1971, Vegetal development following prescribed burning of Douglas fir in south-central Idaho: U.S. Department of Agriculture, Forest Service Research Paper INT-105, 30 pp.

Includes five sets of repeated photographs taken from 1963 to 1970 that illustrate the effects of prescribed burning as follows: a set of two photographs taken in 1963 before and after burning, followed by seven photographs taken at yearly intervals through 1970; and four sequences of three photographs taken in 1964, 1966, and 1970.

Lyon, L. Jack, 1976, Vegetal development on the Sleeping Child Burn in western Montana, 1961 to 1973: U.S. Department of Agriculture, Forest Service Research Paper INT-184, 24 pp.

Vegetation development on two sites, one with little herbaceous cover, the other with heavy cover, is shown in two sets of photographs (1962, 1963, 1965, 1967, 1969, 1971, and 1973).

Lyon, L. Jack, and Peter F. Stickney, 1976, Early vegetal succession following large Northern Rocky Mountain wildfires, in Tall Timbers Fire Ecology Conference, No. 14, Missoula, Montana, 1974, Proceedings: Tallahassee, Florida, Tall Timbers Research Station, pp. 355-75.

Sets of matched photographs of representative transects are used to evaluate recovery of vegetation after three large forest fires as follows: Sleeping Child fire, August 1961, Bitterroot National Forest (1962, 1963, 1964, 1967, 1969, and 1973); Neal Canyon fire, August 1963, Sawtooth National Forest (1964, 1965, 1966, 1967, 1969, 1972); and Sundance fire, September 1967, Kaniksu National Forest (1967, 1968, 1969, 1970, 1972, 1974).

Macleod, Norman S. See Rowley and others (1981).

Magill, Arthur W., and R. H. Twiss, 1965, A guide for recording aesthetic and biologic changes with photographs: U.S. Department of Agriculture, Forest Service Research Note PSW-77, 8 pp.

Recommends repeating photographs every five years or even more frequently and describes a system for permanently marking the camera station; recording changes; and filing the photographs, negatives, and records. Includes as an example an approximately matched pair of photographs taken in 1954 and 1964, which shows changes at an unnamed campground.

Major, Jack See Vankat and Major (1978).

Major, Jack, 1974, Kinds and rates of changes in vegetation and chronofunctions, in R. Knapp, ed., Vegetation dynamics. Handbook of Vegetation Science 8: The Hague, Dr. W. Junk, pp. 7-18.

Cites 10 studies in which matched photographs are used to document plant succession.

Malde, Harold E., 1973, Geologic bench marks by terrestrial photography: U.S. Geological Survey Journal of Research, v. 1, no. 2, pp. 193-206.

Gives detailed instructions for finding an unmarked photographic site, recording the new photographic data, and marking the site. Describes a method by which the focal length of a camera can be accurately determined, and discusses the value of stereophotography for making subsequent photogrammetric measurements of changes in landscapes when the focal length of the camera and the separation of the stereo images are known. Includes two pairs of matched photographs (1915 by Nelson H. Darton, 1970) from sites near Santa Fe, New Mexico, and matched stereo images that show the effect of a flood in 1971.

Malde, Harold E., 1983, Panoramic photographs: American Scientist, v. 71, no. 2, pp. 132-40.

Includes a photographic mosaic covering a horizontal angle of 180 degrees, which closely matches a panoramic sketch made of the Pikes Peak area, Colorado, by William Henry Holmes in 1874.

Malde, Harold E., and Arthur G. Scott, 1977, Observations of contemporary arroyo cutting near Santa Fe, New Mexico, U.S.A.: Earth Surface Processes, v. 2, no. 1, pp. 39-54.

Changes in the positions of headwalls of two arroyos between 1971 and

1974 are shown by lines traced from initial photographs on matched subsequent photographs.

Manchester, Ellen See Klett and others (1984); Rephotographic Survey Project (1979).

Martin, Lawrence See Tarr and Martin (1914).

Martin, S. Clark See Parker and Martin (1952); Reynolds and Martin (1968); Tschirley and Martin (1961); Turner, R. M., Applegate, Bergthold, Gallizioli, and Martin (1980).

Martin, S. Clark, 1964, Some factors affecting vegetation changes on a semi-desert grass-shrub cattle range in Arizona: Tucson, University of Arizona, Ph.D. dissertation, 122 pp.

Vegetation changes on the Santa Rita Experimental Range are documented by a pair of closely matched photographs (1903, 1964).

Martin, S. Clark, 1966, The Santa Rita Experimental Range--A center for research on improvement and management of semidesert rangelands: U.S. Department of Agriculture, Forest Service Research Paper RM-22, 24 pp.

Several kinds of vegetational change related to natural factors and management practices are shown by two pairs of matched photographs (1903 and 1964, 1960 and 1964), by three sets of three matched photographs (1959 to 1963, 1959 to 1963, and 1905 to 1962), and by a set of four matched photographs (1920 to 1962).

Martin, S. Clark, 1968, Improving semidesert ranges in southern Arizona, U.S.A., by grazing management and shrub control: The Arid Zone Research Association of India, Jodhpur, Annals of the Arid Zone, v. 7, no. 2, pp. 235-42.

Aspects of vegetational changes on the Santa Rita Experimental Range induced by grazing management and shrub control are shown by two sets of three matched photographs (1919, 1935, and 1958; 1919, 1948, and 1962).

Martin, S. Clark, 1975, Ecology and management of southwestern semi-desert grass-shrub ranges--The status of our knowledge: U.S. Department of Agriculture, Forest Service Research Paper RM-156, 39 pp.

Several pairs of matched photographs and sets of three matched photographs, six altogether, which were taken at various times between 1921 and 1965, show short-term and long-term vegetational changes.

Martin, S. Clark, and Dwight R. Cable, 1974, Managing semidesert grass-shrub ranges--Vegetation responses to precipitation, grazing, soil texture, and mesquite control: U.S. Department of Agriculture, Forest Service Technical Bulletin No. 1480, 45 pp.

Various aspects of vegetational change on the Santa Rita Experimental Range, Arizona, are shown by two pairs of matched photographs and by a set of three matched photographs.

Martin, S. Clark, and Howard L. Morton, 1980, Responses of falsemesquite, native grasses and forbs, and Lehmann lovegrass after spraying with Picloram: Journal of Range Management, v. 33, no. 2, pp. 104-6.

A pair of matched photographs (1973, 1977) shows vegetation change in the grass-shrub community at the Santa Rita Experimental Range, Arizona, after herbicide treatment.

Martin, S. Clark, John L. Thames, and Ernest B. Fish, 1974, Changes in cactus numbers and herbage production after chaining and mesquite control: Progressive Agriculture in Arizona, v. 26, no. 6, pp. 3-6.

Changes in the population of Opuntia fulgida (jumping cholla) at the Santa Rita Experimental Range, Arizona, from 1905 to 1962 are shown by a set of three matched photographs. A pair of photographs (1970, 1974) shows the response of the same cactus to its mechanical removal.

Martin, S. Clark, and Fred H. Tschirley, 1969, Changes in cactus numbers after cabling: Progressive Agriculture in Arizona, v. 21, no. 1, pp. 16-17.

A set of three matched photographs (January 1961, March 1961, and January 1966) shows vegetation changes after mechanical removal of Opuntia fulgida (jumping cholla) at the Santa Rita Experimental Range, Arizona. Jumping cholla knocked down by a tractor-drawn chain did not

recover. Also, a pair of matched photographs at a nearby undisturbed site (January 1961, January 1966) shows a natural decline in jumping cholla.

Martin, S. Clark, and Raymond M. Turner, 1977, Vegetation change in the Sonoran Desert region, Arizona and Sonora: Journal of the Arizona Academy of Science, v. 12, no. 2, pp. 59-69.

The argument that natural as well as man-made causes may be responsible for changes in vegetation that have occurred in the Southwest is supported by three groups of matched photographs, as follows: the Santa Rita Experimental Range, southern Arizona (1922, 1935, 1947, 1958, 1969, and 1975; 1905, 1941, 1962, and 1975; 1903, 1941, and 1975; and 1919, 1951, and 1975); the Pinacate Region, northern Sonora, Mexico (1907, 1959, and 1970); and Tumamoc Hill, Tucson, Arizona (1906, 1928, 1959, 1968, and 1975).

Martinson, Holly A. See Janda and others (1981).

Mason, John W. See Lohman (1980).

Matthews, Samuel W., 1976, What's happening to our climate?: National Geographic Magazine, v. 150, no. 5, pp. 576-615.

Includes a set of matched photographs showing progressive retreat of the glaciers Hintereisferner and Kesselwandferner in the Austrian Alps (1903, 1929, 1940, and 1956).

Mayo, Lawrence R. See Post and Mayo (1971).

McClane, Alvin R. See Hattori and McClane (1980).

McDougall, Angus See Hurley and McDougall (1971).

McEwen, Lowell C. See Dietz, D. R., and others (1980).

McLeod, D., 1967, The high country, then and now: Tussock Grasslands and

Mountain Lands Review, v. 13, pp. 18-23.

Comparisons of matched photographs show the degree of change in ground cover in the high country of South Island, New Zealand, as follows: Craigieburn Creek (1904, 1966 by John Harrison); Cora Lynn (1890 by John Beaumont, 1951 by R. D. Dick); and Craigieburn Stables (1904, 1966 by John Harrison). There is no text.

McQuaid, James, ed., 1982, An index to American photographic collections: Boston, Massachusetts, G. K. Hall, 407 pp.

Describes 458 photographic collections in museums, libraries, and other archives, most of them itemized under the names of more than 19,000 photographers.

Mehringer, Peter J. See Peterson, K. L., and Mehringer (1976).

Meier, Mark F., and Austin Post, 1980, G. K. Gilbert and the great iceberg-calving glaciers of Alaska, in Ellis L. Yochelson, ed., The scientific ideas of G. K. Gilbert: Geological Society of America Special Paper 183, pp. 115-23.

Points out the importance of maps, photographs, and descriptions of glaciers by Grove Karl Gilbert, which Gilbert intended to be used by later observers to measure changes. The discussion is focused on Columbia Glacier. In particular, many of Gilbert's photographic and mapping stations have since been reoccupied several times. Two of Gilbert's photographs of 1899 are reproduced. Gilbert's contributions to the physics of glaciers are also discussed.

Mesirow, Lynne E. See Schneider with Mesirow (1976).

Messner, Harold E. See Dietz, D. R., and others (1980).

Miller, Don See Cohen and Miller (1978).

Miller, Reuben F. See Branson and Miller (1981).

Minnich, Richard A., 1980, Vegetation of Santa Cruz and Santa Catalina islands, in Dennis M. Power, ed., The California islands: Proceedings of a multidisciplinary sysposium: Santa Barbara, California, Santa Barbara Museum of Natural History, pp. 123-37.

Vegetation changes on Mount Black Jack, Santa Catalina Island, are shown in a pair of approximately matched photographs taken in the 1880s and 1978(?).

Mitchell, R. J. See Williams, D. R., and others (1979).

Molenaar, C. M. See Baars and Molenaar (1971).

Mono Lake Committee See Gaines and the Mono Lake Committee (1981).

Mono Lake Committee, 1982, Mono Lake; Endangered oasis. Position Paper of the Mono Lake Committee: Lee Vining, California, Mono Lake Committee, 28 pp.

Includes a set of approximately matched photographs (1962 and 1968 by Eban McMillan, and 1978 by David Gaines) showing how two tufa towers became progressively high and dry when water diversions caused Mono Lake to fall 46 feet. Also, a pair of matched photographs by Viki Lang and David Gaines shows the effect of wind on the dry lake bed.

Mooney, Harold A., 1977, Southern coastal scrub, in Michael G. Barbour and Jack Major, eds., Terrestrial vegetation of California: New York, John Wiley and Sons, pp. 471-89.

Includes a pair of matched photographs (1931, 1972) of chaparral vegetation in San Diego County, California, from Bradbury (1974).

Moore, James G. See Richter and others (1964); Tilling and others (1976).

Moore, James G., and William C. Albee, 1981, Topographic and structural changes, March-July 1980--Photogrammetric data, in Peter W. Lipman and Donal R. Mullineaux, eds., The 1980 eruptions of Mount St. Helens, Washington: U.S. Geological Survey Professional Paper 1250, pp. 123-34.

Describes and illustrates a method of analyzing changes produced by the eruption of May 18, 1980, in which ground-level photographs are compared with computer-generated perspective models of preeruption and posteruption digitized maps as viewed from the camera stations. "This new technique permits reliable estimation of the elevation and position of features visible in the photographs."

Moore, James G., and Wayne U. Ault, 1965, Historic littoral cones in Hawaii: Pacific Science, v. 19, no. 1, pp. 3-11.

Includes a photograph of the littoral cone that formed as the 1868 Mauna Loa flow entered the sea, taken by Harold T. Stearns and William O. Clark in 1924, and a comparable photograph of the cone taken by the authors in 1962.

Moore, James G., Peter W. Lipman, Donald A. Swanson, and Tau Rho Alpha, 1981, Growth of lava domes in the crater, June 1980-January 1981, in Peter W. Lipman and Donal R. Mullineaux, eds., The 1980 eruptions of Mount St. Helens, Washington: U.S. Geological Survey Professional Paper 1250, pp. 541-47.

Includes six perspective drawings of the summit and amphitheater reproduced from matched oblique aerial photographs taken from a helicopter.

Moore, Lucy B., 1976, The changing vegetation of Molesworth Station, New Zealand, 1944-1971: New Zealand Department of Science and Industrial Research Bulletin 217, 118 pp.

Molesworth Station is an experimental range of 183,000 hectares on New Zealand's South Island. Matched photographs taken from some of the 120 photographic sites on the station are given, along with quantitative data, in order to document the vegetational changes since management practices were fundamentally altered in 1938.

Morisawa, Marie, 1975, Tectonics and geomorphic models, in Wilton N. Melham and Ronald C. Flemal, eds., Theories of landform development: Binghamton, New York, State University of New York, Publications in Geomorphology, pp. 199-216.

A set of three matched photographs taken one month, two years, and four years after the Hebgen Earthquake of August 1959, near West

Yellowstone, Montana, shows changes in a fault scarp at Cabin Creek Campground. Knickpoint changes on Cabin Creek and Red Canyon Creek are shown in two pairs of matched photographs (September 1959 and July 1960; and 1960 and 1969, respectively).

Morris, John G., 1983, A century old; The wonderful Brooklyn Bridge: National Geographic Magazine, v. 163, no. 5, pp. 565-79.

Includes a reduced reproduction of a seven-foot panorama assembled from five views of lower Manhattan, New York, taken by Joshua H. Beal from the bridge's Brooklyn tower in 1876, and a matched panorama taken in 1982 by Donal F. Holway. Some of the conspicuous changes in the famous skyline along the East River are pointed out with marginal leaders.

Morris, William G., and Edwin L. Mowat, 1958, Some effects of thinning a ponderosa pine thicket with prescribed fire: Journal of Forestry, v. 56, no. 3, pp. 203-9.

Describes effects of prescribed burning of a dense stand of ponderosa saplings on the Colville Indian Reservation, Washington, during the next six growing seasons, using as one of the illustrations a pair of matched photographs (1942, 1950).

Morton, Howard L. See Cox and others (1983); Martin, S. C., and Morton (1980).

Mosley, M. P. 1978, Erosion of the south-eastern Ruahine Range; Its implications for downstream river control: New Zealand Journal of Forestry, v. 23, pp. 21-48.

Discusses increased erosion since about 1936 in Ruahine State Forest Park, North Island, New Zealand, giving as illustrations a pair of matched photographs of Kumeti Stream (1936, 1977) and a pair of vertical aerial photographs of the Kumeti catchment (1946, 1974). The above-average erosion was associated with deterioration of vegetation and a build-up of the animal population, but is attributed more probably to increased storminess.

Mourant, Walter A., 1980, Hydrologic maps and data for Santa Fe County, New Mexico: New Mexico State Engineer, Basic Data report, 180 pp.

The cover has a pair of matched photographs of Santa Fe (1891, Museum of New Mexico, and 1980 by the author) showing the growth in the urban area.

Mowat, Edwin L. See Morris, W. G., and Mowat (1958).

Mueggler, W. F., and D. L. Bartos, 1977, Grindstone Flat and Big Flat exclosures--A 41-year record of changes in clearcut aspen communities: U.S. Department of Agriculture, Forest Service Research Paper INT-195, 16 pp.

Includes two pairs of matched photographs (1942, 1975) showing changes in grazing exclosures on Beaver Mountain, Utah.

Mullineaux, Donal R. See Lipman and Mullineaux (1981).

Murdock, J. R., and S. L. Welsh, 1971, Land use in Wah Wah and Pine Valleys, western Utah: Brigham Young University Science Bulletin, Biological Series, v. 12, no. 4, pp. 1-25.

A pair of matched photographs taken in 1909 and 1959 shows the demise of the town of State Line (Iron County, Utah) and an increase in pinyon and juniper.

Naef, Weston J., and James N. Wood, 1975, Era of exploration; The rise of landscape photography in the American West, 1860-1885: Boston, New York Graphic Society, 260 pp.

This review of the role of photography in exploration of the West features the photographs of Carleton E. Watkins, Timothy H. O'Sullivan, Eadweard J. Muybridge, Andrew Joseph Russell, and William Henry Jackson. For comparison, several similar views taken in Yosemite Valley by various photographers are reproduced and discussed as follows: El Capitan (Charles L. Weed, 1865; Watkins, before 1866; and Muybridge, 1867), Yosemite Valley from the Mariposa Trail (Weed, 1885; and Watkins, 1866), the Lyell Group and Yosemite Falls from Sentinel Dome (Muybridge, 1867; and Watkins, 1866), Agassiz Rock (Thomas Houseworth and Co., publishers, 1867; Watkins, 1874; and Muybridge, 1872), and Half Dome from Glacier Point (Watkins, 1866; and Muybridge, 1867).

78 Nakata

Nakata, John K. See Wilshire and others (1981).

Nakata, John K., 1983, Off-road vehicular destabilization of hill slopes; The major contributing factor to destructive debris flows in Ogden, Utah, 1979, in Robert H. Webb and Howard G. Wilshire, eds., Environmental effects of off-road vehicles; Impacts and management in arid regions: New York, Springer-Verlag, pp. 343-53.

A pair of approximately matched, undated photographs shows erosion produced by a diverted canal.

Nevada River Basin Survey Staff, 1969, Water and related land resources, central Lahontan basin, Walker River Subdivision, Nevada-California: Carson City, Nevada, U.S. Department of Agriculture, 232 pp.

Growth of sagebrush at the townsite of Aurora, Nevada, from just before 1900 to 1967 is documented by a pair of matched photographs.

Newman, Evelyn B. See Webb, R. H., and Newman (1982).

Niering, William A., 1975, Naturalistic landscaping in the Connecticut Arboretum, in William A. Niering and Richard H. Goodwin, eds., Energy conservation on the home grounds: Connecticut College, Connecticut Arboretum Bulletin 21, pp. 12-15.

A sequence of four matched photographs shows changes in vegetation between 1953 and 1967 in an area used to demonstrate naturalistic landscaping.

Niering, William A., 1982, The conservation and research programs, in The Connecticut Arboretum; Its first fifty years: Connecticut College, Connecticut Arboretum Bulletin 28, pp. 32-44.

Vegetational changes over a period of 24 years are shown by a pair of matched photographs.

Nilsson, Christer See Grelsson and Nilsson (1982).

Noble, I. R., 1977, Long-term biomass dynamics in an arid chenopod shrub

community at Koonamore, South Australia: Australian Journal of Botany, v. 25, no. 6, pp. 639-53.

Gives a method for estimating plant biomass from photographs taken at long-term photographic stations. Photographic examples are shown. See also Crisp (1978).

Noble, I. R., and M. D. Crisp, 1980, Germination and growth models of short-lived grass and forb populations based on long term photo-point data at Koonamore, South Australia: Israel Journal of Botany, v. 28, nos. 3-4, pp. 195-210.

Photographs repeated almost yearly between 1925 and 1956 are used to determine ephemeral germination events and biomass changes. A model is then constructed that incorporates daily rainfall, mean annual air temperature, and annual potential evapotranspiration to predict germination events.

Nolan, K. Michael See Janda and others (1981).

Notarianni, Philip F., 1982, Faith, hope, and prosperity; The Tintic mining district: Eureka, Utah, Tintic Historical Society, 190 pp.

This historical account of the birth and development of the Tintic mining district, Utah, is profusely illustrated with historical and recent photographs. Most of the recent photographs are in an epilogue by Gary B. Peterson, which includes three pairs of approximately matched photographs of the town of Eureka, taken first between 1910 and 1920 and then by Peterson in 1982. Another pair of matched photographs in chapter 3 shows further aspects of historical change between the 1920s and 1982.

Ohmart, Robert D., Wayne O. Deason, and Constance Burke, 1977, A riparian case history; The Colorado River, in R. Roy Johnson and Dale R. Jones, eds., Importance, preservation, and management of riparian habitats--A symposium: U.S. Department of Agriculture, Forest Service General Technical Report RM-43, pp. 35-47.

One pair of oblique aerial photographs (1945, 1976) and a pair of ground-level photographs (1894, 1976) show changes in the channel and the vegetation on the lower Colorado River above Yuma, Arizona.

O'Laughlin, C. L., 1969, Streambed investigations in a small mountain catchment: New Zealand Journal of Geology and Geophysics, v. 12, no. 4, pp. 684-706.

Includes a pair of matched photographs of the lower reach of Centre Creek in the Rakaia drainage basin, South Island, New Zealand, showing changes produced by a flood in November 1967.

Olin, George See Turner, R. M., Alcorn, and Olin (1969).

Osborn, T. G. B., J. G. Wood, and T. B. Paltridge, 1935, On the climate and vegetation of Koonamore Vegetation Reserve to 1931: Proceedings of the Linnean Society of New South Wales, v. 60, pts. 5-6, pp. 392-427.

Vegetation changes on this reserve in the North-East District of South Australia from 1926 to 1931 are shown in five sets of from 4 to 8 matched photographs.

Ostaficzuk, Stanislaw, 1968, Reconstruction of phototheodolite-camera stations in taking repeated photo records (Rekonstruktion der Photo-theodolit-Standorte bei der Herstellung von in Bestimmten Zeitabstaen-den Wiederholten Augnahmen. Jena. 1968, p. 284-291): U.S. Department of Commerce, National Technical Information Service Document AD-844 490/3ST, 12 pp. (English translation.)

A method is described for finding the unknown camera station of a present mapping photo. This method is based on the comparison of directions, measured in the field, which are aimed at salient points, with the corresponding directions taken from the present mapping photo. The station is determined in a step-by-step approach. The method has been applied to reascertain stations for carrying out time-based measurements (Author). (From NTIS.)

Osterwald, Frank W. See Dunrud and Osterwald (1980).

Ostroff, Eugene, 1981, Western views and Eastern visions: Washington, D.C., Smithsonian Institution, 118 pp.

Analyzes the role of photography in exploration of the West, primarily during the territorial surveys of Clarence King, Ferdinand Vandiveer Hayden, John Wesley Powell, and Lt. George M. Wheeler. Many compar-

isons are made between photographs and their published reproductions in toned lithographs and wood engravings. Comparisons are also made with related stereographic views and with artists' renditions of the same subjects. A few of the reproductions reprinted here are from Albertype photomechanical prints or from heliotypes, both of which reverse the photographic image. The comparisons provide a basis for assessing the accuracy of details in lithographs, engravings, or drawings, when based on early photographs.

Packer, Paul E. See Berntsen and others (1983).

Palmer, Howard, 1924, The Freshfield Glacier, Canadian Rockies: Smithsonian Miscellaneous Collections, v. 76, no. 11, (publication 2757), pp. 1-16.

The author surveyed the terminus of Freshfield Glacier, Alberta, in 1922 and established several stations for observing future changes in its position. Photographs from two of these stations are given, including a pair of matched photographs taken 20 years apart (1902 by Hermann Woolley, and 1922 by J. Monroe Thorington). Matched photographs from the other station (1937 by Thorington, and 1953 by William O. Field) are given by Field and Heusser (1954).

Palmer, Leonard, and KOIN-TV Newsroom 6, Portland, Oregon, 1980, Mt. St. Helens; The volcano explodes!: Portland(?), Oregon, Northwest Illustrated, 119 pp.

Includes the series of matched photographs of the eruption of Mount St. Helens, Washington, May 18, 1980, taken by Gary Rosenquist, as reproduced also in Foxworthy and Hill (1982) and Voight (1981). Several sequences of closely related oblique aerial views are also shown.

Paltridge, T. B. See Osborn and others (1935).

Parker, Kenneth W., and S. Clark Martin, 1952, The mesquite problem on southern Arizona ranges: U.S. Department of Agriculture, Forest Service, Southwest Forest and Range Experiment Station Circular No. 908, 70 pp.

Vegetational changes with and without various experimental treatments are shown in six pairs of matched photographs taken between 1902 and

1946, which span intervals ranging from five months to 38 years. The emphasis is on the Santa Rita Experimental Range, southern Arizona.

Parkes, Don, and Nigel Thrift, 1980, Times, spaces, and places, a chrono-geographic perspective: New York, John Wiley & Sons, 527 pp.

Three pairs of matched photographs and a set of three matched photographs show changes in urban settings in England. The set of three photographs compares the previous century with views in 1910 and 1969.

Patton, Peter C., and Stanley A. Schumm, 1981, Ephemeral-stream processes; Implications for studies of Quaternary valley fills: Quaternary Research, v. 15, no. 1, pp. 24-43.

A pair of matched photographs at a cross section on Sand Creek, Sioux County, Nebraska, shows that 2 m of sediment was deposited in the channel bed between 1957 and 1971.

Pearson, G. A., 1950, Management of ponderosa pine in the southwest: U.S. Department of Agriculture Monograph 6, 218 pp.

Changes in a pine forest are shown by five pairs of matched photographs taken between 1909 and 1941. Two other pairs of photographs, one only approximately matched, also show changes in pine forests.

Perroud, P. See Bauer and others (1968).

Peterson, Donald W. See Holcomb and others (1974); Swanson and others (1972, 1979); Swanson and Peterson (1972).

Peterson, Kenneth Lee, 1981, 10,000 years of climatic change reconstructed from fossil pollen, La Plata Mountains, southwestern Colorado: Pullman, Washington State University, Ph.D. dissertation, 197 pp.

Two approximately matched pairs of photographs and a third closely matched pair show changes in timberline in the Cumberland Basin, Colorado, between 1897 and 1978.

Peterson, Kenneth L., and Peter J. Mehringer, 1976, Postglacial timberline

fluctuations, La Plata Mountains, southwestern Colorado: Arctic and Alpine Research, v. 8, no. 3, pp. 275-88.

Vegetation changes shown by a pair of matched photographs (1894, 1974) of La Plata City, Colorado, are accurately reflected by pollen types trapped in the upper part of a peat deposit in a nearby lake.

Pettersson, Bengt, 1958, Dynamik och konstans I Gotlands flora och vegetation: Acta Phytogeographica Suecica, v. 40, pp. 1-288.

Includes 45 pairs of matched photographs from Gotland, Sweden, ranging from less than 1 to 50 years apart, which show changes in the vegetation.

Philbrick, R. N., 1972, The plants of Santa Barbara Island, California: Madrono, v. 21, no. 5, pt. 2, pp. 329-93.

Three sets of matched photographs show vegetation changes between 1939 and 1970 that were caused by the introducion of rabbits and by the expansion of introduced plants.

Phillips, Walter S., 1963, Photographic documentation, vegetational changes in northern Great Plains: University of Arizona, Agricultural Experiment Station Report 214, 185 pp.

Includes 163 pairs of matched photographs based on the records and photographs of Homer LeRoy Shantz for the period from 1908 to 1931. Phillips repeated the photographs in 1958 and 1959 but gives little discussion of the causes for the observed changes.

Pickle, John See Wells, S. G., and others (1983).

Pierson, T. C., 1980, Debris flows; An important process in high country gully erosion: Review 39, Journal of the Tussock Grasslands and Mountain Lands Institute, December 1980 issue, pp. 3-14 (New Zealand Forest Service reprint 1360).

This discussion of debris flows on steep hillslopes in South Island, New Zealand, includes a pair of matched photographs of Mt. Thomas (1947, 1979) and a set of three approximately matched photographs by B. Fields of a gully on the Liebig Range (1975, 1976, 1980).

Pond, Floyd W., 1971, Chaparral; 47 years later: U.S. Department of Agriculture, Forest Service Research Paper RM-69, 11 pp.

The longevity of chaparral plant species in the Sierra Ancha Experimental Forest, Arizona, is examined by using several series of repeated photographs taken between 1920 and 1967. The photographs are mainly close-up views of individual plants.

Post, Austin S. See Brugman and Post (1981); Frank and others (1975); Krimmel and Post (1981); Meier and Post (1980).

Post, Austin S., 1965, Alaskan glaciers; Recent observations in respect to earthquake-advance theory: Science, v. 148, no. 3668, pp. 366-68.

Includes a pair of closely matched oblique aerial photographs of Sherman Glacier (1963, 1964) showing a rock slide produced by the 1964 Alaskan earthquake. See also Post (1967).

Post, Austin S., 1966, Recent surge of Walsh Glacier, Yukon and Alaska: Journal of Glaciology, v. 6, no. 45, pp. 375-81.

Approximately matched oblique aerial photographs show effects of surge in the central section of Walsh Glacier and its east branch between August 1960 and August 1965.

Post, Austin S., 1967, Effects of the March 1964 Alaska earthquake on glaciers: U.S. Geological Survey Professional Paper 544-D, 42 pp.

Approximately matched oblique aerial photographs show conditions before and after the earthquake for Sherman Glacier (1963, 1964), Schwan Glacier (1963, 1964), Sioux Glacier (1963, 1964), Saddlebag Glacier (1963, 1965), and Childs Glacier (1963, 1965).

Post, Austin S., 1969, Distribution of surging glaciers in western North America: Journal of Glaciology, v. 8, no. 53, pp. 229-40.

Closely matched oblique aerial photographs show surges of Variegated Glacier, Alaska (1964, 1965) and Nesham Glacier, Yukon Territory (1961, 1963).

Post, Austin S., 1972, Periodic surge origin of folded medial moraines on Bering piedmont glacier, Alaska: Journal of Glaciology, v. 11, no. 62, pp. 219-26.

Vertical aerial photographs taken before and after recent surges establish the direction and magnitude of ice flow. This report has two individual oblique aerial views showing parts of Bering Glacier.

Post, Austin S., 1975, Preliminary hydrography and historic terminal changes of Columbia Glacier, Alaska: U.S. Geological Survey Hydrologic Investigations Atlas HA-559.

Changes in the terminus and the rate of flow are shown by repeated matching oblique and vertical aerial photographs dating from 1938 to 1974. Also, changes in the glacier margin and vegetation on Heather Island are shown by ground photographs (1910, 1974).

Post, Austin S., and Edward R. LaChapelle, 1971, Glacier ice: Seattle, University of Washington Press, 111 pp.

This photographic atlas of representative glaciers includes several matched (and approximately matched) photographs as follows: Figure 27, three ground-level views of Blue Glacier, Olympic Mountains, Washington, showing glacier flow over a period of two and a half months, year not specified, by LaChapelle; Figure 40, two ground-level views of South Mowich Glacier, Mount Rainier, Washington (1960, 1962, both by Post); Figure 41, two ground-level views of "Spillway Glacier," Washington (1959, 1960, both by Post); Figure 42, three ground-level views of Aiguille d'Argentière, France (1899 by M. Roch, 1942 by A. Roch, 1958 by Erich Vanis); Figure 59, two similar oblique aerial views of Susitna Glacier, Alaska (1941 by Bradford Washburn, 1966 by Post), showing changes in looped and folded medial moraines, partly caused by a surge in 1952; Figure 70, two oblique aerial views of Gerstle Glacier, Alaska, taken in 1960 and 1961, both by Post, to show the annual periodicity of ogives; and Figure 94, two oblique aerial views showing tidewater recession of Guyot Glacier, Alaska (1938 by Bradford Washburn, 1963 by Post).

Post, Austin S., and Lawrence R. Mayo, 1971, Glacier dammed lakes and outburst floods in Alaska: U.S. Geological Survey Hydrologic Investigations Atlas HA-455.

This study was made possible by aerial photography. Of 15,000 aerial

photographs taken by Post between 1960 and 1970, 800 were used, together with photographs by A. W. Balvin (1963), Bradford Washburn (1934, 1942), U.S. Air Force (1942 to 1948), U.S. Navy (1929, 1948, 1957), and U.S. Geological Survey (1950 to 1962). Approximately matched photographs are shown for Tikke Glacier (1965, 1966), Redoubt Volcano (1963, 1966), the bridge at Sheep Creek east of Valdez (date unknown, 1945), and the bridge across Nizina River near McCarthy (1933, 1934).

Potter, Loren D., and John C. Krenetsky, 1967, Plant succession with released grazing on New Mexico range lands: Journal of Range Management, v. 20, no. 3, pp. 145-51.

Eight pairs of matched photographs are used to compare vegetation changes from 1939 to 1965 on grazed and ungrazed areas. The areas shown are in mountain grassland, desert grassland, the pinyon-juniper vegetation type, and the aspen community.

Poulin, Ambrose O. See Corte and Poulin (1972).

Poulin, Ambrose O., 1962, Measurement of frost formed soil patterns using airphoto techniques: Photogrammetric Engineering, v. 28, no. 1, pp. 141-47.

Describes a photogrammetric method for making topographic maps of patterned ground in Northwest Greenland and the Colorado Rockies at a scale of 1 to 4 and a contour interval of 0.02 foot, using vertical photographs taken with a modified aerial mapping camera from scafolding 10 to 20 feet above ground. Repeated annually, movement of soil particles during freezing and thawing can be measured with an accuracy of 2 to 3 mm. In Greenland, three plots were mapped by this method in 1959, 1960, and 1961. The design of a stable control point in permafrost is also described.

Press, Frank, and Raymond Siever, 1982, Earth (3d ed.): San Francisco, W. H. Freeman, 613 pp.

Figure 2-4 is a pair of matched photographs of Bowknot Bend on the Green River, Utah, taken by E. O. Beaman in 1871 and repeated in 1968 by H. G. Stephens. See also Lohman (1980).

Progulske, Donald R., with photography by Richard H. Sowell, 1974, Yellow

ore, yellow hair, yellow pine--A photographic study of a century of forest ecology: South Dakota State University, Agricultural Experiment Station Bulletin 616, 169 pp.

Gives 42 pairs of matched photographs based on the photographs made by William H. Illingworth during the 1874 Black Hills Expedition of General George Armstrong Custer.

Progulske, Donald R., and F. J. Shideler, n.d., Following Custer: South Dakota State University, Agricultural Experiment Station Bulletin 674, 139 pp.

Contains maps and aerial photographs of the route of the 1874 Black Hills Expedition of General George Armstrong Custer. The report and its appendix include 25 pairs of the matched photographs first published by Progulske (with Sowell) (1974).

Rabson, Diane M., 1983, Forty years of change; Contrasting images of lower downtown Denver: Colorado Heritage, Issue 4, pp. 36-47.

Gives 10 pairs of matched photographs of the business district of Denver, Colorado, based on 224 photographs taken in 1937 by Cyril Norred and repeated by the author in 1978. The discussion and the captions emphasize the patterns of change in the city's core.

Rea, Amadeo M., 1983, Once a river; Bird life and habitat changes on the middle Gila: Tucson, University of Arizona Press, 285 pp.

Includes a contemporary photograph that matches a sketch of the Gila River near its confluence with the Santa Cruz River, Arizona, as drawn by John Russell Bartlett in 1852. Also includes a pair of matched photographs taken on the lower Gila River, showing how a marsh nesting-habitat for several bird species was almost completely destroyed by earth-moving machines in a few hours.

Rea, Kenneth H. See West and others (1975).

Reams, Max W., 1981, Illustrating time in geologic processes with long-interval time-lapse photography: Journal of Geological Education, v. 29, pp. 257-58.

Two sets of three matched photographs illustrate the value of repeated photographs for showing the importance of time in geologic processes.

Redfern, Ron, 1980, Corridors of time; 1,700,000,000 years of Earth at Grand Canyon: New York, Times Books, 198 pp.

Includes several panoramic photographs taken by the author at the Grand Canyon, Arizona, and Zion National Park, Utah. The panorama from Point Sublime covers most of the view sketched by William Henry Holmes in 1880.

Rees, P. Max See Berntsen and others (1983).

Reich, William J. See Gruell and others (1982).

Reid, Elbert H. See Arnold and others (1964).

Reid, Elbert H., Gerald S. Strickler, and Wade B. Hall, 1980, Green fescue grassland--40 Years of secondary succession: U.S. Department of Agriculture, Forest Service Research Paper PNW-274, 39 pp.

The effect of improved grazing practices in changing the vegetation and reducing soil erosion in rangeland in the Wallowa Mountains, eastern Oregon, is shown in 13 pairs of matched photographs.

Reid, Harry Fielding, 1895, The variations of glaciers: Journal of Geology, v. 3, no. 3, pp. 278-88.

Discusses the use of photographs in studies of glacier variation.

Relph, D. H., 1958, A century of human influence on high country vegetation: New Zealand Geographer, v. 14, no. 2, pp. 131-46.

Includes two pairs of matched photographs (1882, 1953) showing the degree of change in ground cover in the high country of South Island, New Zealand.

Renaud, A. See Bauer and others (1968).

Rephotographic Survey Project (directed by Mark Klett, Ellen Manchester, and JoAnn Verburg), 1979, Second view--A rephotographic survey: Sun Valley, Idaho, Rephotographic Survey Project, 5 pp. (mimeographed).

Distributed at the Clarence Kennedy Gallery, Boston, for an exhibit of 22 pairs of matched photographs (1873, 1978) by the Rephotographic Survey Project. See also Klett and others (1984); Verburg and Klett (1978).

Reynard, Kenneth G. See Cox and others (1983).

Reynolds, Hudson G., 1954, Meeting drought on southern Arizona rangelands: Journal of Range Management, v. 7, no. 1, pp. 33-40.

A set of three matched photographs shows short-term (1948 to 1952) variations in forage production at the Santa Rita Experimental Range, Arizona.

Reynolds, Hudson G., 1959, Managing grass-shrub cattle ranges in the Southwest: U.S. Department of Agriculture, Forest Service Agricultural Handbook No. 162, 40 pp.

Various management principles are discussed in light of a pair of matched photographs and two sets of three matched, but undated, photographs taken at the Santa Rita Experimental Range, southern Arizona. See also Reynolds and Martin (1968).

Reynolds, Hudson G., and John W. Bohning, 1956, Effects of burning on a desert grass-shrub range in southern Arizona: Ecology, v. 37, no. 4, pp. 769-77.

Long-term vegetational changes and short-term effects of fires on vegetation at the Santa Rita Experimental Range, Arizona, are illustrated by sets of matched photographs as follows: 1903 and 1931; before and after a fire in 1952; and 1952, 1953, and 1954.

Reynolds, Hudson G., and S. Clark Martin, 1968, Managing grass-shrub cattle ranges in the Southwest: U.S. Department of Agriculture, Forest Service Agricultural Handbook No. 162 (revised), 44 pp.

This is a revision of Reynolds (1959). One of the sets of three matched

photographs in the earlier version is replaced by another set (1919, 1930, and 1948; 1959, 1962, and 1963). The pair of matched photographs in the earlier version was taken 18 years apart.

Rich, Lowell R., 1961, Surface runoff and erosion in the lower chaparral zone, Arizona: U.S. Department of Agriculture, Forest Service Rocky Mountain Forest and Range Experimental Station Paper No. 66, 35 pp.

Five sets of matched photographs made between 1935 and 1960 illustrate the effects of various watershed treatments on chaparral vegetation.

Richter, D. H., W. U. Ault, J. P. Eaton, and J. G. Moore, 1964, The 1961 eruption of Kilauea Volcano, Hawaii: U.S. Geological Survey Professional Paper 474-D, 34 pp.

An increase in displacement of a newly formed fault scarp associated with the eruption, from 7 feet at 2:00 p.m. on September 24 to 10.8 feet at noon on September 26, is shown in a pair of approximately matched photographs.

Rifkin, Glenn See Holmes and Rifkin (1978).

Robertson, Joseph H., 1939a, A quantitative study of true-prairie vegetation after three years of extreme drought: Lincoln, University of Nebraska, Ph.D. dissertation, 492 pp.

See Robertson (1939b).

Robertson, Joseph H., 1939b, A quantitative study of true-prairie vegetation after three years of extreme drought: Ecological Monographs, v. 9, no. 4, pp. 433-92.

A pair of matched photographs taken in 1936 and 1937 in southeast Nebraska shows replacement of Spartina by weeds.

Robinson, T. W., 1965, Introduction, spread, and areal extent of saltcedar (Tamarix) in the western States: U.S. Geological Survey Professional Paper 491-A, 12 pp.

Includes a pair of aerial photographs of the Arkansas River at the Otero-Bent County line, Colorado, which shows that areas of scattered cottonwood trees in 1936 had become dominated by a dense growth of tamarisk in 1957. In the area studied, the area of phreatophytes, largely tamarisk, increased at an average rate of 47 acres a year from 1936 to 1947 and 57 acres a year from 1947 to 1957.

Rogers, Garry F., 1980, Photographic documentation of vegetation change in the Great Basin Desert: Salt Lake City, University of Utah, Ph.D. dissertation, 160 pp.

Discusses methods of repeat photography and gives 40 pairs of matched photographs covering the period from 1868 to 1980. See also Rogers (1982).

Rogers, Garry F., 1982, Then and now; A photographic history of vegetation change in the central Great Basin Desert: Salt Lake City, University of Utah Press, 152 pp.

Matched photographs (1868 to 1980) from 49 sites in the Bonneville Basin are used to show representative changes in the Great Basin shrub and woodland communities of this region. The photographs are selected from approximately 400 matched photographs made by the author. A few of the pairs of matched photographs were made by Raymond M. Turner, and one was made by Rick Dingus. (The left and right photographs in Plate 40 are reversed.) Sources of historic photographs, field methods, and darkroom techniques are discussed. The use of multiple photographs from each camera station is recommended to facilitate future relocation of the site. This is a revised version of Rogers (1980).

Romeril, P. M. See Williams, D. R., and others (1979).

Ronne, F. C. See Zeigler and Ronne (1957).

Rowley, Peter D., Mel A. Kuntz, and Norman S. Macleod, 1981, Pyroclastic-flow deposits, in Peter W. Lipman and Donal R. Mullineaux, eds., The 1980 eruptions of Mount St. Helens, Washington: U.S. Geological Survey Professional Paper 1250, pp. 489-512.

A sequence of four matched photographs taken by Peter W. Lipman over a span of 8 minutes from Coldwater Ridge about 8 km north of Mount

St. Helens shows development of a pyroclastic flow on August 7, 1980.

Rudberg, Sten, 1967, The cliff coast of Gotland and the rate of cliff retreat: Geografiska Annaler, v. 49A, pp. 283-98.

Rates of retreat for well-developed cliffs on the coast of Gotland, Sweden, are found to be about 0.4-0.6 cm/year, as learned partly by repeating old photographs. Two pairs of matched photographs are shown: a "rauk" coast near the south tip of Gotland (1900 by G. Holm, 1966 by the author) and a marl cliff on the northwestern coast (1950, 1966, both by the author).

Russell, Israel Cook, 1898, Glaciers of Mount Rainier: U.S. Geological Survey, 18th Annual Report, 1896-97, pt. 2, pp. 349-415.

Recommends taking annual photographs of the terminus of Nisqually Glacier from marked locations to determine advances and recessions of the glacier.

Sable, Edward G., 1961, Recent recession and thinning of Okpilak Glacier, northeastern Alaska: Arctic, v. 14, no. 3, pp. 176-87.

Includes three pairs of closely related views (1907, 1958) showing changes in the lower end of Okpilak Glacier and recession of a small unnamed hanging glacier. The 1907 photographs were taken by Ernest de Koven Leffingwell.

Samson, L. See Bozozuk, Fellenius, and Samson (1978).

Schiller, Ely, ed., 1978, The first photographs of Jerusalem; The Old City: Jerusalem, Ariel Publishing House, 252 pp.

The selected photographs in this album, although not strictly a study in repeat photography, include several sets of approximately matched (or closely related) views that reflect changes in Jerusalem until about 1910 as follows: Jerusalem from Mount Scopus in 1865 and 1893; Jerusalem from the north in 1887 and 1905; the city walls and Mamilla Pool in 1864 (a lithograph made from a photograph) and 1893; the city walls from the southwest in 1870 and 1893; Jaffa Gate in 1870, 1893, 1896, 1900, and 1910; the Citadel in 1865 and 1887; the Wailing Wall in 1877 and 1900; Hezekiah's Pool in 1865 and 1877; Zion Gate in 1856 and

1870; the Lions' Gate in 1856, 1865, and 1870; Damascus Gate in 1856, 1887, and 1912; the Tomb of the Kings in 1856 and 1890; and the Mount of Olives in 1870 and 1905. Many other views show differing aspects of the same subjects at various times, although not from the same positions. The identified photographers (some being listed only by surname) are: the American Colony Photographers; John Anthony; R. Bain; Yaacov Ben Dov; Melville Peter Bergheim; Felix Bonfils; L. Fiorillo; Francis Frith; Stephen Graham; Karl Grober; Hentschel; Hornstein; Leo Kahan; Benor Kalter; J. McDonald; E. Pierotti; C. Raad; Auguste Salzmann; Savignac; E. and F. Thévoz; and the Armenian Patriarch Yessayi. The editor points out that "photographs are free from subjective views, unsubstantiated assumptions and inexactitudes," when compared with sketches and paintings. The text is in Hebrew and English.

Schiller, Ely, ed., 1979a, The first photographs of Jerusalem; The New City: Jerusalem, Ariel Publishing House, 204 pp.

This companion volume to Schiller (1978) gives photographic evidence of expansion beyond the walls of the Old City. Only two pairs of photographs show related views of the same subjects: the Jaffa Road in 1912 and the 1930s; and the area opposite the Damascus Gate in 1910 and 1912. The identified photographers (one being listed only by surname) are: the American Colony Photographers; Yaacov Ben Dov; the British Air Force; G. E. Franklin; the German Air Force; Hornstein; C. Raad; I. Raffalovich; M. E. Sachs; and George Adam Smith. The text is in Hebrew and English.

Schiller, Ely, ed., 1979b, The first photographs of the Holy Land: Jerusalem, Ariel Publishing House, 380 pp.

The photographs in this album, which date from 1847 to 1930, are grouped in several categories: the Land of Galilee and the North; the Coastal Plain; Jerusalem , Judea, and Samaria; the South; and the human landscape. Only two views are of the same scene: Tiberias viewed from the shores of the Sea of Galilee in 1862 and 1870; and Haifa and Mount Carmel viewed from the bay in 1887, 1893, and 1912. The photographs are credited to the following photographers (some being listed only by surname): the American Colony Photographers; the Armenian Photographers; R. Bain; Francis Bedford; Yaacov Ben Dov; Melville Peter Bergheim; Felix Bonfils; the English photographer Cramb; G. E. Franklin; Francis Frith; German Air Force; Frank M. Good; Stephen Graham; Karl Grober; Hentschel; Leo Kahan; George Skene Keith; E. Pierotti; Ludwig Preiss; I. Raffalovich; M. E. Sachs; Cecil V. Shadbolt; E. and F. Thévoz; and Bert Underwood. The Holy Land and its land-

scape and towns in the nineteenth century are briefly discussed. The text is in Hebrew and English.

Schiller, Ely, ed., with the participation of Dan Kyram, 1980, The first photographs of Jerusalem and the Holy Land: Jerusalem, Ariel Publishing House, 238 pp.

This album extends the photographic coverage given in Schiller (1978, 1979a, and 1979b) and includes an introduction on "The pioneers of photography in the Holy Land, 1840-1930," by Dan Kyram. The photographs are credited to the following photographers (some being listed only by surname): the American Colony Photographers; the Armenian Photographers; R. Bain; Francis Bedford; Yaacov Ben Dov; Melville Peter Bergheim; Felix Bonfils; British Air Force; G. E. Franklin; Francis Frith; German Air Force; Frank M. Good; Graves; Hentschel; Hornstein; Edward Kilburn; J. McDonald; Alois Payer; Ludwig Preiss; I. Raffalovich; M. E. Sachs; Auguste Salzmann; Savignac; George Adam Smith; Sweig; E. and F. Thévoz; and Edward Wilson. The photographs date from 1856 to the 1930s but are mainly from the nineteenth century. Although differing aspects of many subjects are shown at various times, only a few of the photographs are approximately matched (or closely related) as follows: Jerusalem from the Mount of Olives in 1862 and 1900; Jerusalem from Mount Scopus in 1862 and 1898; the Wailing Wall in 1870, 1977, and 1900; and the area south of the Temple Mount in 1862 and 1908. Besides the photographers cited here and in Schiller 1978, 1979a, and 1979b, Kyram discusses work in the Holy Land by the photographers Joseph Philibert Girault de Prangey (1842), C. G. Wheelhouse (1849-1850), Maxime Du Camp (1849-1851), August Jacob Lorent (1852-1860), James Robertson (1857), Felice A. Beato (1857), Louis DeClerq (1859), Tancrede Dumas (1861), William E. James (1863-1865), Charles Bierstadt (1872), Benjamin-West Kilburn (brother of Edward, 1875), the Armenian photographer Krikorian (1870s), Adrian Bonfils (son of Felix, 1878-1894), and Eric Matson and Edith Yantiss (members of the American Colony Photographers, 1898-1946). The text is in Hebrew and English.

Schmautz, Jack E. See Berntsen and others (1983).

Schmidt, Wyman C. See Gruell and others (1982).

Schmidt, Wyman C., David G. Fellin, and Clinton E. Carlson, 1983, Alternatives to chemical insecticides in budworm-susceptible forests: Western

Wildlands, v. 9, no. 1, pp. 13-19.

Includes a set of four matched photographs (1909, 1927, 1938, 1948) of a stand of ponderosa pine and Douglas fir in the Bitterroot National Forest, Montana, showing development of an understory composed primarily of Douglas fir.

Schneider, Stephen H., with Lynne E. Mesirow, 1976, The Genesis strategy, climate and global survival: New York, Plenum Press, 419 pp.

The illustrations include an engraving of the Argentière Glacier in the French Alps, dated about 1850 to 1860, which is compared with a closely matched photograph taken in the mid-1960s, when the glacier had become greatly reduced in length.

Schooland, John B., 1967, Boulder then and now: Boulder, Colorado, Pruett Press, 270 pp.

Consists mostly of related views of Boulder, Colorado, and its environs that show changes between the 1860s and the 1960s. The early photographs were taken primarily by Joseph B. Sturtevant and Martin R. Parsons.

Schumm, Stanley A. See Patton and Schumm (1981).

Schumm, Stanley A., 1977, The fluvial system: New York, John Wiley and Sons, 338 pp.

Figure 5-31 is a pair of matched photographs (with different scales and cropping) of the North Platte River and Scotts Bluff at Scottsbluff, Nebraska, showing that the river was from 2500 to 4000 feet wide in 1890 but about 200 feet wide in 1960.

Scott, Arthur G. See Malde and Scott (1977).

Scott, Kevin M. See Janda and others (1981).

Searle, Leroy See Berger and others (1983).

Shamberger, Hugh A., 1970, The story of Rawhide, Mineral County, Nevada: Carson City, Nevada Department of Conservation and Natural Resources and U.S. Geological Survey, Historic mining camps of Nevada, no. 2, 50 pp.

A pair of matched photographs shows that the town of Rawhide, Nevada, had all but disappeared between about 1908 and 1969.

Shamberger, Hugh A., 1973, The story of Fairview, Churchill County, Nevada: Carson City, Nevada Department of Conservation and Natural Resources and U.S. Geological Survey, Historic mining camps of Nevada, no. 5, 61 pp.

The decline of the communities of Nevada Hills and Fairview, Nevada, from about 1914 to 1971 is documented by a pair of approximately matched photographs.

Shamberger, Hugh A., 1976, The story of Silver Peak, Esmeralda County, Nevada: Carson City, Nevada Department of Conservation and Natural Resources and U.S. Geological Survey, Historic mining camps of Nevada, no. 8, 111 pp.

A decrease in the size of the town of Silver Peak, Nevada, is shown by a pair of approximately matched photographs (1938, 1974).

Shamberger, Hugh A., 1982, The story of Goldfield, Esmeralda County, Nevada: Carson City, Nevada Historical Press, Historic mining camps of Nevada, no. 10, 240 pp.

Rapid urban growth of Goldfield, Nevada, from August 1904 to the summer of 1907 is documented by a pair of approximately matched photographs.

Shantz, Homer L., and B. L. Turner, 1958, Photographic documentation of vegetational changes in Africa over a third of a century: University of Arizona, College of Agriculture Report 169, 158 pp.

Reproduces 78 pairs of matched photographs representative of changes in the natural plant cover from Capetown to Lake Albert, which are selected from 241 images. The views repeat in 1957 and 1958 some of the 5,000 4 x 5-inch photographs made by Shantz in 1919 to 1920 and 1924 during trips that reached from Capetown to Cairo. The causes of

the changes are discussed in long captions and in the text.

Sharsmith, C. W., 1959, A report on the status, changes and ecology of back country meadows in Sequoia and Kings Canyon National Parks: National Park Service, Regional Office, San Francisco, California. (Unpublished manuscript.)

According to Magill and Twiss (1965), the manuscript includes matched photographs.

Shelton, John S., 1966, Geology illustrated: San Francisco, W. H. Freeman, 434 pp.

A pair of matched photographs taken in February and May 1960 shows seasonal variations in the flow of the Rillito River northeast of Tucson, Arizona. Another pair of matched, but undated photographs taken in summer and winter shows loss of sand during the winter at Boomer Beach, La Jolla, California.

Shepard, Francis P. See Kuhn and Shepard (1983).

Shepard, Francis P., 1950, Photography related to investigations of shore processes: Photogrammetric Engineering, v. 16, no. 5, pp. 756-69.

Includes four pairs of matched photographs of beaches, cliffs, and rock formations at La Jolla, California. The photographs show that sandy beaches changed markedly in six months in 1938 and in nine months in 1947 to 1948. However, a photograph taken of a sandstone cliff by U. S. Grant IV in 1948 shows no appreciable change since a photograph taken in 1906. The destruction of Cathedral Arch in 1900 is shown in photographs taken in 1897 and by Grant in 1945.

Shepard, Francis P., and Ulysses S. Grant IV, 1947, Wave erosion along the southern California coast: Geological Society of America Bulletin, v. 58, no. 10, pp. 919-26.

Photographic comparisons indicate that erosion of rocky coasts has been negligible in the past 50 years. In contrast, photographs and measurements of unconsolidated formations on the open coast show retreat of as much as a foot per year.

Shepard, Francis P., and Harold R. Wanless, 1971, Our changing coastlines: New York, McGraw-Hill, 579 pp.

Pairs of matched photographs taken from ground level show coastal changes in Massachusetts: Gay Head Cliffs (1917, 1968); at several sites in California: Sunset Cliffs (1946, 1968), Ocean Beach (1887, 1968), Cathedral Rock (1900, 1963), La Jolla Cove (1906, 1968), Boomer Beach (summer and winter), Scripps Institution of Oceanography at La Jolla (summer and winter 1936 by U. S. Grant IV), Point Ferman (1898, 1968), Miramar Beach (1927 and 1936 by Grant), Sandyland (1936 and 1968 by Grant), Refugio State Park (1950, 1968), Pt. San Luis (1898 by George W. Stose, 1945 by Grant), Arch Rock (1950, 1968), Pt. Arena (1950, 1968), and Mendocino (1860, 1960 by Joe W. Johnson); and a beach in Oregon: Jumpoff Joe (1880, 1910, and 1930 by Warren Dupré Smith). Except as noted, the matching photographs are by the authors. In addition, coastal changes are illustrated by many vertical aerial photographs.

Shideler, Frank J. See Progulske and Shideler (n.d.)

Shideler, Frank J., 1973, Custer country--One-hundred years of change: The American West, v. 10, no. 4, pp. 25-31.

Includes four pairs of matched photographs from a South Dakota State University project and discusses the work of Progulske (with Sowell) (1974).

Shinn, Dean A., 1980, Historical perspectives on range burning in the Inland Pacific Northwest: Journal of Range Management, v. 33, no. 6, pp. 415-23.

Includes three pairs of matched photographs and a set of four matched photographs, which show an increase in juniper. On the basis of the photographs and descriptive accounts of burning by Indians, it is argued that fires declined after European settlement. The initial photographs were taken from 1900 to the early 1930s, and the matched photographs were taken between 1945 and 1976.

Shoemaker, Eugene M., and H. G. Stephens, 1969, The Green and Colorado River canyons observed from the footsteps of Beaman and Hillers 97 years after Powell: Geological Society of America Abstracts with Programs 1969, pt. 5, Rocky Mountain Section, p. 73 (abstract).

See Shoemaker and Stephens (1975).

Shoemaker, Eugene M., and Hal G. Stephens, 1975, First photographs of the Canyon Lands, in James E. Fassett, ed., Canyonlands country: Four Corners Geological Society Guidebook, 8th Field Conference, Guidebook, pp. 111-222.

In 1968, Shoemaker and Stephens repeated virtually all of the approximately 150 photographs of the second Powell Expedition (1871 to 1872) in the National Archives, Washington, D.C. The 10 pairs of matched photographs given here are selected from a larger set based on 20 surviving photographs made by E. O. Beaman between Green River, Utah, and the lower end of Cataract Canyon. The photographs are the basis for a discussion of changes in vegetation and geomorphology and for reconstructing the day-by-day progress of the Powell party.

Shreve, Forrest, 1929, Changes in desert vegetation: Ecology, v. 10, no. 4, pp. 364-73.

A pair of matched photographs (1906, 1928) taken at Tumamoc Hill near Tucson, Arizona, is used to supplement repeated observations of small plots.

Siever, Raymond See Press and Siever (1982).

Simmons, Norman M., 1966, Flora of the Cabeza Prieta Game Range: Journal of the Arizona Academy of Science, v. 4, no. 2, pp. 93-104.

Four photographs taken by the International Boundary Commision in 1894, which show areas along the United States-Mexico boundary within the Cabeza Prieta Game Range, are matched with photographs taken about 70 years later.

Simpson, George Gaylord, 1951, Hayden, Cope, and the Eocene of New Mexico: Proceedings of the Academy of Natural Sciences of Philadelphia, v. 53, pp. 1-21.

Includes three photographs made in 1948 that match sketches made by Edward Drinker Cope during the 1870s.

Small, John Kunkel, 1929, From Eden to Sahara; Florida's tragedy: Lancaster, Pennsylvania, The Science Press Printing Company, 123 pp.

Describes and illustrates destruction of the plant cover of Florida, as seen in 1922, using pairs of contrasting, but unmatched, photographs of 11 distinctive sites. Most of the views emphasize burning of the vegetative cover for real-estate development.

Smith, George I., ed., 1978, Climate variation and its effects on our land and water; Part B, Current research by the Geological Survey: U.S. Geological Survey Circular 776-B, 52 pp.

Includes two pairs of matched photographs of the following subjects: arroyo cutting in New Mexico since 1915, as given by Malde (1973); and increased numbers of large cactus on an island near Guaymas, Sonora, Mexico, as given by Hastings and Turner (1965).

Smith, Larry N. See Wells, S. G., and others (1983).

Snead, Rodman E., 1982, Coastal landforms and surface features; A photographic atlas and glossary: Stroudsburg, Pennsylvania, Hutchinson Ross Publishing Company, 247 pp.

Includes several pairs of matched photgraphs that show coastal changes in California: Plate 56, low-altitude aerial oblique views of landslides at Palo Verdes Hills, Los Angeles (1924, 1941); Plate 220, high-altitude aerial oblique views of urban development at Palo Verdes Hills (1953, 1969, both by Francis P. Shepard); Plate 222, low-altitude aerial oblique views of urban development at Palisades del Rey (1924, 1928, both by Shepard); Plate 242, ground-level views of Sunset Cliffs, San Diego (1968 by Shepard, 1978 by the author); and Plate 243, ground-level views of a beach at La Jolla (March and August, 1938, both by Shepard).

Sowell, Richard H. See Progulske (with Sowell) (1974).

Spangle, W. E. See Waananen and others (1977).

Specht, R. L. See Hall, E. A. A., and others (1964).

Springfield, H. W., 1976, Characteristics and management of southwestern pinyon-juniper ranges--The status of our knowledge: U.S. Department of Agriculture, Forest Service Research Paper RM-160, 32 pp.

A pair of matched, but undated, photographs shows conditions before and after mechanical removal of pinyon-juniper vegetation. No location is given.

Steenbergh, Warren F., and Charles H. Lowe, Jr., 1977, Ecology of the saguaro. II, Reproduction, germination, establishment, growth, and survival of the young plant: U.S. Department of the Interior, National Park Service Scientific Monograph Series, no. 8, 242 pp.

A pair of matched photographs (1930, 1968) shows a dramatic decline in the number of saguaro cactus at Saguaro National Monument, Arizona.

Steenbergh, Warren F., and Charles H. Lowe, Jr., 1983, Ecology of the saguaro: III, Growth and demography: U.S. Department of the Interior, National Park Service Scientific Monograph Series, no. 17, 228 pp.

Four pairs of matched photographs from Saguaro National Monument, Arizona, taken between 1941 and 1979, illustrate a decrease in saguaro, especially the effects of catastrophic freezing.

Stephens, Hal G. See Shoemaker and Stephens (1969, 1975).

Stephens, P. R. See Trustrum and Stephens (1981).

Stewart, John H., and Valmore C. LaMarche, Jr., 1967, Erosion and deposition produced by the flood of December 1964 on Coffee Creek, Trinity County, California: U.S. Geological Survey Professional Paper 422-K, 22 pp.

Five approximately matched pairs of photographs show the effects of a flood on a small mountain stream in northern California. The preflood photographs were taken in the late 1950s or the early 1960s. One of the matched photographs was taken about 10 hours after the crest of the flood. The other matched photographs were taken in May 1965.

Stickney, Peter F., See Lyon and Stickney (1976).

102 Strickler

Strickler, Gerald S. See Reid, E. H., and others (1980).

Strickler, Gerald S., 1961, Vegetation and soil condition changes on a sub-alpine grassland in eastern Oregon: U.S. Department of Agriculture, Forest Service Research Paper PNW-40, 46 pp.

Changes in terrain and vegetation between 1938 and 1956 are shown in 16 pairs of matched photographs.

Strickler, Gerald S., and Wade B. Hall, 1980, The Standley allotment--A history of range recovery: U.S. Department of Agriculture, Forest Service Research Paper PNW-278, 35 pp.

Includes pairs of matched photographs and sets of three matched photographs, 16 altogether, which were taken from 1907 to 1976 in the Wallowa Mountains of eastern Oregon.

Stüssi, B., 1970, Vegetationsdynamik in Dauerbeobachtung. Naturbedingte Entwicklung subalpiner Weiderasen auf Alp La Schere im Schweizer Nationalpark wärend der Reservatsperiode 1939-1965: Ergebnisse der wissenschaftlichen Untersuchungen im schweizerischen Nationalpark, v. 13, no. 61, 365 pp.

Shows many photographs taken from 1939 to 1960 of alpine quadrats measuring one square meter in Swiss National Park, Switzerland.

Swanson, Donald A. See Moore, J. G., and others (1981); Tilling and others (1976).

Swanson, D. A., W. A. Duffield, D. B. Jackson, and D. W. Peterson, 1972, The complex filling of Alae Crater, Kilauea Volcano, Hawaii: Bulletin Volcanologique, v. 36, no. 1, pp. 105-26.

A sequence of four related photographs taken from the tourist overlook of Alae Crater shows some aspects of how the crater was filled with lava, beginning in February 1969, suddenly drained on August 4, 1969, and then filled again from August 1970 to May 1971. The photographs are dated as follows: August 18, 1965, by Dallas L. Peck; April 6, 1969; August 4, 1969; and mid-November 1970.

Swanson, Donald A., Wendell A. Duffield, Dallas B. Jackson, and Donald W. Peterson, 1979, Chronological narrative of the 1969-71 Mauna Ulu eruption of Kilauea Volcano, Hawaii: U.S. Geological Survey Professional Paper 1056, 55 pp.

Includes a drawing of superimposed profiles of Mauna Ulu based on matched photographs taken by Howard A. Powers from Pauahi Crater on May 22, May 30, June 7, June 10, June 20, and July 2, 1970. A further profile in mid-June 1971, after collapse of material into the enlarging summit crater, was traced from a photograph taken no more than 3 m from the site occupied by Powers. Also includes a set of six matching photographs showing the final minutes of fountaining at the Mauna Ulu vent area from 0800 to 0823 hours on October 20, 1969. Another sequence of eight matching photographs shows drainback and refilling of the eastern compartment of the Mauna Ulu vent area on November 13, 1969, and the compartment after activity had ceased on November 14, 1969. A subsequent drainback sequence at the Mauna Ulu vent area on December 29, 1969, is shown by a pair of matched photographs.

Swanson, Donald A., and Donald W. Peterson, 1972, Partial draining and crustal subsidence of Alae lava lake, Kilauea Volcano, Hawaii, in Geological Survey Research 1972: U.S. Geological Survey Professional Paper 800-C, pp. C1-C14.

Includes a pair of approximately matched photographs of an actively forming compressional ridge in the lava lake, taken on February 26 and June 28, 1971.

Sykes, Godfrey, 1937, The Colorado delta: Carnegie Institution of Washington Publication No. 460; American Geographical Society Special Publication No. 19, 193 pp.

Includes two pairs of matched photographs of features in the Colorado River delta, Sonora, Mexico: one showing silting and abandonment of the former channel between 1904 and 1925, the other showing the Rio Hardy in 1905 during a flood and in 1907 during the dry season.

Szarkowski, John, 1981, American Landscapes--Photographs from the collection of the Museum of Modern Art: New York, Museum of Modern Art (Catalog for an exhibition in the Summer of 1981), 80 pp.

A brief introductory essay traces the development of landscape photography. Reproduces and discusses a photograph by Rick Dingus that

matches a photograph by Timothy H. O'Sullivan, but which was taken with a wider lens and with an accurately leveled camera to show the degree to which O'Sullivan's photograph had ignored the true horizon.

Tansley, A. G., 1946, Introduction to plant ecology; A guide for beginners in the study of plant communities: London, George Allen and Unwin, 260 pp.

Provides a brief discussion of the methods of repeat photography, stressing the need for exact matching of the camera position and orientation.

Tarr, Ralph Stockman, and Lawrence Martin, 1914, Alaskan glacier studies of the National Geographic Society in the Yakutat Bay, Prince William Sound and lower Copper River regions: Washington, D.C., National Geographic Society, 498 pp.

Reproduces a number of pairs or sets of matched photographs based on earlier photographs by the authors and by others. Some of the sites previously occupied are further marked permanently by stakes driven into the ground, and such sites are identified by letters on maps. The features shown include: Arevida Glacier (1906, 1909); Turner Glacier (1905, 1909); a tongue of Nunatak Glacier (1899 by Grove Karl Gilbert, 1909); the tidal arm of Nunatak Glacier (1899 by Gilbert, 1905, 1906, 1909); other views of Nunatak Glacier (1905, 1909, 1910); delta of Hidden Glacier (1899 by Gilbert, 1910); Columbia Glacier (1899 by Gilbert, 1909); Barry Glacier (1905 by Ulysses Sherman Grant and Sidney Paige, 1909 by Grant, 1910); and Childs Glacier (1909, 1910).

Tausch, Robin J. See West and others (1975).

Thalen, D. C. P., 1979, Ecology and utilization of desert shrub rangelands in Iraq: The Hague, Dr. W. Junk, 448 pp.

Includes photographs of two sites that show vegetation changes in the southern desert of Iraq as follows: A pair of approximately matched photographs taken in 1960 and 1972 shows the effects of establishing an exclosure in 1959 at Khedr-el-Mai; and a set of three matching photographs at a site between Khedr-el-Mai and the Samah shows the seasonal contribution of annual plants to the vegetation between December 1971 and May 1972.

Thalen, D. C. P., 1980, On photographic techniques in permanent plot studies, in Wim G. Beeftink, ed., Vegetation dynamics; Proceedings of the Second Symposium of the Working Group on Succession Research on Permanent Plots, Delta Institute for Hydrobiological Research, Yerseke, October 1-3, 1975: The Hague, Dr. W. Junk, pp. 19-24.

Encourages greater use of repeat photography as a means of collecting data in studies of permanent plots. As examples, the author discusses (1) use of aerial photographs to extrapolate from permanent plots, (2) use of ground photography to collect data in permanent plots, and (3) use of aerial photographs to establish permanent plots.

Thames, John L. See Martin, S. C., and others (1974).

Thatcher, Wayne, 1974, Strain release mechanism of the 1906 San Francisco earthquake: Science, v. 184, no. 4143, pp. 1283-85, and caption on contents page for cover illustration.

The cover illustration shows a photograph taken by Grove Karl Gilbert in April 1906 of the trace of the San Andreas fault a mile northwest of Olema, California (now part of the Point Reyes National Seashore), and an approximately matched view of the same feature taken by the author in April 1974. The caption points out that the appearance of vertical displacement is largely due to horizontal displacement of the sloping ground.

Thomas, David H., 1971, Historic and prehistoric land-use patterns in the Reese River Valley: Nevada Historical Society Quarterly, v. 14, no. 4, pp. 3-9.

An increase in woodland vegetation on the hills around Austin, Nevada, is shown by a 1970 photograph that repeats a 1868 view by Timothy H. O'Sullivan.

Thompson, Wesley W. See Gartner and Thompson (1973).

Thorington, J. Monroe See Ladd and Thorington (1924).

Thorington, J. Monroe, 1925, The glittering mountains of Canada; A record of exploration and pioneer ascents in the Canadian Rockies, 1914-1924:

Philadelphia, Pa., John W. Lea, 310 pp.

Includes a photograph of Saskatchewan Glacier, Alberta, taken in 1922 by William O. Field. According to William O. Field (personal communication, 1983), the photograph was taken from a site established by the Interprovincial Boundary Survey between Alberta and British Columbia, which was subsequently reoccupied in 1924, 1948, 1953, and 1963. See also Field (1949).

Thornton, Gene, 1979, Corporate angels for creative projects, in Photography Year 1979: Alexandria, Virginia, Time-Life Books, pp. 38-48.

Discusses various projects currently funded by major grants and reproduces two pairs of matched photographs by the Rephotographic Survey Project (1979).

Thrift, Nigel See Parkes and Thrift (1980).

Tilling, Robert I. See Holcomb and others (1974).

Tilling, Robert I., Robert Y. Koyanagi, Peter W. Lipman, John P. Lockwood, James G. Moore, and Donald A. Swanson, 1976, Earthquake and related catastrophic events, Island of Hawaii, November 29, 1975; A preliminary report: U.S. Geological Survey Circular 740, 33 pp.

Subsidence amounting to 3.5 m at Halape on the southeastern coast is shown by comparing a preearthquake photograph taken by Don Reeser with a similar photograph taken on November 29, 1975, by the authors. Also, subsidence at Keauhou Landing is shown in related oblique aerial views taken before and after the earthquake by Robin Holcomb and Boone Morrison, respectively.

Torlegärd, Kennert See Dauphin and Torlegärd (1976, 1977).

Torlegärd, Kennert, and Edgar Dauphin, 1976, Displacement between building elements using an amateur camera: Fotogrammetriska Meddelanden, series 2. (Stockholm, Sweden.)

Describes an experimental method to determine the displacements of facade elements in a prefabricated multistory building, by comparing

photographs made with a Hasselblad superwide-angle camera.

Trefethen, James B., 1976, The American Landscape--1776-1976; Two centuries of change: Washington, D.C., The Wildlife Management Institute, 91 pp.

Discusses and illustrates changes in American landscapes since 1776, mainly using pairs of matched photographs.

Trent, D. D., 1983, California's ice age lost; The Palisade Glacier, Inyo County: California Geology, v. 36, no. 12, pp. 264-69.

Includes a pair of matched panoramic photographs of Palisade Glacier (1940 by W. B. Raub, and 1980 by the author) that shows significant shrinkage.

Trimble, Stanley W., and Steven W. Lund, 1982, Soil conservation and the reduction of erosion and sedimentation in the Coon Creek Basin, Wisconsin: U.S. Geological Survey Professional Paper 1234, 35 pp.

Includes matched photographs showing erosional effects and the results of soil conservation practices in the Driftless Area of Wisconsin and Minnesota as follows: development of bank and channel erosion on the North Fork of the Whitewater River, Wisconsin (1905, 1940); and healing of hillside gullies at Elba, Minnesota (1905, 1940, and 1978). A pair of matched vertical aerial photographs, which shows the contrast between rectangular cultivated fields in 1934 and contoured and strip-cropped fields in 1967, is also reproduced.

Tromble, J. M. See Hennessy and others (1983).

Trustrum, N. A., and P. R. Stephens, 1981, Selection of hill-country pasture measurement sites by interpretation of sequential aerial photographs: New Zealand Journal of Experimental Agriculture, v. 9, pp. 31-34.

Sites for measurement of pasture production on hillslopes in New Zealand, which are being continually modified by erosion processes, are selected in light of dates of erosion scars and cultural changes as determined from large-scale aerial photographs taken variously since the early 1940s. The illustrations include a set of three matching aerial photographs of an area in the Wairarapa hill country (1944, 1965, and

1979, the last being a false-color composite print from multispectral aerial photographs).

Tschirley, Fred H. See Martin, S. C., and Tschirley (1969).

Tschirley, Fred H., 1963, A physio-ecological study of jumping cholla (Opuntia fulgida Engelm.): Tucson, University of Arizona, Ph.D. dissertation, 100 pp.

Includes a series of photographs from the same point at the Santa Rita Experimental Range, southern Arizona, showing changes from 1903 to 1960.

Tschirley, Fred H., and S. Clark Martin, 1961, Burroweed on southern Arizona range lands: University of Arizona, Agricultural Experiment Station Technical Bulletin 146, 34 pp.

A set of four matched photographs shows changes in the numbers of Haplopappus tenuisectus (burroweed) between 1922 and 1958.

Tschirley, Fred H., and R. F. Wagle, 1964, Growth rate and population dynamics of jumping cholla (Opuntia fulgida Engelm.): Journal of the Arizona Academy of Science, v. 3, no. 2, pp. 67-71.

A set of five matched photographs shows changes in a population of Opuntia fulgida (jumping cholla) between 1903 and 1960 at a site in the Santa Rita Experimental Range, southern Arizona. See also Tschirley (1963).

Tsvetkov, D. G. See Blagovolin and Tsvetkov (1971).

Tueller, P. T. See Blackburn and Tueller (1970).

Turner, B. L. See Shantz and Turner (1958).

Turner, John H., 1983, Charles L. Weed historic photographs of Middle Fork American River mining activities: Sacramento, California, U.S. Bureau of Reclamation, 47 pp., 14 appendices.

Gives an exhaustive historical analysis of the Weed photographs of placer mining in the Middle Fork American River Canyon, California. A date of 1858 is favored for the photographs, and historical information about them is drawn primarily from captions in an album of 31 photographs assembled by Edward Perry Vollum, possibly before Vollum left California in 1861. The Vollum album was acquired in 1948 by the International Museum of Photography at George Eastman House, Rochester, New York. Appendix 2 reproduces 17 of the Weed photographs within the impoundment area of the proposed Auburn Reservoir, paired with matched photographs of the same scenes taken in 1977 and 1978 by Donald M. Westphal, U.S. Bureau of Reclamation. The locations of the photographs and of various features that can be seen in the 1858 photographs are given in a set of maps.

Turner, Raymond M. See Hastings and Turner (1965); Martin, S. C., and Turner (1977).

Turner, Raymond M., 1974a, Map showing vegetation in the Tucson area, Arizona: U.S. Geological Survey Miscellaneous Investigations Series Map I-844-H.

Includes one pair of matched photographs (1909, 1968) taken near the Santa Rita Mountains, Arizona, which illustrates encroachment of grassland by shrubs.

Turner, Raymond M., 1974b, Quantitative and historical evidence of vegetation changes along the Upper Gila River, Arizona: U.S. Geological Survey Professional Paper 655-H, 20 pp.

The frontispiece is a pair of photographs of an area near Calva showing encroachment of tamarisk on the Gila River flood plain between 1932 and 1964. Other photographs show features of the area near Fort Thomas in 1881 and 1885. See also Culler and others (1970).

Turner, Raymond M., 1982, Great Basin desertscrub, in David E. Brown, ed., Biotic communities of the American Southwest--United States and Mexico: Desert plants, v. 4, pp. 145-55.

A pair of matched photographs from southwestern Utah shows a change from dominance by sand sagebrush (Artemisia filifolia) in 1914 to creosotebush (Larrea tridentata) in 1979.

Turner, Raymond M., Stanley M. Alcorn, and George Olin, 1969, Mortality of transplanted saguaro seedlings: Ecology, v. 50, no. 5, pp. 835-44.

A pair of matched photographs, also given and described by Hastings and Turner (1965), shows loss of saguaro cacti and other perennial plants at Saguaro National Monument, Arizona, between 1935 and 1962.

Turner, Raymond M., Lee H. Applegate, Patricia M. Bergthold, Steve Gallizioli, and S. Clark Martin, 1980, Arizona range reference areas: U.S. Department of Agriculture, Forest Service General Technical Report RM-79, 34 pp.

Includes three pairs of matched photographs (1929 and 1978, 1906 and 1978, and 1905 and 1961) and one set of three matched photographs (1930, 1958, and 1978) of exclosures. The examples are from the pinyon-juniper vegetation type in northern Arizona and the desert grassland in southern Arizona.

Turner, Raymond M., and Martin M. Karpiscak, 1980, Recent vegetation changes along the Colorado River between Glen Canyon Dam and Lake Mead, Arizona: U.S. Geological Survey Professional Paper 1132, 125 pp.

Discusses the changes shown by 48 sets of matched photographs, which include one set of three matched photographs and one pair of aerial photographs. The earlier photographs, which were taken before the Glen Canyon Dam was completed, show conditions of the riverine habitat as early as 1872 (second Powell Expedition) and as recently as 1963.

Twiss, R. H. See Magill and Twiss (1965).

U.S. Bureau of Land Management, 1962, Classification of national land reserve, North Platte River Basin, Colorado, Wyoming, Nebraska; Volume 1 (Prepared by Richard D. Burr): U.S. Department of the Interior, Bureau of Land Managment, Denver, Colorado, Administrative Report, 119 pp., 6 appendices.

Includes three of William Henry Jackson's photographs of Independence Rock and the Sweetwater Valley in Wyoming (Hayden Expedition, 1870) and compares the same subjects with photographs taken by Burr in 1958.

U.S. Bureau of Land Management, 1967, Land Planning and Classification Report of the public domain lands in the Tongue River Area, Montana and Wyoming (Prepared by Richard D. Burr): U.S. Department of the Interior, Bureau of Land Management, Denver, Colorado, Administrative Report, 35 pp., 3 appendices.

Figures 31 and 32 are photographs made by Burr in 1962 of sites southeast of Miles City, Montana, that were initially photographed by the U.S. Geological Survey in 1907. Photographic comparisons by Homer LeRoy Shantz and Walter S. Phillips in 1963 are mentioned in the captions. Analogous observations by James Rodney Hastings and Raymond M. Turner in Arizona are also noted. Section 3 of Appendix B has 15 pairs of matched photographs that are used to evaluate vegetational changes at various times since 1907. The discussion further evaluates the changes indicated by a total of 168 pairs of matched photographs that have been made by the author.

U.S. Bureau of Land Management, 1969, Land Planning and Classification Report of the public domain lands in the Middle Yellowstone River Area, Montana (Prepared by Richard D. Burr): U.S. Department of the Interior, Bureau of Land Management, Denver, Colorado, Administrative Report, 56 pp., 3 appendices.

The text includes a pair of matched photographs looking across the Yellowstone River at Forsyth, Montana. Section 2 in Appendix B has 24 pairs of matched photographs of the Middle Yellowstone drainage area based on U.S. Geological Survey photographs dating from 1907 to 1930 and repeated by Burr in 1962 and 1963. The discussion emphasizes a great increase in amount of timber.

U.S. Bureau of Land Management, 1971, Land Planning and Classification Report of the public domain lands in the Musselshell River Area, Montana (Prepared by Richard D. Burr): U.S. Department of the Interior, Bureau of Land Management, Denver, Colorado, Administrative Report, 44 pp., 3 appendices.

The text includes three pairs of matched photographs of Kline townsite (1913, 1965), Maiden Canyon (1892, 1962), and the Missouri River near Fort Benton (1910, 1967) by Burr. Section 2 of Appendix B has 10 pairs of matched photographs of the Musselshell River drainage area based on U.S. Geological Survey photographs dating from 1892 to 1910 and repeated by Burr from 1964 to 1966. The discussion emphasizes a great increase in amount of timber.

U.S. Bureau of Land Management (with photographs by Michael Gilkerson), 1979, Historical comparison photography, Missouri Breaks, Montana: U.S. Department of the Interior, Bureau of Land Management, Billings, Montana, 109 pp.

Repeats 71 photographs, primarily made in the early 1900s by geologists of the U.S. Geological Survey. Several of the matched photographs are by Richard D. Burr. A few of the early photographs are by Homer L. Shantz, University of Arizona.

U.S. Bureau of Land Management (with photographs by Michael Gilkerson), 1980, Historical comparison photography, mountain foothills, Dillon Resource Area, Montana: U.S. Department of the Interior, Bureau of Land Management, Billings, Montana, 120 pp.

Includes 56 pairs of matched photographs of this area but provides little interpretative commentary. The photographs are reproduced at a small scale, making comparisons difficult.

U.S. Geological Survey, 1981, United States Geological Survey yearbook, Fiscal Year 1980: Washington, D.C., Superintendent of Documents, 137 pp.

The front and back covers make a pair of matched photographs of Mount St. Helens, Washington, taken by John Marshall from a site about seven miles north-northeast of the volcano, which shows changes produced by the catastrophic eruption of May 18, 1980.

Uggla, Evald, 1974, Fire ecology in Swedish forests, in Tall Timbers Fire Ecology Conference, No. 13, Tallahassee, Florida, 1973, Proceedings: Tallahassee, Florida, Tall Timbers Research Station, pp. 171-90.

Discusses the unfavorable and favorable effects of prescribed burning of forests in Sweden, using as illustrations a pair of approximately matched photographs of an area in Muddus National Park, taken 12 and 24 years after a fire in 1933.

Uresk, Daniel W. See Dietz, D. R., and others (1980).

Vale, Thomas R., 1973, The sagebrush landscape of the Intermountain West: Berkeley, University of California, Ph.D. dissertation, 508 pp.

The advantages and limitations of historical photographs for inter-
preting sagebrush landscape are discussed, and 18 pairs of matched
photographs dating back to 1869 are presented.

Vale, Thomas R., 1978, The Sagebrush Landscape: Landscape, v. 22, no. 2,
pp. 31-37.

Photographs made by William Henry Jackson in 1870 and 1872 in Idaho
and Wyoming, respectively, which were repeated by the author in 1972,
show that sagebrush was abundant in the nineteenth century.

van Everdingen, Robert O., and James A. Banner, 1979, Use of long-term
automatic time-lapse photography to measure the growth of frost
blisters: Canadian Journal of Earth Sciences, v. 16, no. 8, pp. 1632-35.

Describes an automatic time-lapse camera system, using an Eastman
Kodak type KB9A strike-recording motion-picture camera, which was
used to take daily photographs at solar noon between September 26,
1977, and May 3, 1978, to determine the time and rate of growth of frost
blisters at Bear Rock near Fort Norman, N.W.T., Canada. In addition to
producing a time-lapse motion picture, the use of paired cameras
allowed the making and viewing of daily stereo pairs. None of the time-
lapse photographs is shown, but a stereoscopic view of the area is repro-
duced.

Vankat, John L., 1970, Vegetation change in Sequoia National Park, Cali-
fornia: Davis, University of California, Ph.D. dissertation, 197 pp.

Includes many repeat photographs taken before 1967.

Vankat, John L., and Jack Major, 1978, Vegetation changes in Sequoia
National Park, California: Journal of Biogeography, v. 5, pp. 377-402.

Includes six pairs of matched photographs, the earliest dating from the
1880s.

van Wijk, M. C. See Bozozuk, van Wijk, and Fellenius (1978).

Veatch, Fred M., 1969, Analysis of a 24-year photographic record of Nis-
qually Glacier, Mount Rainier National Park, Washington: U.S. Geologi-

cal Survey Professional Paper 631, 52 pp.

Includes 12 sets of approximately matched photographs for the period 1942 to 1965. Each set contains from two to four photographs, and some of the photographs are annotated to mark changes in the glacier. The photographic procedures are discussed.

Venstrom, Cruz See Hardman and Venstrom (1941).

Verbeek, Earl R. See Clanton and Verbeek (1981).

Verburg, JoAnn See Klett and others (1984); Rephotographic Survey Project (1979).

Verburg, JoAnn, and Mark Klett, 1978, Rephotographing Jackson: Afterimage (Visual Studies Workshop, Rochester, N.Y.), Summer 1978, pp. 6-7.

Describes the Rephotographic Survey Project and reproduces two pairs of matched photographs.

Voight, Barry, 1981, Time scale for the first moments of the May 18 eruption, in Peter W. Lipman and Donal R. Mullineaux, eds., The 1980 eruptions of Mount St. Helens, Washington: U.S. Geological Survey Professional Paper 1250, pp. 69-86.

A set of nine matched photographs taken by Gary Rosenquist from a site near Bear Meadows, 16 km northwest of Mount St. Helens, over a span of 31.8 seconds, shows the initial stages of the eruption. Movement of the north slope of the volcano, as identified from the photographs, is shown in a set of sketches by Voight and others (1981).

Voight, Barry, Harry Glicken, R. J. Janda, and P. M. Douglas, 1981, Catastrophic rockslide avalanche of May 18, in Peter W. Lipman and Donal R. Mullineaux, eds., The 1980 eruptions of Mount St. Helens, Washington: U.S. Geological Survey Professional Paper 1250, pp. 347-78.

Includes a set of three oblique aerial photographs taken by Dorothy B. and Keith L. Stoffel, showing rapid movement of a rockslide during the initial stages of the eruption of May 18, 1980. The position of the airplane when these photographs were taken is given by Foxworthy and

Hill (1982, pp. 46-47), where the photographs are reproduced in a sequence of eight photographs taken on the same flight. Also includes a set of sketches that shows slide displacements identifiable on photographs taken by Gary Rosenquist, as reproduced in Voight (1981).

Waananen, A. O., J. T. Limerinos, W. J. Kockelman, W. E. Spangle, and M. L. Blair, 1977, Flood-prone areas and land-use planning; Selected examples from the San Francisco Bay region, California: U.S. Geological Survey Professional Paper 942, 75 pp.

A pair of matched, but undated, photographs shows a flood-prone area in Napa during and after urban redevelopment.

Wadden, Douglas See Berger and others (1983).

Wagle, R. F. See Tschirley and Wagle (1964).

Walker, Richard I., 1968, Photography as an aid to wilderness resource inventory and analysis: M.A. thesis, Colorado State University, 114 pp.

Reviews and analyses photographic techniques for study of wilderness, including selecting permanent camera stations, choosing photographic equipment, and recording and measuring features of the landscape. No matching photographs are included.

Wallace, Robert E., 1977, Profiles and ages of young fault scarps, north-central Nevada: Geological Society of America Bulletin, v. 88, pp. 1267-81.

About 2 m of retreat of a fault scarp on the east flank of Fairview Peak, Nevada, is shown in a set of three matched photographs (1954, 1957, and 1974) and in a pair of matched photographs (1954, 1974). The 1954 photographs were taken by Karl Steinbrugge shortly after the scarp was formed. Another pair of matched photographs of a scarp on the Paris Ranch, Tobin Range, which was formed in 1915, shows only slight changes in 17 years (1957, 1974).

Wallace, Robert E., 1980a, Degradation of the Hebgen Lake fault scarps of 1959: Geology, v. 8, pp. 225-29.

Degradation of two fault scarps, which were formed in 1959 near Hebgen Lake, Montana, is shown in four pairs of matched photographs (1959, 1978). The 1959 photographs were taken by John R. Stacy and Irving J. Witkind.

Wallace, Robert E., 1980b, G. K. Gilbert's studies of faults, scarps, and earthquakes, in Ellis L. Yochelson, ed., The scientific ideas of G. K. Gilbert: Geological Society of America Special Paper 183, pp. 35-44.

Includes a pair of matched photographs of fault scarps along the west flank of the Wasatch Range, 1 km north of Little Cottonwood Canyon, Utah, taken by Grove Karl Gilbert in 1901 and by the author in 1979.

Wanless, Harold R. See Shepard and Wanless (1971).

Ward, A. W., and Ronald Greeley, 1984, Evolution of the yardangs at Rogers Lake, California: Geological Society of America Bulletin, v. 95, no. 7, pp. 829-37.

By relocating yardangs photographed by Eliot Blackwelder in 1932, the rates of headward and lateral erosion of these streamlined, wind-eroded hills in the Mojave Desert are estimated to have been 2 cm/yr and 0.5 cm/yr, respectively. One pair of approximately matched photographs (not at the same scale) is reproduced.

Watson, Edward B., and Edmund V. Gillon, Jr., 1976, New York then and now; 83 Manhattan sites photographed in the past and present: New York, Dover Publications, 171 pp.

Rapid structural changes in the city and the increase in vacant land are shown by comparing photographs taken between 1868 and 1934 with matching photographs taken by Gillon in 1974 and 1975.

Weaver, Harold, 1955, Fire as an enemy, friend, and tool in forest management: Journal of Forestry, v. 53, no. 7, pp. 499-504.

The role of fire in promoting the growth of surviving trees is discussed and illustrated in part by a pair of matched photographs of a forest in the Colville Indian Reservation, Washington, which was treated by prescribed burning in October 1942 (November 1942; 1950 by Henry Wershing).

Weaver, Harold, 1957, Effects of prescribed burning in ponderosa pine: Journal of Forestry, v. 55, no. 2, pp. 133-38.

The effects of prescribed burning on stands of ponderosa pine on the Colville Indian Reservation, Washington, is described, using as illustrations two pairs of matched photographs, both taken in 1943 and 1955.

Weaver, Harold, 1959, Ecological changes in the ponderosa pine forest of the Warm Springs Indian Reservation in Oregon: Journal of Forestry, v. 57, no. 1, pp. 15-20.

As documented by a pair of matched photographs (1939, 1957) and by other photographs, development of a dense understory at this forested area in Oregon since the 1900s is attributed to overgrazing and exclusion of fires.

Weaver, Harold, 1967, Some effects of prescribed burning in the Coyote Creek test area, Colville Indian Reservation: Journal of Forestry, v. 65, no. 8, pp. 552-58.

Discusses improved growth of ponderosa pine over a 23-year period in this area in Washington as a result of prescribed burning, using as part of the documentation two pairs of matched photographs (1942 and 1965, 1960 and 1965).

Weaver, Harold, 1968, Fire and its relationship to ponderosa pine, in Tall Timbers Fire Ecology Conference, No. 7, Hoberg, California, 1967, Proceedings: Tallahassee, Florida, Tall Timbers Research Station, pp. 127-49.

This discussion of the effects of prescribed burning of ponderosa pine on the Colville Indian Reservation, Washington, includes three pairs of matched photographs by the author showing stand development after fires that occurred shortly before the initial photographs (1944 and 1967, 1955 and 1967, 1945 and 1966).

Webb, Kempton E., 1974, The changing face of northeast Brazil: New York, Columbia University Press, 205 pp.

This book, which is concerned with changes in the natural and cultural landscape, contains six sets of aerial photographs spanning the period from 1942 to 1959.

Webb, Robert H., and Evelyn B. Newman, 1982, Recovery of soil and vegetation in ghost-towns in the Mohave Desert, southwestern United States: Environmental Conservation, v. 9, no. 3, pp. 245-48.

Two pairs of approximately matched photographs (1907 and 1980, 1906 and 1981) show reestablishment of Mohave desert-scrub vegetation at two abandoned townsites in Inyo County, California.

Webb, Robert H., Howard G. Wilshire, and Mary Ann Henry, 1983, Natural recovery of soils and vegetation following human disturbance, in Robert H. Webb and Howard G. Wilshire, eds., Environmental effects of off-road vehicles; Impacts and management in arid regions: New York, Springer-Verlag, pp. 280-302.

A set of three photographs taken from the same vantage point shows Skidoo, California (Death Valley National Monument), in 1907 and as it appeared as an abandoned townsite in 1960 and 1980.

Wells, Philip V., 1966, Vegetational changes in northern Great Plains by W. S. Phillips and H. L. Shantz, 1963 (book review): Ecology, v. 47, no. 1, pp. 171-72.

Interprets some of the pairs of matched photographs in Phillips (1963).

Wells, Stephen G. See Hawley and others (1983); Love and others (1983); White and Wells (1979).

Wells, Stephen G., Devon E. Jercinovic, Larry N. Smith, Alberto A. Gutierrez, John Pickle, and Dave W. Love, 1983, Instrumented watersheds in the coal fields of northwestern New Mexico, in Stephen G. Wells, David W. Love, and Thomas W. Gardner, eds., Chaco Canyon country; A field guide to the geomorphology, Quaternary geology, paleoecology, and environmental geology of northwestern New Mexico: Albuquerque, New Mexico, American Geomorphological Field Group, 1983 Field Trip Guidebook, pp. 99-112.

Two pairs of matched photographs show changes in the surface texture of the weathered mantle in the Ah-shi-sle-pah badlands between early fall 1978 and late spring 1979.

Wells, Stephen G., and Wayne Lambert, eds., 1981, Environmental geology

and hydrology in New Mexico: New Mexico Geological Society Special Publication No. 10, 152 pp.

The frontispiece is a pair of matched photographs showing the Rio Puerco and Cabezon Peak from Cabezon, New Mexico, as photographed by E. A. Bass in 1884 and by Harold E. Malde in 1977.

Welsh, S. L. See Murdock and Welsh (1971).

West, Neil E., Kenneth H. Rea, and Robin J. Tausch, 1975, Basic synecological relationships in juniper-pinyon woodlands, in The pinyon-juniper ecosystem; A symposium: Logan, Utah, Utah State University, College of Natural Resources, pp. 41-52.

A pair of matched photographs (1907, 1963) shows a great increase in pinyon and juniper at the abandoned townsite of Stateline (State Line), Utah.

Wheeler, Arthur O., 1920, Notes on the glaciers of the Main and Selkirk Ranges of the Canadian Rocky Mountains: Canadian Alpine Journal, v. 11, pp. 121-46.

Includes a photograph of Saskatchewan Glacier, Alberta, by A. S. Thomson. According to William O. Field (personal communication, 1983), the photograph was taken in 1919 from a site established by the Interprovincial Boundary Survey between Alberta and British Columbia, which was subsequently reoccupied in 1924, 1948, 1953, and 1963. See also Field (1949).

White, William D., and Stephen G. Wells, 1979, Forest-fire de-vegetation and drainage basin adjustments in mountainous terrain, adjustments of the fluvial system; in Proceedings of the Tenth Annual Geomorphology Symposium, Binghamton, New York: Dubuque, Iowa, Kendall/Hall Publishing Co., pp. 199-223.

Describes a study in 1977 and 1978 of a burned area in Bandelier National Monument, New Mexico, using repeat photography and various other monitoring techniques to observe hydrologic adjustments. Reproduces a pair of matched photographs and five other photographs of selected features by Rick Dingus.

Whitehouse, Ian E., 1978, A century of erosion and recovery: Soil and Water, v. 14, no. 5, pp. 10-14.

Gives four pairs of matched photographs in the high country of South Island, New Zealand, as evidence that the pattern of screes, gullies, and bare ground has remained generally unchanged for 70 years. The initial photographs were made in the 1880s, 1890s, and 1905; and the subsequent photographs were made by the author in 1977. The changes in vegetation or erosion features seen in the photographs, or the lack of changes, are identified by annotations on drawings that accompany the photographs.

Whitehouse, Ian E., 1979, Stream aggradation following recent glacier retreat (note): Journal of Hydrology (NZ), v. 18, no. 1, pp. 49-51.

A pair of matched photographs is reproduced from a collection of 200 pairs, showing changes in the Reischek Stream and Glacier in the Rakaia River Catchment, South Island, New Zealand (1933 by J. Pascoe, 1979 by the author).

Whitehouse, Ian E., 1982a, Numerical assessment of erosion from old and recent photographs; A case study from a section of Highway 73, Canterbury, New Zealand: Journal of the Royal Society of New Zealand, v. 12 no. 2, pp. 91-101.

Includes several pairs of matched photographs that show erosional features and changes in vegetation as follows: Ghost Stream, Torlesse Range (1880s by Burton Brothers, 1977); Craigieburn Range (1868 by E. P. Sealy, 1978); slopes north of Porters Pass (1890s by J. R. Morris 1978); Cloudy Hill (1890 by Burton Brothers, 1978); slopes of Lyndon Hill from northern end of Lake Lyndon (1889 from the collection of the Canterbury Museum, 1979); and slope south of Porters Pass (1890 from the Canterbury Museum, 1978). The modern photographs were taken by the author.

Whitehouse, Ian E., 1982b, Erosion on Sebastopol, Mt Cook, New Zealand, in the last 85 years: New Zealand Geographer, v. 38, no. 2, pp. 77-80.

Includes a set of matched photographs of Sebastopol, a small peak near Mt. Cook Village, as follows: about 1914, January 1979, and April 1980 The photographs show no significant erosion between 1914 and 1979 although 491 mm of rainfall was recorded on December 26, 1957. Then on December 2, 1979, a severe storm at Mt. Cook brought 537 mm of

rain. The 1980 photograph shows that channels on the north slopes of Sebastopol were scoured clean, and a large gully with a volume of about 150,000 cubic meters was eroded in glacio-fluvial gravel. The gullying took place on the morning of December 3 near the end of the storm, by which time at least 637 mm of the total storm rainfall of 655 mm had fallen.

Williams, Chuck, 1980, Mount St. Helens, a changing landscape; with an introduction by Ray Atkeson: Portland, Oregon, Graphic Arts Center Publishing Company, 128 pp.

Includes several sets of matched photographs showing changes produced by the eruption of Mount St. Helens, Washington, May 18, 1980. One set of four photographs taken seconds apart by Glen Finch from a point 12 miles northeast of the volcano shows the beginning of the initial explosion. A set of three photographs taken by Richard Anderson shows the explosion as seen from Mt. Rainier, 55 miles north. A pair of matched photographs by Ron Cronin before and after the eruption shows how the volcano was reduced in height. Matched before-and-after panoramas taken from a site above the east arm of Spirit Lake by Michael Lawton in April and August 1980 show the devastating effect of the eruption. Finally, the effects of the eruption are further shown by matched color-infrared vertical aerial photographs taken from a height of 60,000 feet.

Williams, D. R., P. M. Romeril, and R. J. Mitchell, 1979, Riverbank erosion and recession in the Ottawa area: Canadian Geotechnical Journal, v. 16, no. 4, pp. 641-50.

Includes a set of three vertical aerial photographs of the south bank of the Ottawa River at CFB Rockcliffe (1955, 1968, 1975), Canada, showing changes caused by landsliding. The effects of other landslides of the riverbank near Ottawa are also described and illustrated.

Williams, Garnett P., 1978, The case of the shrinking channels--The North Platte and Platte Rivers in Nebraska: U.S. Geological Survey Circular 781, 48 pp.

Includes six sets of comparative, but non-matching, views of bridge sites that show a marked decrease in channel width. The earliest of the initial photographs was taken by William Henry Jackson in 1869, and the others were taken in the early 1900s. The contemporary photographs were taken in 1977. The observations are supplemented with six pairs of matched aerial photographs (1938, 1969).

Williams, Garnett P., and M. Gordon Wolman, 1984, Downstream effects of dams on alluvial rivers: U.S. Geological Survey Professional Paper 1286, 83 pp.

Describes changes in channels since dams were constructed at 21 sites, using as some of the illustrations several sets and pairs of related, but non-matching, ground-level photographs as follows: the Jemez River downstream from Jemez Canyon Dam, New Mexico (1952, 1980; 1957, 1980; 1936, 1980); the Arkansas River 3 km downstream from John Martin Dam, Colorado (1946, 1959, 1980); Wolf Creek 2.6 km downstream from Fort Supply Dam, Oklahoma (1940, 1958, 1972); the North Canadian River 0.8 km downstream from Canton Dam, Oklahoma (about 1938, 1980); the Canadian River 3 km downstream from Ute Dam, New Mexico (1954, 1980); the Republican River 4 km downstream from Trenton Dam, Nebraska (1949, 1980) and 19 km downstream (1932, 1980); the Canadian River 400 m downstream from Sanford Dam, Texas (1960, 1980) and 120 km downstream (1960, 1980); and the Washita River 1.4 km downstream from Foss Dam, Oklahoma (1958, 1962, 1967, 1970). In addition, the Republican River before and after closure of Harlan County Dam, Nebraska, is shown in a pair of matched aerial photographs (1949, 1956).

Wilshire, Howard G. See Webb, R. H., and others (1983).

Wilshire, Howard G., 1977, Study results of 9 sites used by off-road vehicles that illustrate land modifications: U.S. Geological Survey Open-File Report 77-601, 22 pp.

Effects of off-road vehicles on hillsides in California are shown in part by matched pairs of photographs of the Red Canyon State Recreation Area (November 1975, September 1976), Jawbone Canyon (September 1976, March 1978), and Hungry Valley (two views, each September 1976 and March 1978).

Wilshire, Howard G., J. K. Nakata, and Bernard Hallet, 1981, Field observations of the December 1977 wind storm, San Joaquin Valley, California, in Troy L. Péwé, ed., Desert dust; Origin, characteristics, and effect on Man: Geological Society of America Special Paper 186, pp. 233-51.

Includes a pair of matched photographs (April 1977, March 1978) showing the extent of stripping of vegetation and soil by a severe wind storm on December 20, 1977, at a site east of Bakersfield, where patches of bare soil had been exposed by the stress of grazing and a drought in

1976 to 1977.

Winters, Harold A. See Buckler and Winters (1983).

Wolman, M. Gordon See Williams, G. P., and Wolman (1984).

Wood, J. G. See Osborn and others (1935).

Wood, James N. See Naef and Wood (1975).

Woolley, Ralf Rumel, 1941, Then and now: U.S. Geological Survey, Denver,
 Colorado, Unpublished photographic album.

 This is an album of pairs of matched photographs made by Woolley in
 1939 and 1940, based on photographs made by William Henry Jackson in
 the 1870s and by Grove Karl Gilbert in 1901, primarily in the Wasatch
 Mountains, Utah. The album is in the U.S. Geological Survey Photo-
 graphic Library in Denver, Colorado.

Wright, Henry A., 1980, The role and use of fire in the semi-desert grass-
 shrub type: U.S. Department of Agriculture, Forest Service General
 Technical Report INT-85, 24 pp.

 Contains a pair of matched photographs (1903, 1941) and a set of four
 matched photographs taken before and at three subsequent times after
 a rangeland fire in the Santa Rita Experimental Range, southern
 Arizona.

Wright, Henry A., and Arthur W. Bailey, 1982, Fire ecology--United States
 and southern Canada: New York, John Wiley and Sons, 501 pp.

 Pairs and sets of matched photographs are used to discuss the ecology
 of fires in several areas: semidesert grass-shrub vegetation in the Santa
 Rita Experimental Range, Arizona (1903, 1941), as also illustrated in H.
 A. Wright (1980); exclusion of fire for 75 years in ponderosa pine forest
 at the Black Hills, South Dakota (1874, 1974); a marked increase in
 Douglas fir at Snow King Mountain, Jackson, Wyoming; and a site of
 mixed-grass prairie just before burning (March 1969) and then 20
 minutes, 1 hour, 1 day, 1 month, and 4 months later.

Wright, John W. <u>See</u> Lowe and others (1970).

Wyoming State Historical Society, 1976, Re-discovering the Big Horns--A
pictorial study of 75 years of ecological change: Cheyenne, Bighorn
National Forest Volunteer Committee, 79 pp.

Includes 37 pairs of matched photographs based on unpublished views
taken in the Big Horn Mountains of Wyoming in 1900 by John George
Jack and repeated in 1975 and 1976 by members of the Big Horn
Johnson, Sheridan, and Washakie County Chapters of the Wyoming State
Historical Society in cooperation with the Big Horn National Forest
U.S. Forest Service. An effort was made to repeat Jack's photographs
at the same times of the year as given in his diary. Each pair of photo
graphs is shown with a map of the location and the direction of view
The captions give Jack's original descriptions and explain the subsequen
changes in the vegetation, as well as changes produced by human
activites. Several of the captions emphasize recovery from the effects
of fire.

Young, James A., and Jerry D. Budy, 1979, Historial use of Nevada's pinyon-
juniper woodlands: Journal of Forest History, v. 23, no. 3, pp. 112-21.

Includes a pair of approximately matched photographs (1900, 1977)
showing an increase in pinyon-juniper woodland near Cortez, Nevada.

Yuan, Georgia, 1979, The geomorphic development of an hydraulic mining
site in Nevada County, California: Stanford University, M.S. Thesis, 57
pp.

Rates and patterns of erosion in badlands at Malakoff Diggings are
discussed in light of changes shown in four pairs of matched photographs
based on photographs taken in 1909 by Grove Karl Gilbert and in 1953
by Mary Hill, and repeated by the author in 1978. The rates of erosion
are estimated to be 40 to 170 mm/year.

Zeigler, J. M., and F. C. Ronne, 1957, Time-lapse photography--An aid to
studies of the shoreline: U.S. Office of Naval Research, Research
Reviews, v. 10, no. 4, pp. 1-6.

Describes taking low-angle oblique time-lapse aerial photographs of the
Atlantic and Gulf coasts of the United States, using a motion picture
camera at two frames per second. A flight made in April 1956 reached

from the Canadian border to Venice, Florida, and a second flight in October 1956 extended from Montauk Point, Long Island, to the Rio Grande in Texas. Three examples of related photographs are given that show changes that took place between these flights as follows: Fire Island Inlet on the south shore of Long Island, New York; and Cape Hatteras and Cape Fear, North Carolina. When projected at 16 frames per second, the apparent flying speed is about 850 knots. The authors point out various kinds of applications that can be made from the changes seen in successive flights.

Zinke, Paul J. See Heady and Zinke (1978).

Zonneveld, I. S., 1975, A photo report on a 1/4 century vegetation succession in a fresh water tidal area (Biesbosch), Netherlands, in Wolfgang Schmidt, Redaktion, Sukzessionsforschung: Vaduz, Liechtenstein, J. Cramer, pp. 517-23.

A sequence of annual photographs supplements other information that demonstrates successional trends. Large-format cameras were found to produce the most useful results.

Index

Sioux Glacier: Post, 1967.
Smith Glacier: Field, 1937,
 1974.
Surging glaciers: Field, 1969;
 Post, 1966, 1969, 1972;
 Post and LaChapelle,
 1971.
Susitna Glacier: Post and
 LaChapelle, 1971.
Talus cone: Clark-and others,
 1972.
Tidewater recession, Guyot
 Glacier: Post and
 LaChapelle, 1971.
Tikke Glacier: Post and Mayo,
 1971.
Toboggan Glacier: Field, 1937,
 1974.
Turner Glacier: Tarr and
 Martin, 1914.
Tyeen Glacier: Field, 1969.
Variegated Glacier: Post, 1969.
Vassar Glacier: Field, 1974;
 Keen, 1915.
Wellesley Glacier: Field, 1974;
 Keen, 1915.
Yakutat Bay, glaciers: Gilbert,
 1903; Tarr and Martin,
 1914.
Albertype prints
Comparison with early photo-
 graphs: Ostroff, 1981.
Alpine vegetation
Swiss National Park, Switzer-
 land: Frey, 1959; Stüssi,
 1970.
Alps
Repeated glacier surveys:
 Hattersley-Smith, 1966.
**American Colony Photographers,
 photographs:** Schiller, 1978,
 1979a, 1979b, 1980.
American Geographical Society
Glacier photographs, permanent
 files: Harrison, A. E.,
 1960.

Anderson, R. M., photographs:
 Falconer, 1962.
Anderson, Richard, photographs:
 Williams, C., 1980.
Anthony, John, photographs:
 Schiller, 1978.
Archaeology
Egypt: Alinder, 1979.
Israel: Alinder, 1979.
United States:
 Chaco Canyon, New Mexico:
 Lekson, 1983.
 Faraway Ranch, Arizona:
 Baumler, 1984.
Architectural subjects
Photogrammetric recording:
 Borchers, 1977.
Storefronts, changing faces of
 Main Street: Fleming,
 1982.
Arizona
Beale Trail, vegetation and
 terrain: Lockett, 1939.
Cabeza Prieta Game Range:
 Simmons, 1966.
Chaparral zone:
 Runoff and erosion: Rich,
 1961.
 Sierra Ancha Experimental
 Forest: Pond, 1971.
 Tonto National Forest:
 Cable, 1975.
Colorado River:
 Beach erosion: Dolan and
 others, 1974.
 Channel and vegetation
 changes above Yuma:
 Ohmart and others,
 1977.
 Vegetation change: Shoe-
 maker and Stephens,
 1975; Turner, R. M.,
 and Karpiscak, 1980.
Communities, changes in:
 Dutton and Bunting,
 1981.

Desert grassland: Cable, 1976;
Cox and others, 1983;
Glendening, 1952, 1955;
Hastings, 1963; Hastings
and Turner, 1965; Hum-
phrey, 1953, 1958, 1959,
1963; Lowe and others,
1970; Turner, R. M.,
Applegate, Bergthold,
Gallizioli, and Martin,
1980.
Falsemesquite (Calliandra
eriophylla): Martin, S. C.,
and Morton, 1980.
Faraway Ranch, archaeology:
Baumler, 1984.
Gila River basin:
Bird life and habitat
changes: Rea, A. M.,
1983.
Encroachment of tamarisk:
Burkham, 1972;
Culler and others,
1970; Graf, 1982a;
Turner, R. M., 1974b.
Fort Thomas: Turner, R. M.,
1974b.
Gila River Phreatophyte
Project: Culler and
others, 1970.
Phoenix area, channel
changes: Graf, 1983a.
Safford Valley, channel
changes: Burkham,
1972.
San Francisco River, channel
changes: Burkham,
1970.
Tamarisk, hydrologic effects
on floods: Burkham,
1976.
Glen Canyon, vegetation
change: Turner, R. M.,
and Karpiscak, 1980.
Grand Canyon: Dolan and
others, 1974; Graf, 1978;

Redfern, 1980; Turner, R.
M., and Karpiscak, 1980.
Grassland, herbicide treatment:
Martin, S. C., and
Morton, 1980.
Grassland-juniper woodland
ecotone, vegetation
change: Johnsen and
Elson, 1979.
Haplopappus tenuisectus
(burroweed), effects of
fire: Cable, 1967.
Lake Mead, vegetation change:
Turner, R. M., and
Karpiscak, 1980.
Lehmann lovegrass (Eragrostis
lehmanniana): Martin, S.
C., and Morton, 1980.
Mesquite problem: Cable, 1976;
Parker and Martin, 1952.
Mummy Cave, photograph by J.
K. Hillers: Heller, 1981.
Oak woodland: Hastings, 1963;
Hastings and Turner,
1965.
Opuntia fulgida (jumping
cholla): Martin, S. C., and
others, 1974; Martin, S.
C., and Tschirley, 1969;
Tschirley, 1963;
Tschirley and Wagle,
1964.
Pinyon-juniper vegetation type:
Arnold and others, 1964;
Laycock, 1975; Turner,
R. M., Applegate, Berg-
thold, Gallizioli, and
Martin, 1980.
Ponderosa pine bunchgrass
ranges: Arnold, 1950.
Powell Expedition photographs:
Graf, 1978, 1979b;
Shoemaker and Stephens,
1969, 1975; Turner, R.
M., and Karpiscak, 1980.
Rangelands, southern: Tschirley

Shreve, 1929.
Vegetation map: Turner, R.
M., 1974a.
Tumamoc Hill, changes in
desert vegetation:
Blydenstein and others,
1957; Lowe, 1958-1959;
Martin, S. C., and Turner,
1977; Shreve, 1929.
Vegetation in nineteenth
century: Leopold, 1951.
Armenian Photographers, photo-
graphs: Schiller, 1979b, 1980.
Arroyo cutting
Near Santa Fe, New Mexico:
Malde, 1973; Malde and
Scott, 1977; Smith, G. I.,
1978.
Rio Puerco at Cabezon, New
Mexico: Wells, S. G., and
Lambert, 1981.
Ashfalls
Mount St. Helens, Washington:
Halliday, 1982.
Aspen community
Beaver Mountain, Utah:
Mueggler and Bartos,
1977.
Jackson Hole, Wyoming: Gruell
and Loope, 1974.
New Mexico: Potter and
Krenetsky, 1967.
Aubert, E., drawing: Le Roy
Ladurie, 1971.
Australia
Demography and survival of
semi-desert shrubs under
grazing: Crisp, 1978.
T. G. B. Osborn Vegetation
Reserve, Koonamore,
South Australia: Crisp,
1978; Hall, E. A. A., and
others, 1964; Noble,
1977; Noble and Crisp,
1980; Osborn and others,
1935.

Austria
Glaciers: Mathews, 1976.
Avalanches
Mount Baker, Washington: Frank
and others, 1975.

Bain, R., photographs: Schiller,
1978, 1979b, 1980.
Baird, P. D., photographs: Falcon-
er, 1962.
Balvin, A. W., photographs: Post
and Mayo, 1971.
Bartlett, John Russell, sketches:
James, 1969; Rea, A. M.,
1983.
Bass, E. A., photographs: Wells, S.
G., and Lambert, 1981.
Beach erosion
California: Emery and Kuhn,
1980; Kennedy, 1973;
Shelton, 1966; Shepard,
1950; Shepard and Grant,
1947; Shepard and Wan-
less, 1971; Snead, 1982.
Colorado River: Dolan and
others, 1974.
Lake Michigan, bluff recession:
Buckler and Winters,
1983.
Massachusetts: Knutson, 1979;
Shepard and Wanless,
1971.
Oregon: Byrne, 1963; Shepard
and Wanless, 1971.
Sweden: Rudberg, 1967.
Beaches, shoreline change: Berg-
quist, 1979; Buckler and
Winters, 1983; Byrne, 1963;
Dietz, R. S., 1947; Emery
and Kuhn, 1980; Jensén,
1979; Kaye, 1964; Kennedy,
1973; Komar, 1976; Kovacs,
1983; Kuhn and Shepard,
1983; Rudberg, 1967;
Shepard, 1950; Shepard and

1965; Steenbergh and
Lowe, 1977, 1983; Turner,
R. M., Alcorn, and Olin,
1969.
Desert grassland, increase:
Cox and others, 1983;
Glendening, 1952.
Increase of saguaro in Sonoran
Desert: Martin, S. C., and
Turner, 1977; Simmons,
1966.
Opuntia fulgida (jumping
cholla): Martin, S. C., and
Turner, 1977; Tschirley,
1963; Tschirley and
Wagle, 1964.
California
Arch Rock: Shepard and Wan-
less, 1971.
Bolinas Lagoon: Bergquist, 1979.
Boomer Beach: Shelton, 1966;
Shepard and Wanless,
1971.
Cathedral Arch: Shepard, 1950.
Cathedral Rock: Shepard and
Wanless, 1971.
Chaparral vegetation: Bradbury,
1974.
Coastal change: Dietz, R. S.,
1947; Emery and Kuhn,
1980; Kennedy, 1973;
Komar, 1976; Kuhn and
Shepard, 1983; Shepard,
1950; Shepard and Grant,
1947; Shepard and Wan-
less, 1971; Snead, 1982.
Coffee Creek, flood of
December 1964: Stewart
and LaMarche, 1967.
Colorado River, channel and
vegetation changes
above Yuma: Ohmart and
others, 1977.
Cultural change: Ganzel, 1984.
Dana Glacier: Harrison, A. E.,
1950.

Encinitas: Kuhn and Shepard,
1983.
Ghost towns: Webb, R. H., and
Newman, 1982; Webb, R.
H., and others, 1983.
Glaciers, Sierra Nevada:
Harrison, A. E., 1950,
1960.
Grassland, rapid seasonal
changes in vegetation:
Heady, 1958.
Kings Canyon National Park,
backcountry meadows:
Sharsmith, 1959.
La Jolla: Emery and Kuhn, 1980;
Shelton, 1966; Shepard,
1950; Snead, 1982.
La Jolla Cove: Shepard and
Wanless, 1971.
Los Angeles: Hurley and
McDougall, 1971.
Lyell Glacier, Sierra Nevada:
Gilbert, 1904; Harrison,
A. E., 1950, 1960, 1974.
Maclure Glacier, Sierra Nevada:
Harrison, A. E., 1950,
1974.
Malakoff Diggings: Yuan, 1979.
Mariposa Grove, Yosemite
National Park:
Hartesveldt, 1962.
Mendocino: Shepard and
Wanless, 1971.
Mendocino County, grassland:
Heady, 1958.
Middle Fork American River,
placer mining: Turner, J.
H., 1983.
Miramar Beach: Shepard and
Wanless, 1971.
Mohave Desert vegetation: Kay
and Graves, 1983; Webb,
R. H., and Newman,
1982.
Mono Lake: Gaines and the
Mono Lake Committee,

Grober, Karl, photographs:
Schiller, 1978, 1979b.
Growth rates
Opuntia fulgida (jumping
cholla): Tschirley and
Wagle, 1964.
Vegetation on arid rangeland:
Hall, E. A. A., and others,
1964.
Gutekunst, Frederick,
photographs: Frassanito,
1975.

Haplopappus tenuisectus
(burroweed)
Rangelands: Martin, S. C., and
Turner, 1977; Tschirley
and Martin, 1961.
Re-establishment after fire:
Cable, 1967.
Harmon, Byron, photographs:
Field, 1949; Freeman, 1925.
Harrison, John, photographs:
McLeod, 1967.
Hayden, Ferdinand Vandiveer,
Territorial survey
W. H. Jackson photographs:
Burr, 1961a, 1961b.
Role of photographs: Ostroff,
1981.
Hawaii
Historic littoral cones: Moore,
J. G., and Ault, 1965.
Kilauea Volcano:
Alae Crater: Swanson and
others, 1972.
Alae lava lake: Swanson and
Peterson, 1972.
Fault scarp: Richter and
others, 1964.
Landforms: Holcomb and
others, 1974.
Mauna Ulu eruption, 1969-
1971: Swanson and
others, 1979.

Subsidence of coast after
earthquake of November
29, 1975: Tilling and
others, 1976.
Heliotypes
Comparison with early photo-
graphs: Ostroff, 1981.
Hentschel, photographs: Schiller,
1978, 1979b, 1980.
Herbicide treatment
Effect on grass-shrub
community: Cable, 1976;
Martin, S. C., and
Morton, 1980.
Hickson, Paul and Catherine J.,
photographs: Hickson, C. J.,
and Barnes, 1982; Hickson,
C. J., and others, 1982.
Hill, Mary, photographs: Yuan,
1979.
Hillers, John K., photographs:
Anonymous, 1979a; Borchers,
1977; Graf, 1978; Heller,
1981; Klett and others, 1984;
Lohman, 1980; Shoemaker
and Stephens, 1969, 1975;
Turner, R. M., and
Karpiscak, 1980.
Hirst, David, photographs:
Brugman and Post, 1981.
Historical ecology
Examples of studies using
repeat photography:
Barber, 1976.
Holcomb, Robin T., photographs:
Holcomb and others, 1974;
Tilling and others, 1976.
Holm, G., photographs: Rudberg,
1967.
Holmes, William Henry
Panoramic sketch matched by
photographic mosaic:
Malde, 1983; Redfern,
1980.
Holway, Donal F., photographs:
Morris, J. G., 1983.

Ladurie, 1971.
Jack, John George, photographs:
Wyoming State Historical
Society, 1976.
Jackson, William Henry,
photographs
Colorado: Anonymous, 1979a,
1979b; Digerness, 1980;
Edwards, 1979; Johnson,
Alexandra, 1979; Com-
mittee on Surface Mining
and Reclamation, 1979;
Verburg and Klett, 1978.
Nebraska: Williams, G. P., 1978.
Repeated by H. G. Stephens:
Anonymous, 1979a.
Repeated by Rephotographic
Survey Project: Berger
and others, 1983; Klett
and others, 1984.
Review of role in Western
exploration: Naef and
Wood, 1975.
Utah: Christensen, 1957;
Rogers, 1980, 1982;
Woolley, 1941.
Wyoming: Burr 1961a, 1961b;
Gruell, 1979, 1980a; Vale
1973, 1978.
James, William E.
As photographer in the Holy
Land: Schiller, 1980.
Jenkins, F., photographs: Komar,
1976.
Johnson, Joe W., photographs:
Shepard and Wanless, 1971.
Jordan
Jerusalem and the Holy Land:
Schiller, 1978, 1979a,
1979b, 1980.
Jumping cholla (see Opuntia
fulgida)
Juniper (see Pinyon-juniper
vegetation type)

Kahan, Leo, photographs: Schiller,
1978, 1979b.
Kalter, Benor, photographs:
Schiller, 1978.
Kansas
Cultural change: Ganzel, 1984.
Kearney, Ty, photographs:
Foxworthy and Hill, 1982.
Keen, Dora, photographs: Field,
1932, 1974.
Keith, George Skene, photographs:
Schiller, 1979b.
Kilburn, Benjamin-West
As photographer in the Holy
Land: Schiller, 1980.
Kilburn, Edward, photographs:
Schiller, 1980.
King, Clarence, Territorial survey
Role of photographs: Ostroff,
1981.
Klett, Mark C., photographs:
Committee on Surface Min-
ing and Reclamation, 1979;
Berger and others, 1983.
Kolb, E. C., photographs: Turner,
R. M., and Karpiscak, 1980.
Koonamore Vegetation Reserve
(see Australia, T. G. B.
Osborn Vegetation Reserve,
Koonamore, South Australia
Krikorian (Armenian
photographer)
As photographer in the Holy
Land: Schiller, 1980.

Lakes
Changes in level: Gaines and
the Mono Lake Commit-
tee, 1981; Hardman and
Venstrom, 1941; Mono
Lake Committee, 1982.
Lake Michigan, bluff recession:
Buckler and Winters,
1983.

Lithographs
Comparison with early
photographs: Ostroff,
1981.
Litter
Rates of decomposition: Hall, E.
A. A., and others, 1964.
Litton, R. Burton, Jr.,
photographs: Berntsen and
others, 1983.
Livestock management: Anony-
mous, 1943; Buchanan, 1971.
Lorent, August Jacob
As photographer in the Holy
Land: Schiller, 1980.

Macdonald, Mrs. W. H.,
photographs: Grant, P. J.,
1977.
MacDougal, Daniel T., photo-
graphs: Hastings and Turner,
1965; Turner, R. M., and
Karpiscak, 1980.
Malde, Harold E., photographs:
Smith, G. I., 1978; Wells, S.
G., and Lambert, 1981.
Management
Beachgrass: Knutson, 1979.
Chaparral vegetation, grazing
practices, Arizona:
Cable, 1975.
Ecology and management:
Martin, S. C., 1975.
Grasses and shrubs: Branson and
Miller, 1981.
Green fescue grassland: Reid, E.
H., and others, 1980.
Livestock: Anonymous, 1943;
Buchanan, 1971.
National Forests, Wyoming:
Berntsen and others,
1983.
Pinyon-juniper ranges: Cotner,
1963; Springfield, 1976.
Ponderosa pine: Gruell and

others, 1982; Pearson,
1950.
Range and livestock production,
effects of management
practices: Anonymous,
1943; Reynolds, 1959.
Riparian habitats: Ames, 1977b.
Semidesert grass-shrub commu-
nity: Martin, S. C., 1966,
1968, 1975; Martin, S. C.,
and Cable, 1974;
Reynolds, 1959; Reynolds
and Martin, 1968.
Tamarisk: Graf, 1982a.
Tussock grassland, New
Zealand: Campbell, 1966.
Vegetation changes since
management was altered
in 1938: Moore, L. B.,
1976.
Maps: Barber, 1976; Burkham,
1972; Corte and Poulin,
1972; Godwin and others,
1974; Poulin, 1962.
Markham, A. H., sketch: Falconer,
1962.
Marshall, John, photographs: U.S.
Geological Survey, 1981.
Massachusetts
Bass Rock: Kaye, 1964.
Cape Cod, sand stabilization:
Knutson, 1979.
Coastal change: Shepard and
Wanless, 1971.
Gay Head Cliffs: Shepard and
Wanless, 1971.
Minot's Ledge Lighthouse: Kaye,
1964.
Pulpit Rock: Kaye, 1964.
Sea-level change, shown by
upper barnacle limit:
Kaye, 1964.
Matson, Eric
As photographer in the Holy
Land: Schiller, 1980.
McDonald, J., photographs:

Forest-grassland ecotone, fire
history: Arno and Gruell,
1983.
Glacier National Park, Grinnell
and Sperry Glaciers,
shrinkage: Johnson,
Arthur, 1980.
Great Plains: Phillips, 1963.
Kaniksu National Forest: Lyon
and Stickney, 1976.
Maiden Canyon: Burr, 1966.
Middle Yellowstone River Area:
U.S. Bureau of Land
Management, 1969.
Missouri Breaks, historical
comparison photographs:
U.S. Bureau of Land
Management, 1979.
Missouri River near Fort
Benton: U.S. Bureau of
Land Management, 1971.
Mountain grassland vegetation:
Laycock, 1975.
Musselshell River Area: U.S.
Bureau of Land
Management, 1971.
Northeastern, increased cover
of grasses and shrubs:
Branson and Miller, 1981.
Range reference areas:
Laycock, 1975.
Sawtooth National Forest: Lyon
and Stickney, 1976.
Square Butte, landscape change:
Burr, 1970.
Tongue River Area, vegetation
change: U.S. Bureau of
Land Management, 1967.
Western, vegetation change:
Gruell, 1983; Gruell and
others, 1982.
Yellowstone River at Forsyth:
U.S. Bureau of Land
Management, 1969.
Morris, J. R., photographs:
Whitehouse, 1982a.

Morrison, Boone, photographs:
Tilling and others, 1976.
Mortality rates, plants: Hastings
and Turner, 1965.
**Muybridge, Eadweard J.,
photographs:** Naef and Wood,
1975.

Nebraska
Cultural change: Ganzel, 1978,
1984.
Great Plains: Phillips, 1963.
North Platte and Platte Rivers,
shrinking channels:
Schumm, 1977; Williams,
G. P., 1978.
Prairie vegetation, quantitative
study of drought:
Robertson, 1939a, 1939b.
Republican River, downstream
effects of dams:
Williams, G. P., and
Wolman, 1984.
Sand Creek, channel
aggradation: Patton and
Schumm, 1981.
Neff, Johnson A., photographs:
Johnson, R. R., and
Carothers, 1982.
Netherlands
Fresh-water tidal area,
vegetational succession:
Zonneveld, 1975.
Nevada
Austin, increase in woodland:
Thomas, 1971.
Black sagebrush community,
invasion by pinyon and
juniper: Blackburn and
Tueller, 1970.
Carson Lake: Hattori and
McClane, 1980.
Cortez, pinyon-juniper
vegetation type: Young
and Budy, 1979.

Eureka, increase in pinyon pine:
Lanner, 1981.
Fault scarps: Wallace, 1977.
Ghost towns: Nevada River
Basin Survey Staff, 1969;
Shamberger, 1970, 1973,
1976, 1982.
Jackson, William Henry,
photographs repeated by
Rephotographic Survey
Project: Berger and
others, 1983.
Lahontan basin, sagebrush
community: Nevada
River Basin Survey Staff,
1969.
Lake Tahoe area: Glancy, 1981.
Pyramid Lake: Hardman and
Venstrom, 1941.
Reese River Valley, Austin, land
use patterns: Thomas,
1971.
Simpson Pass: Hattori and
McClane, 1980.
Truckee River, estimate of 100-
year runoff: Hardman
and Venstrom, 1941.
Winnemuca Lake: Hardman and
Venstrom, 1941.

New Hampshire
Hubbard Brook Experimental
Forest: Bormann and
Likens, 1979.

New Jersey
Palisades, basalt columns:
Lobeck, 1939.

New Mexico
Arroyo cutting near Santa Fe:
Malde, 1973; Malde and
Scott, 1977; Smith, G. I.,
1978.
Bandelier National Monument,
hydrologic adjustment of
burned area: White and
Wells, 1979.
Beale Trail, vegetation and

terrain: Lockett, 1939.
Boundary with Mexico: James,
1969.
Cabezon Peak, photograph:
Wells, S. G., and
Lambert, 1981.
Canadian River, downstream
effect of Ute Dam:
Williams, G. P., and
Wolman, 1984.
Carlsbad Caverns National
Park, effects of fire on
vegetation: Kittams,
1973.
Chaco Wash: Love and others,
1983.
Chetro Ketl Indian ruin, Chaco
Canyon: Lekson, 1983.
Cope, Edward Drinker, sketches
of 1870s compared with
1948 photographs:
Simpson, 1951.
Cultural change: Ganzel, 1984.
Elephant Butte Reservoir:
Barger, 1982.
Fuelwood harvesting near Santa
Fe: Carey, 1980.
Inscription Rock, Spanish
inscriptions: Berger and
others, 1983.
Jemez River, downstream
effect of Jemez Canyon
Dam: Williams, G. P., and
Wolman, 1984.
Jornada Experimental Range,
replacement of grassland
by mesquite duneland:
Hennessy and others,
1983.
Northwestern, surface texture
of weathered mantle:
Wells, S. G., and others,
1983.
Rangelands, plant succession:
Potter and Krenetsky,
1967.

Management: Cotner, 1963;
Springfield, 1976.
Range reference areas: Potter
and Krenetsky, 1967;
Turner, R. M., Applegate,
Bergthold, Gallizioli, and
Martin, 1980.
Regrowth after fuelwood
harvesting: Carey, 1980.
Plant communities
Applications of repeat
photography:
Daubenmire, 1968.
Plant succession (see Vegetation
change)
Plots
Beachgrass: Knutson, 1979.
Crested wheatgrass: Frisch-
knecht and Harris, 1968.
Desert grassland: Glendening,
1952.
Establishment and methods of
use: Thalen, 1980.
Lichen vegetation: Frey, 1959;
Stüssi, 1970.
Pinyon-juniper vegetation type:
Arnold and others, 1964.
Sagebrush-grass ranges, grazing
study: Laycock, 1967.
Salt marsh vegetation: Lausi
and Feoli, 1979.
Polaroid photographs
Use in relocating unmarked
camera station: Harrison,
A. E., 1974.
Use in vegetation photographic
charting method:
Claveran, 1966.
Ponderosa pine forest
Alternatives to chemical
insecticides: Schmidt and
others, 1983.
Development of shrubs in sites
of old fires: Dietz, D. R.,
and others, 1980.
Exclusion of fires, effects on

understory: Weaver,
1959.
Forest ecology: Progulske and
Shideler, n.d.; Progulske
(with Sowell), 1974;
Shideler, 1973; Wright, H.
A., and Bailey, 1982.
Managment: Gruell and others,
1982; Pearson, 1950.
Prescribed burning: Biswell,
1963; Morris, W. G., and
Mowat, 1958; Weaver,
1955, 1957, 1967, 1968.
Thinning, Blue Mountains,
Oregon: Hall, F. C., 1976,
1977.
Pony Express route, Nevada:
Hattori and McClane, 1980.
Population dynamics
Opuntia fulgida (jumping
cholla): Tschirley and
Wagle, 1964.
Maireana sedifolia and Acacia
aneura: Crisp, 1978.
**Powell, John Wesley, Second
Expedition (1871-1872)**
Photographs: Baars and
Molenaar, 1971; Graf,
1978, 1979b; Lohman,
1974, 1980; Press and
Siever, 1982; Shoemaker
and Stephens, 1969, 1975;
Turner, R. M., and
Karpisak, 1980.
Role of photographs: Ostroff,
1981.
Powers, Howard A., photographs:
Swanson and others, 1979.
Prairie vegetation
Drought, quantitative study:
Robertson, 1939a, 1939b.
Precipitation
Effects of increase: Branson
and Miller, 1981.
Severe storms: Whitehouse,
1982b.

Sagebrush-grass ranges: Laycock,
1967.
Saguaro
Decrease in Sonoran Desert:
Hastings, 1963; Hastings
and Turner, 1965; Steen-
bergh and Lowe, 1977,
1983; Turner, R. M.,
Alcorn, and Olin, 1969.
Increase in Sonoran Desert:
Martin, S. C., and Turner,
1977; Simmons, 1966.
Salt cedar (see Tamarisk)
Salt marsh vegetation: Lausi and
Feoli, 1979.
Salzmann, Auguste, photographs:
Schiller, 1978, 1980.
Sand dunes (see Dunes, changes in)
Sand stabilization: Knutson, 1979.
Sandveld
Rhodesia, prescribed burning:
Kennan, 1972.
Savignac, photographs: Schiller,
1978, 1980.
Schneebeli, W., photographs:
Lamb, 1982.
Schrader, F. C., photographs:
Grant, U. S., and Higgins,
1913.
Schultz, Alfred Reginald,
photographs: Burr, 1965.
Sea-level, changes in
Shown by upper barnacle limit:
Kaye, 1964.
Sealey, E. P., photographs:
Whitehouse 1982a.
Semidesert grass-shrub
community
Ecology and management:
Martin, S. C., 1975.
Grazing management and shrub
control: Martin, S. C.,
1968.
Role and use of fire: Wright, H.
A., 1980; Wright, H. A.,
and Bailey, 1982.

Santa Rita Experimental Range:
Effects of fire: Cable, 1967,
1973; Reynolds and
Bohning, 1956;
Wright, H. A., 1980;
Wright, H. A., and
Bailey, 1982.
Grass production following
mesquite control:
Cable, 1976.
Vegetation change: Martin,
S. C., 1964, 1966.
Vegetation response to
precipitation, grazing,
soil texture, and
mesquite control:
Martin, S. C., and
Cable, 1974.
Woody shrubs, invasion by:
Humphrey, 1953;
Lowe and others,
1970.
Sequoia gigantea
Effect of human impact:
Hartesveldt, 1962.
Shadbolt, Cecil V., photographs:
Schiller, 1979b.
Shantz, Homer LeRoy, photo-
graphs: Hastings and Turner,
1965; Phillips, 1963; Rogers,
1980, 1982; Steenbergh and
Lowe, 1977; Turner, R. M.,
Alcorn, and Olin, 1969; U.S.
Bureau of Land Manage-
ment, 1979.
Shepard, Francis P., photographs:
Komar, 1976; Snead, 1982.
Shoemaker, Eugene M., photo-
graphs: Baars and Molenaar,
1971; Graf, 1978, 1979b;
Lohman, 1974.
Shoreline (see Beaches, shoreline
change)
Shrubs
Control on semidesert ranges:
Martin, S. C., 1968;

South Dakota 165

Martin, S. C., and
Morton, 1980.
Development in sites of old
fires: Dietz, D. R., and
others, 1980.
Effects of removal: Cable,
1975.
Great Basin Desert, vegetation
change: Rogers, 1980,
1982.
Herbicide treatment: Martin, S.
C., and Morton, 1980.
Invasion, desert grassland:
Humphrey, 1953.
Iraq, effects of an exclosure:
Thalen, 1979.
Precipitation, effects of
increase: Branson and
Miller, 1981.
Sonoran Desert, vegetation
change: Hastings, 1963;
Hastings and Turner,
1965; Shreve, 1929.
Slope processes
Crimean Peninsula: Blagovolin
and Tsvetkov, 1971.
New Zealand, slope stability:
Gage and Black, 1979.
Use of photographs to observe
changes in slope: Curry,
1967.
Smith, George Adam, photographs:
Schiller, 1979a, 1980.
Smith, Philip Sidney, photographs:
Hamilton, 1965.
Smith, Warren Dupré, photographs:
Byrne, 1963; Shepard and
Wanless, 1971.
Soil
Changes on subalpine grassland:
Strickler, 1961.
Erosion, green fescue grassland:
Reid, E. H., and others,
1980.
Loss after exclusion of live-
stock; Buchanan, 1971.

Recovery on former sheep
trails: Hall, E. A. A., and
others, 1964.
Semidesert grass-shrub
rangeland: Martin, S. C.,
and Cable, 1974.
Surface texture of weathered
mantle: Wells, S. G., and
others, 1983.
Soil conservation
Coon Creek Basin, Wisconsin:
Trimble and Lund, 1982.
Waitaki Catchment, New
Zealand: Campbell, 1966.
Wasatch Mountains, Utah:
Copeland, 1960.
Sonneman, Eve, photographs:
Berger and others, 1983.
**Sonoran Desert, Arizona and
Mexico**
Vegetation change: Hastings,
1963; Hastings and
Turner, 1965; Lowe,
1958-1959; Martin, S. C.,
and Turner, 1977;
Simmons,1966; Steen-
bergh and Lowe, 1983.
South Dakota
Black Hills: Progulske and
Shideler, n.d.; Progulske
(with Sowell), 1974;
Shideler, 1973; Wright, H.
A., and Bailey, 1982.
Cultural change: Ganzel, 1984.
Custer Expedition: Progulske
and Shideler, n.d.;
Progulske (with Sowell),
1974; Shideler, 1973.
Development of shrubs in sites
of old fires: Dietz, D. R.,
and others, 1980.
Forest-grass ecotone, controlled
burning: Gartner and
Thompson, 1973.
Great Plains: Phillips, 1963.

Scandes mountain chain,
vegetation change:
Kullman, 1979, 1982.
Umealven river, vegetation
change: Grelsson and
Nilsson, 1982.
Sweig, photographs: Schiller, 1980.
Switzerland
Swiss Alps, glaciers: Lamb,
1982; Le Roy Ladurie,
1971.
Swiss National Park, alpine
quadrats: Frey, 1959;
Stüssi, 1970.

Talus
Growth, Chugach Mountains,
Alaska: Clark and others,
1972.
Tamarisk
Encroachment of: Burkham,
1972; Culler and others,
1970; Graf, 1982a;
Robinson, 1965; Turner,
R. M., 1974b; Turner, R.
M., and Karpiscak, 1980.
Fluvial adjustments: Graf, 1978.
Hydrologic effects on floods:
Burkham, 1976.
River-channel management,
Salt and Gila Rivers:
Graf, 1982a.
Taylor, Becky, photographs:
Halliday, 1982.
Techniques
Aerial photographs:
Coastal change: Shepard and
Wanless, 1971; Snead,
1982; Zeigler and
Ronne, 1957.
Mount St. Helens:
Foxworthy and Hill,
1982; Janda and
others, 1981;
Krimmel and Post,

1981; Voight and
others, 1981;
Williams, C., 1980.
Time-lapse motion picture
photography: Zeigler
and Ronne, 1957.
Used to record vegetation:
Goldsmith and
Harrison, 1976.
Annual photographs: Corte and
Poulin, 1972; Hall, E. A.
A., and others, 1964;
Nobel and Crisp, 1980;
Poulin, 1962; Russell,
1898; Zonneveld, 1975.
Camera height: Farrow, 1915a;
Malde, 1973.
Camera stations:
Choosing a site for
recording changes in
a glacier: Gilbert,
1904; Harrison, A. E.,
1960.
Matching of position and
camera orientation,
plant communities:
Tansley, 1946.
Multiple photographs from a
station: Rogers, 1980,
1982.
Permanent marks: Cavell,
1983; Cooper, 1928;
Dingus, 1979; Farrow,
1915a; Gary and
Currie, 1977; Gilbert,
1904; Magill and
Twiss, 1965; Malde,
1973; Poulin, 1962;
Russell, 1898; Tarr
and Martin, 1914;
Walker, 1968.
(See also Techniques,
reoccupying un-
marked camera
stations)

Vachon, John, photographs:
Ganzel, 1978, 1984.
Vanis, Erich, photographs: Post
and LaChapelle, 1971.
Vantage point, discussion of:
Klett, 1979.
Vaux, George, Jr., photographs:
Cavell, 1983.
Vaux, George, Sr., photographs:
Cavell, 1983.
Vaux, Mary M., photographs:
Cavell, 1983.
Vaux, William S., Jr., photographs:
Cavell, 1983.
Vay, C. D., photographs: Johnson,
D. L., 1972.
Vegetation change
Africa: Shantz and Turner,
1958.
Arizona:
Colorado River above Yuma:
Ohmart and others,
1977.
Colorado River canyon:
Shoemaker and
Stephens, 1975;
Turner, R. M., and
Karpiscak, 1980.
Gila River: Burkham, 1972;
Culler and others,
1970; Graf, 1982a;
Rea, A. M., 1983;
Turner, R. M., 1974b.
Grass and herbs: Leopold,
1951.
Grassland-juniper woodland
ecotone: Johnsen and
Elson, 1979.
Haplopappus tenuisectus
(burroweed): Cable,
1967; Tschirley and
Martin, 1961.
Mesquite: Cable, 1976;
Martin, S. C., and
Cable, 1974; Martin,
S. C., and others,

1974; Parker and
Martin, 1952.
Santa Cruz River:
Hydraulic effects near
Tumacacori:
Applegate, 1981.
Riparian habitat and
recreation:
Johnson, R. R.,
and Carothers,
1982.
Santa Rita Experimental
Range: Cable, 1967,
1973, 1976; Glen-
dening, 1952, 1955;
Humphrey 1963;
Lowe and others,
1970; Martin, S. C.,
1964, 1966; Martin, S.
C., and Cable, 1974;
Martin, S. C., and
others, 1974; Martin,
S. C., and Tschirley,
1969; Martin, S. C.,
and Turner, 1977;
Reynolds and Bohn-
ing, 1956; Tschirley,
1963; Tschirley and
Wagle, 1964; Wright,
H. A., 1980; Wright,
H. A., and Bailey,
1982.
Secondary succession of
abandoned field
vegetation:
Karpiscak, 1980.
Semidesert ranges: Cox and
others, 1983; Martin,
S. C., 1968.
Sierra Ancha Experimental
Forest: Pond, 1971.
Sonoran Desert: Blydenstein
and others, 1957;
Hastings, 1963;
Hastings and Turner,
1965; Lowe, 1958-

Virginia
Channel changes in badlands:
Howard and Kerby, 1983.
Volcanoes
Alaska, Redoubt Volcano: Post
and Mayo, 1971.
Hawaii:
Historic littoral cones:
Moore, J. G., and
Ault, 1965.
Kilauea: Holcomb and
others, 1974; Richter
and others, 1964;
Swanson and others,
1972, 1979; Swanson
and Peterson, 1972.
Washington:
Mount Baker: Frank and
others, 1975.
Mount St. Helens, Washing-
ton: Brugman and
Post, 1981; Findley,
1981; Foxworthy and
Hill, 1982; Halliday,
1982; Hickson, C. J.,
and Barnes, 1982;
Hickson, C. J., and
others, 1982; Janda
and others, 1981;
Keith and others,
1981; Krimmel and
Post, 1981; Moore, J.
G., and Albee, 1981;
Moore, J. G., and
others, 1981; Palmer,
L., and KOIN-TV
Newsroom 6, 1980;
Rowley and others,
1981; U.S. Geological
Survey, 1981; Voight,
1981; Voight and
others, 1981;
Williams, C., 1980.
Vollum, Edward Perry, album:
Turner, J. H., 1983.

Vroman, Adam Clark, photographs:
Borchers, 1977.

Wasatch Mountains
Matched photographs based on
G. K. Gilbert and W. H.
Jackson: Rogers, 1980,
1982; Woolley, 1941.
Washburn, Bradford, photographs:
Post and LaChapelle, 1971;
Post and Mayo, 1971.
Washington
Blue Glacier, Olympic
Mountains: Post and
LaChapelle, 1971.
Boulder Glacier, Mount Baker,
debris avalanches: Frank
and others, 1975.
Cultural change: Ganzel, 1984.
Mount Rainier National Park:
Human and natural impacts:
Lindsey, 1977.
Nisqually Glacier: Harrison,
A. E., 1960; Veatch,
1969.
South Mowich Glacier: Post
and LaChapelle, 1971.
Mount St. Helens:
Ashfalls, posteruption
effects: Halliday,
1982.
Effects of volcanism on
glaciers: Brugman
and Post, 1981.
Eruption of May 18, 1980:
Findley, 1981;
Foxworthy and Hill,
1982; Hickson, C. J.,
and Barnes, 1982;
Hickson, C. J., and
others, 1982; Janda
and others, 1981;
Palmer, L., and
KOIN-TV Newsroom